STORIES FOR LITTLE COMRADES

To Sylvia
with my sincere gratitude.

Esterer

dec. 1999

YESHIVA UNIVERSITY
MUSEUM

STORIES
FOR LITTLE
COMRADES

REVOLUTIONARY ARTISTS
AND THE MAKING OF EARLY
SOVIET CHILDREN'S BOOKS

EVGENY STEINER

Translated from the Russian by Jane Ann Miller
University of Washington Press Seattle and London

This publication was supported in part by the
Donald R. Ellegood International Publications Endowment.

Library of Congress Cataloging-in-Publication Data
Steiner, Evgeny.
 Stories for little comrades : revolutionary artists and the making of early
 Soviet children's books / Evgeny Steiner : translated from the Russian by
 Jane Ann Miller.
 p. cm.
 Includes index.
 ISBN 0-295-97791-4 (alk. paper)
 1. Illustrated children's books—Soviet Union. 2. Illustration of books—
 20th century—Soviet Union. 3. Constructivism (Art)—Soviet Union.
 I. Title.
 NC985.S76 1999
 741.6′42′094709042—dc21 99-39879
 CIP

To Julia and Gabriel

CONTENTS

PREFACE

When I was writing this book at the end of 1989, and the end of the Soviet period of my life, I could scarcely predict what sorts of changes lay ahead, either in my own life or—more crucial to the topic at hand—in the social and political situation worldwide. The chief goal of my work at the time was to point out, using as my material texts of secondary modeling systems (art texts), certain deep-seated characteristics of the artistic consciousness (or rather, subconscious) of an era in revolution and turmoil. If I were writing the book now, I would perhaps express it in a different way, emphasizing revolutionary avant-garde strategy as it was captured not in slogans, not in manifestoes, not in the reflexive discourse of any sort, but in texts directly intended for other purposes.

In 1989, I thought it would be interesting to analyze the fundamental artistic, aesthetic, and spiritual stereotypes of the late 1920s and

early 1930s on the basis of rather marginal and what might seem patently "light" material—illustrations in children's books.

Books for preschoolers attracted some of the most prominent representatives of the artistic avant-garde. Those who did not work in children's books can be counted on the fingers of one hand more easily than can all the leading players, their followers, their imitators, and all the extras who served as an expressive (or in a purely aesthetic or perhaps innovative sense, an inexpressive) backdrop for them.

Since, as fate would have it, I had been working on and off with children's books from the end of the 1970s, I supposed that it might be interesting, over and above the work's culturological-interpretational aims, to give it an introductory character as well. By introducing some little-known or heretofore unknown material, I might shed additional light on certain avant-garde names and issues already well known in other respects.

The chief inspiration, perhaps quite independent of the author's will, was the idea that leading artists (and of course writers, but here we are dealing mainly with visual texts and the visual-representational language of the era), whether consciously or unconsciously, shared the same mental framework as the "new life's" political leaders, and that they quite actively took it upon themselves to design that life—or more precisely, to make a blueprint of it, a model for it.

Such ideas couldn't have come at a worse time for the expiring Soviet Union, or rather its intelligentsia. In 1989 and 1990, when perestroika was in full swing, when progressive-minded citizens were reading one Comrade Stalin exposé after another, but not yet daring to think out loud about Comrade Lenin, a steady stream of hitherto hidden treasures and heroes came pouring out of the archives, inundating the reader. For the first time (we are talking here about officially channeled and therefore approved information) people began speaking, loudly and with feeling, about the fact that the avant-garde was, well, something good. They acknowledged the brilliant artistic vision of all those geniuses of the 1920s, and discussed "the tension of pure form" and "the spatial relations between constructive planes," et cetera, et cetera. They were thrilled to discover that there was

nothing counterrevolutionary about the "leftist" artists at all; just like everything else, it was all Comrade Stalin's fault, and the fault of those unreasonable repressions of the 1930s that had diabolically done in everything genuine and truly enlightened in avant-garde Soviet art.

Bringing out a text that maintained that the avant-garde was part and parcel of the totalitarian era, that it hadn't just *shared* the ideology of the day but had *created* the very face (both the artistic and, more important, the ideological face) of that era, turned out to be an endeavor woefully ill-timed. The democratic intelligentsia could not admit that the avant-garde had, on the sublimated-aesthetic level of pure form and global-utopian-totalitarian (and ultimately intolerant) manifesto, drafted the plan for a new world, nor that it had, at best, been simply testing out ideas already in the air. Driven by the material itself, and not entirely aware of the tricks it might play on him, the present author had no idea that his culturological analysis of ideas and forms would, in the intelligentsia's view, simply "play into the hands of so-called reactionaries, antireformers, traditionalists, anti-Semites, and their ilk." No doubt a certain rigidity of affect is to blame—that very affect that in the euphoric days of 1962–63 prompted certain mildly (or would-be) anti-Soviet Soviet critics to come forth with sincere justifications of the notorious 1936 *Pravda* condemnations of "artist-daubers," and in the 1990s to hotly defend the great revolutionary experiment that was art in the 1920s.

And so on. The rest of the story isn't particularly interesting.

Returning to Moscow in the spring of 1994, I felt a renewed interest in children's illustration, in the design of books and the design of life. Fantasmagorical post-Soviet reality forced me back to those early-Soviet-socialist-aesthetic attempts at modeling a world. I looked over the present work and, without changing anything already there, expanded it somewhat. At the same time, I pruned away both the minor set of references to Bakhtin-Florensky-Averintsev (standard for the Brezhnev-era intellectual youth) and the major set of references to Eco-Foucault-Derrida-Baudrillard-Lacan-Deleuze-Guattari-Jameson (standard for the perestroika humanist). In their place I quoted as much poetry and as many remarks by artists them-

selves as the text would hold. Let the material speak for itself, as I would for myself.

There is very little I can add for the English-language edition of this work, although the homage the West pays to the Soviet revolutionary avant-garde is an interesting phenomenon in itself. For many years artistic and intellectual circles in Europe and America have been captivated by the boldness of the aesthetic projects launched in Soviet Russia in the teens and twenties.

The burning interest in early Soviet art evinced by America and all the rest of the free world comes down, simply, to the psychological need for a good scare. Out in the mean green jungle, all those capitalists busy devouring the proletariat, and each other, are uncertain and frightened. What would happen if their surplus value was taken away? The modern businessman looks at some Soviet poster depicting a muscular workman plunging a bayonet into the fat bourgeois belly of his grandpa and feels a sense of catharsis: first fear, then joy. We won, in the end, and the great unwashed (*chumazye*) had to smash not only their bayonets but their plowshares to boot.

Only through a psychoanalytical interpretation of Western phobias is it possible to explain the "free world's" sustained interest in the Soviet avant-garde. The Freudian urge-to-incest reveals itself in the bourgeoisie's unnatural attraction to its offspring, the working class. Here, too, is the equally Freudian death wish—personified in the thirty-year-old Marx's 1848 image of the proletarian digging the grave of the bourgeoisie. (Which, given his youth at the time, is forgivable. But then look what came of it!) Westerners who see terrifying pictures of the builders of the Communist future marching bravely ahead, or scenes of world capitalism's "final hour," deal with their own fears. It's something like the satisfaction certain Jews get from contemplating anti-Semitic horrors; once they see that there's been no pogrom after all, they sigh in relief. Were there to be no displays of anti-Jewish sentiment whatsoever, they would find life quite boring.

Moreover, the Soviet avant-garde between 1910 and the early 1930s holds

yet another hidden attraction in the West, especially for the Western intel-
lectual. This is the spirit of collectivism.

It was individualism that made the West the West: individualism as a
personal responsibility before God, understanding of the value of one's own
personality, self-dependency, profession of one's own worldview. These
were the foundation of Humanism, Protestantism, and Capitalism, and lie
at the base of the European freedom and wealth. But on the other hand, in-
dividualism appeared to be pregnant with alienation, personality crisis,
and the death of God. The burden of making independent decisions ap-
peared to be unbearable for many. At the beginning of the twentieth cen-
tury the voluntarism of Self had brought some people to immorality and
decadence, and others to a horror before the freedom of choice and their
own uninhibited ego. Intellectual thinkers sang laudatory hymns to collec-
tivism; they were longing for *sobornost'* (mystically understood together-
ness, in terms of Orthodox Christianity); they thirsted for the place of poet
in the workers' ranks, as Mayakovsky put it in his revolutionary verses.
"Left" artists shortly before the Bolshevik revolution began to draw human
figures without faces, but with angular mannequin or soldier-like forms.
Pretty soon came those who took on the task of governing the masses—
people's commissars, duces, and führers. The Left artists appeared in 1918
in the Kremlin and offered their services.

The revolutionary, mass-agitation art of the first years after the October
Revolution is indeed a unique phenomenon, a combination of artistic inno-
vation, sincere social commitment, and no-holds-barred utopian mentality.
This passionate and quite religious belief in the people, the collective, and
the construction of a new world on the ruins of the old led to a powerful
explosion of creative potential. In the visual arts, this expressed itself in
the creation of a new formal language diametrically opposed to the previ-
ous era's means of expression. The language of leftist art was vivid, persua-
sive, and compelling. Sharp angles, dynamic composition, shifted axes,
swiftly tilting verticals and horizontals—all this charged the emotions,
pulled people forward, urged them to volunteer, to build that five-year plan

in four. Bright primary colors with no halftones, flat, single-color masses, contrasts of black against white, and red against black shouted from walls and fences, caught people's attention, forced them to discard their intellectual old-style waverings, helped them breath deeper, walk taller, shoot straighter. Avant-garde pictures aroused in the intellectuals an agonizingly bittersweet, or rather, sweetly terrifying sensation. In them they saw a very determined and blind power, and so fell under their furious and feverish spell.

A history of the Western appreciation and perception of that art deserves special study and analysis. Such a study would, I believe, be quite revealing of Western intellectuals' subconscious inclinations and preferences, which all too often lack any authentic ideological context. If this work can provide some of that context, I will consider my goal achieved.

There is one more thing that I need to mention here. I began this work by inventing a very smart and witty Russian title for it: The "Avant-garde and the Construction of the New Man." In Russian it is a mocking sarcasm to Lenin's "great theoretical teaching" about construction (or building) of Socialism in a single country. Here "Socialism" is replaced by a "New Man," which makes the latter an almost mechanical object for construction and manipulation. And this construction is being made by Constructivists. But in English, alas, this Russian coinage does not work well. So the title has been changed for a more appropriate one.

I wish to express my gratitude to those people who read the manuscript and whose sometimes severe comments on it led me to clarify my own thoughts: Yuri Gerchuk (Moscow), Dmitri Segal (Jerusalem), Vyacheslav V. Ivanov (Los Angeles). I am also grateful to the staff of the Russian State Library, Natal'ya Burlak, Tat'yana Maistrovich, Iraida Pankova, and Igor Melan'in, who assisted me in many ways—especially in the laborious business of preparing illustrations. Many thanks also to Michael Duckworth of the University of Washington Press, who demonstrated remarkable courage in accepting the Russian-language manuscript for consideration, to Jane Ann Miller (Jonesville, Vermont), who undertook the very special labor of rendering my Russian-Soviet idioms into this academic lingua franca, and

to Leila Charbonneau, who gave the manuscript a meticulous editing. My special thanks go to Julia Krichevsky-Steiner (New York), who, during my stay in Japan, helped me keep in touch with Moscow and Seattle.

Returning to an old subject, to an old, crumpled and dog-eared manuscript, returning to one's native city as a visitor and a foreigner—all of this may be just an attempt to step back into the same river and let it pour over the bittersweet smoke of a faintly smoldering ruin.

A valedictory gesture—hail and farewell.

Requiescant in pace.

E. S.
Tokyo
Meiji Gakuin International House

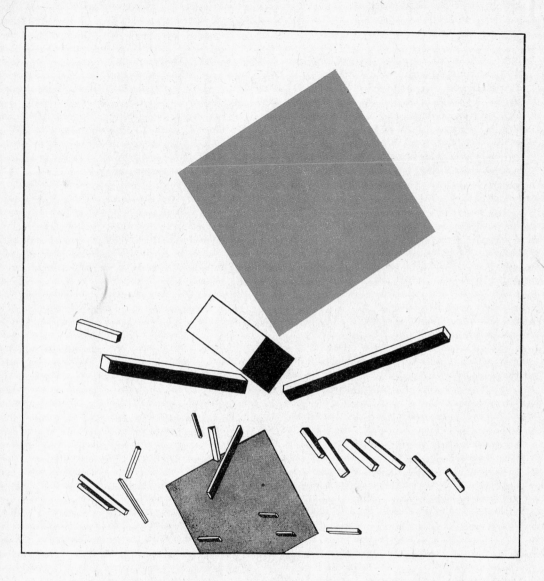

УДАР

все рассыпано

А бывало, к ней с поклоном
Шли девицы с перезвоном,
Шли девицы за водой
По улице мостовой.

Подходили к речке близко,
Речке кланялися низко.
Здравствуй, речка — наша мать,
Дай водицы нам набрать!

(*previous page*) El Lissitzky. *A Suprematist Tale of Two Squares*. Berlin, 1922.

К сундуку бежит толстяк.
От жары он весь размяк,
Щеки, как подушки,
Шляпа на макушке.

„Эй, — кричит он, — старичок!
Положи на пятачок!"

Vladimir Lebedev. From *Ice Cream* (Samuil Marshak). Leningrad, 1925.

(*opposite*) Vladimir Lebedev. From *Yesterday and Today* (Samuil Marshak). 1925.

ДАВАЙТЕ СТРОИТЬ!

На детской площадке
Играют ребятки,—
Хрустит под ногами песок.
Давайте, ребятки,
На нашей площадке
Построим скорей городок.

E. Evsyukova. From *Let's Build* (G. Solovyov). Leningrad, 1928.

(*opposite*) Mikhail Tsekhanovsky. From *Topotun and the Book* (I. Ionov). Leningrad, 1926.

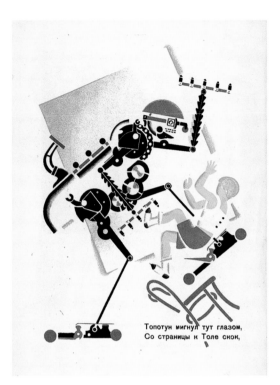

Топотун мигнул тут глазом,
Со страницы к Толе скок,

Торопитесь, братцы, в срок надобно открыть ларек.
Эй, прохожие, с дороги, а не то отдавим ноги!

ПОДБРАСЫВАЕТ СРАЗУ
И ЛОВИТ ОН ШУТЯ

ФАРФОРОВУЮ ВАЗУ,
БУТЫЛКУ И ДИТЯ.

Vladimir Lebedev. From *Circus* (Samuil Marshak). Leningrad, 1925.

(*opposite*) Evgenia Evenbach. From *Market* (Evgeny Shvarts). Leningrad, 1925.

Sergei Chekhonin. From *Kids of Many Colors* (S. Poltavsky). Moscow, 1927.

(*opposite*) A. Kalinichenko. From *Vanya in China* (G. Shaposhnikov). Rostov-on-Don, 1927.

Наступает ночь,
С неба сыплет дождь,
Тучи носятся,

Лес качается,
Люди, птицы и зверье
Все пугаются. .

Только поезд не боится,—
Засияли огоньки,—
Грохоча на рельсах мчится,
Паровоз дает гудки.

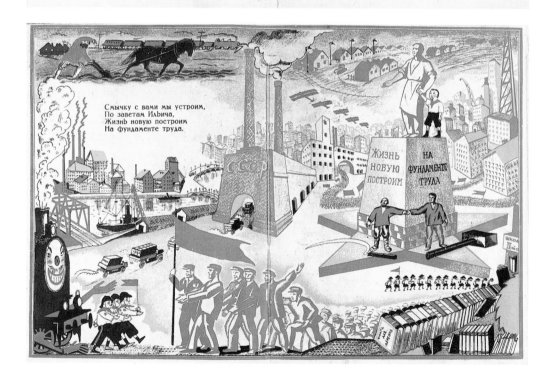

Смычку с вами мы устроим,
По заветам Ильича,
Жизнь новую построим
На фундаменте труда.

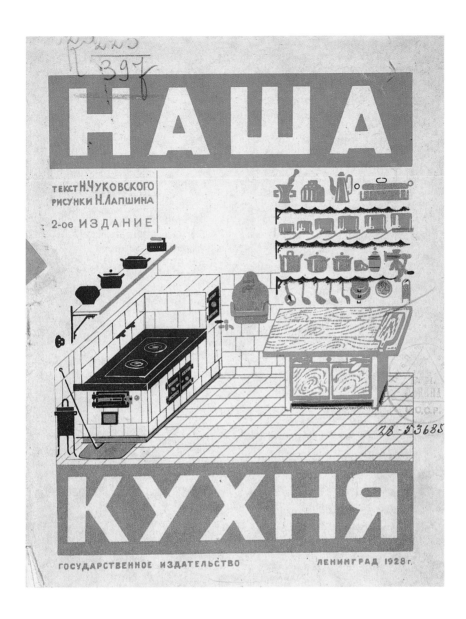

Nikolai Lapshin. From *Our Kitchen* (Nikolai Chukovsky). Leningrad, 1927.

(*opposite top*) Alisa Poret. From *Railroad* (A. Vvedensky). Leningrad, 1929.

(*opposite bottom*) Nikolai Ushin. From *Engines Rampant* (Pyotr Orlovets). Moscow-Leningrad, 1925.

В Т О Р О Й
ЗАКОН

Мы идем за рядом ряд,
Юных ленинцев отряд.

В бой готовый
К ним пришел
Сменой новой
Комсомол,
Чтобы старым
 Коммунарам
 Отдых дать,
И удар
За ударом
Шар земной перековать.

Бодрым маршем,
Дружно в ногу,
Братьям старшим
На подмогу

Комсомольцу младший брат,
Пионер вступает в ряд.
Мы идем на смену смене.
Нас ведет товарищ Ленин.

Makhail Tsekhanovsky. From *The Pioneer Charter* (L. Savelyev). Leningrad, 1926.

STORIES FOR LITTLE COMRADES

INTRODUCTION

n the early 1930s, when the powers-that-be in the Soviet Union
decreed that henceforth the avant-garde had no right to exist, vari-
ous local authorities and the enforcers of the general line within
newly created artists' unions, as well as within the interior-ministry
system, actively took up the task of liquidating these "artist-daubers"
as a class, and in the unprecedentedly short historical span of the
first five-year plan (1928–32) had accomplished that task "on the
whole and in general."

Until the early 1990s, this was practically the only way that the lib-
eral intelligentsia in the USSR viewed the avant-garde's demise in the
1930s at the hands of the Bolsheviks. It remains the dominant view
even today. But in point of fact it is scarcely valid or historically cor-
rect. The avant-garde movement did not die; it merely adapted itself
to a new historical situation. Moreover, it would be a mistake to see
relations between the avant-garde and the Soviet regime as nothing

more than ideological antagonism and a collision of the "innocent victim" with the "senseless executioner."[1]

Roughly twenty years later, at the end of the 1950s and beginning of the 1960s, when everything was indeed built, finished, and done with on the whole and in general, the authorities declared a certain respite in honor of the occasion, and seemed to admit that mistakes had been made and that excesses had taken place—all of which provided a powerful stimulus to the revitalization not only of artistic practice but of the entire set of ideas associated with avant-garde art. "Stark style," minimalist graphics, and the fight against architectural extravagance were all articulated with greater clarity once the formal language of 1920s Constructivism was returned to use. There were also para-artistic factors at work. The aura of righteous martyrdom surrounding those sacrificed to "the period of repression," plus the fact that the authorities very quickly began having second thoughts (for example, Khrushchev's pogrom in the early 1960s of the Manège exhibition "Thirty Years of Moscow Artistic Union"), laid upon every member of the Soviet intelligentsia a moral duty to express nothing but praise for the avant-garde and "leftist" artists, and to contend that, one, they were *not* enemies of the people, and two, they were in fact very good artists. Of course, with just a few exceptions that was indeed the case; but today, with the world of only a few years ago turned upside down, and those once officially persecuted now proclaimed heroes, there is no longer any need to defend them against unjust accusation.[2] Perhaps for the first time, we have the opportunity to approach the work of these artists—major and minor, great and obscure—more calmly. Avoiding both the knee-jerk class antagonism of Socialist Realist zealots and the "Let's just thumb our nose at the system" attitude of the intelligentsia, we can simply look at them as artists, typical of their time, who as a rule expressed that span of time pointedly and brilliantly.

At this juncture it might be worthwhile to point out that I do consider the Russian artistic avant-garde—from the interpreters of Cubism to the Constructivists and Suprematists—the most significant and interesting

artistic and cultural phenomenon of the 1920s. Its newness, its creative force, its depth of formal expressiveness all have been justifiably praised by leading scholars and critics, Western and Soviet alike. The work done by Soviet avant-garde artists during the first few years of that regime—be it in easel painting, *prozodezhda* (work-clothes design), or children's illustration—occupies a rightfully prominent place in the history of twentieth-century art.

Artists are the voice of their time. This commonplace (no less meaningful for being one) is true both for artists who, in Joseph Brodsky's words, "smell the roses," and for those who firmly believe that their songs help us all to "live and build." It was the latter who were in the majority in the 1920s. They consciously strove to develop a language of new artistic forms, one that might express the content of life itself, a revolution both spiritual and earthly.

There are several reasons why the history of avant-garde–Constructivist children's book illustration in the 1920s is particularly suited to the focus I have chosen. We might start with the generally acknowledged artistic quality of these illustrations. As Anatoly Lunacharsky, Commissar of Enlightenment (education and the arts) until 1929, put it in the introduction to his 1931 essay collection entitled *Children's Literature: A Critical Sketch*:

> To the envy of all Europe, illustration of children's books is developing in our country in a most interesting and significant fashion. . . . Illustration, too, has its exploration of new paths, its fierce competition among schools, but all this is being done so richly, so vividly and confidently; the artist of the word has on the whole and in general fallen behind the artist of the image.[3]

Among other primary causes at the heart of this situation, two nonaesthetic ones bear mentioning. Both the absence of an art market and increased government pressure forced artists to look for various ways to

5

adapt. Drawing pictures for children was possibly the very best option. It was not technically burdensome, it was not badly paid, and it had less censorship potential (if we may use such an expression).

Beyond this, and more essential to the topic at hand, is that in this relatively localized sphere, what manifested itself in a particularly forceful and programmed fashion was the postrevolutionary period's chief ideological mission: the creation of a New Man. This is precisely what we have in children's publishing of the time—an ideology-driven attempt to shape the minds of citizens of Bolshevik Russia to a worldview, a set of social attitudes, an everyday ethic and behavior that conformed to Communist teaching.

There is no need to dwell on the fact that art, along with Marxist Holy Writ and political agitation by ideologues on many levels, played a tremendous role in the process of creating a new consciousness. When expressed in the language of artistic forms, the core ideas of the times penetrated far deeper levels of consciousness than direct and didactic instruction or slogans ever could. Images from literature and art reinforced and developed the dominant ideologemes and in some measure even anticipated them. Moreover, they performed a twofold function: they articulated a field of semantic tension within the society, creating a language for society-building; at the same time they facilitated a subconscious psychological adaptation to new conditions. All this is understandable enough. Suffice it to recall Lenin's "Monumental Propaganda Project," conceived as the iconic embodiment of a host of figures from a new social mythology, to be imitated and revered; or else the staging and design of those first revolutionary holidays, which were in essence attempts to create, through art, a ritual time and space for each of the semantically marked moments of the new yearly cycle.

We should also note that the texts of secondary modeling systems let us draw finer distinctions in social consciousness than do purely historical or documentary sources. Compared with either politicians or philosophers, artists often—to their own surprise—speak of their times with more truth and less mercy. In an artistic text, some reflection of a particular epoch's

mindset always filters through, even in the work of opportunists and hacks. Given the nature of the artistic text, what we have is less speech than a slip of the tongue; that is, the suprainformative features of the artist's message carry more than just some outwardly dictated ideological norm. They hold the real content of the artist's consciousness. The reality of an epoch—a notion definable only in semiotic terms—filters through a psychological reality recreated by means of signs. It is in the choice of themes and subjects, in the specific twists and turns of form, in the manner of organizing individual components into a whole that the zeitgeist (perhaps the most intriguing subject of history) makes itself manifest.

Studying artistic texts with the aim of reconstructing the mental clichés of the early Soviet era is an enterprise prompted not only by general considerations but by the peculiarities of the Soviet power structure, which managed to turn the regime itself into a sort of artist-demiurge.[4] And the new regime's objectives were best embodied in children's books.

Picture books for toddlers and young children might seem rather slight material on which to base a reconstruction of the message brought to the masses by leading figures in the art world of the 1920s, but we can find much in them that is both edifying and instructive, for besides artistic factors one should keep several circumstances in mind. Children's books and, accordingly, the illustrations in them, were aimed at an audience numbering in the thousands, and by virtue of that fact alone had a much broader social impact than so-called serious easel painting, which despite the slogan "Art—to the masses" was doomed to remain largely an art for the elite. More important, works made for children had particular significance for the builders of the new world, since here it was not a matter of re-forming the intended audience, but of forming them in the first place, both aesthetically and socially. The role played by the children's artist (and writer too, of course) was immeasurably greater than that of the "adult" easel painter. The former's effect—the response to his "word"—might not be evident immediately, but would become so as years and decades passed, and his children entered adult life. As Naum Gabo wrote, "Art like this needs a new society." And so art in the high "constructive" style sent out a shoot,

7

branching out in the form of children's illustration *ad usum Delphini*, with the idea that those who had been fed on milk would later be ready to take solid food.[5]

But it's not as if this effect was some sort of delayed-action land mine. Or, if one *were* to call what had been planted deep in the cultural consciousness of a people on the first stage of their "shining path" a mine, then the artists themselves might be called the detonating fuse (perhaps a more accurate formulation than the oft-used "drive belt"). Ignited by sparks from all those ideas colliding in the air, they (these creators of a new world) would burn themselves out, leaving behind symbolic images of their times, images born in the smoke and flame of a "fire over all the earth"—or at least over that famous one-sixth of it that concerns us here.

As a rule, from the very beginning people in the arts made a distinction between the ultimate social objective and what were essentially aesthetic issues. And it wasn't just the left wing that did so. For example, Pavel Dulsky, a well-known art historian from Kazan, wrote in a 1925 work that "contemporary children's books and contemporary illustration (in this respect) must educate the citizen in the child, the citizen who will be ready to build the culture of a new world."[6]

In the 1920s, it was in children's book illustration that the new principles of graphic design were taking shape. Leading illustrators found support in the work of the previous decade's avant-garde: the experiments of Kazimir Malevich and his circle; the first formal experiments in book design by publishing houses such as Union of Youth (practically all the noted artists of the time were working in book design, from Tatlin and Ekster to Larionov and Goncharova); the 1914 volume *Futuristy: Pervyi zhurnal russkikh futuristov*; the Futurist group Hylaea; and the publishing house Zhuravl' (Crane), with its Futurist lithograph editions often written by hand or set in a variety of typefaces. And they were intrigued by the *lubok* (a cheap popular print) and other folk or primitivist art. Children's book illustration, by dint of its pragmatic character, most fully absorbed the ambivalent essence of the Russian avant-garde—both its enthusiastic impulse toward

a de-psychologized technicism and its reductive impulse to the simplest of archaic structures.

For the "leftist" artist of the 1920s, illustration was, at its most superficial and primary level, just one variety of the command to serve society, a phenomenon no different from any other sort of service in the common good. As Dulsky penetratingly wrote shortly thereafter:

> With what elan and enthusiasm the left wing of Russian art took over the artistic life of the country in 1918–1919. . . . Clearly, this organization of young artistic forces was not born overnight; it was conceived in 1908–1909, when new western experiments were finding favor among the youth of Russia. The communication of dynamism and the urge to reflect the surrounding world in the simplest of terms (Cubism), in Expressionism, Constructivism— these became the preferred means of transmission of new methods and forms in the art of those who were creating "a contemporary aesthetic." And when the October Revolution broke out, it was the leftist artists themselves who went to the Winter Palace and offered the young regime their experience, their labor and their strength. The artists' task force, which set up the visual arts department of Narkompros and managed to recruit the arts to the cause of nationwide construction, included a number of important names: Natan Al'tman, Nikolai Punin, Sergei Chekhonin, Fal'k, A. Shevchenko, Korolev, Shterenberg, Kandinsky, Tatlin and others.[7]

As early as 1918, when this task force had barely had time to set up anything at all, the regime had already adopted a somewhat apologetic tone, as in the following statement by Commissar of Enlightenment Lunacharsky from an article written that same year:

> There is no harm in the fact that the worker-peasant government has shown considerable support for the new artists and innovators:

they were indeed cruelly rejected by their elders. I hardly need mention that the Futurists were the very first to come to the aid of the Revolution, that they, of all intellectuals, proved to be the closest and most responsive to it, that in many practical ways they proved to be good organizers.[8]

What is interesting here is not only the tone of this statement by a high-ranking Bolshevik and old-line nineteenth-century intellectual, but also the chance slip about the innovators being "cruelly rejected by their elders." This idea (which was never expressed explicitly, but was furtively sensed by many, including the "young artists" themselves) shifts the locus of the conflict away from aesthetic and even social problems and into the realm of conflict between generations. In this we can see another, more profound reason behind the boom in children's illustration. And it matters not one whit that some of the leaders of the avant-garde were by this time over forty. Real collisions between real generations was of little interest to anyone here. Avant-garde movements are generally prone to the feeling that everything done before—by their "elders"—is bad, and must be destroyed or replaced ("Dump Pushkin," "raze the museums," and the like). In essence, the avant-gardists had something of an Oedipus complex in regard to the cultural traditions of their fathers. For so long the "elders" who wielded power in society and art had rejected them, thus forcing the insulted and frustrated "youth" to finally join together and form the Soyuz molodyozhi, the Union of Youth.

Aside from a hypertrophic urge to tear things down to their foundations, this festering, pent-up youthful negativity gave rise to a certain type of infantile personality.[9] On the one hand this manifested itself in a passion for children's books. In addition to the previously mentioned reasons why graphics and literature for children flourished in these years, we should note this one too: there was a quite deliberate escape into childhood, into play, into lighter and smaller forms, into the modeling of a world of "make-believe." To some degree, all the literary-artistic activity in the forefront of children's publishing in the 1920s and early 1930s was a sort of enor-

mously expanded and anxious Oberiu game.[10] On the other hand, the element of play in children's books was a milder version of the socially repressed and internally exhausted "serious" avant-garde game carried on from 1910 into the 1920s. In that period of Sturm und Drang, artistic "output" mainly took the form of what might be called études, consisting of purely formal motifs like the interaction of planes, combination of materials, experimental division of color, and the like. All these formal innovations were a search for a visual poetics socially and psychologically suited to a revolutionary mentality. Another way out of the formal-playful modeling of the new artistic strategy led into production art or directly into "production." (On the next curve of the spiral of Constructivist discourse there was a conditional return from "production" back to children's play, or the "production book." Our third chapter will deal specifically with this genre, which most fully represents Constructivist practice in the making of children's books.)

As a rule, the avant-garde negative personality type finds the parental superego in almost any situation. Hence before the Revolution it was found in the "inert old world," and after the Revolution (with a short breather for sorting out the confusion) in the iron logic of iron commissars, whom the child-artists were neither willing nor able to obey.

The game of re-creating the world ended rather sadly for the avant-gardists, when their simultaneously radical and run-amok rules began to get in the way of the similar but far more ordered game being played by the Party leadership. But for a while, until the early 1930s, children's books would remain a last refuge for all the devices and designs, the elements and rudiments of Constructivist avant-garde aesthetics.

11

Early in the year 1918, an artists' collective named Segodnya (Today) opened at No. 4 Baskov Lane, Petrograd. Its chief organizer was Vera Ermolaeva; members included young graphic artists Natan Al'tman, Yury Annenkov, Nikolai Lapshin, N. Lyubavina, and Elena Turova.[1] Their output consisted mainly of limited editions of children's books, hand printed from linoleum blocks or on a small press. The prints were then hand tinted. The group produced several books with texts by Natan Vengrov; other authors included Alexei Remizov, Mikhail Kuzmin, Ivan Sokolov-Mikitov, and Sergei Esenin. Several of the group's sociocultural aspects deserve mention.

First, this was indeed a collective workshop (*artel'*). It was not just a few artists coming together on aesthetic grounds, but an art-production unit within the greater so-

LAYING OUT THE BOUNDARIES: ARCHITECTS OF THE CONSTRUCTIVIST PROJECT

ciety; its work was aimed at the consumer. The art market had been virtually destroyed by the Revolution, and artists had been forced to consider new ways of selling their work, new ways of producing art. The transition from easel painting to design was natural in economic terms and justifiable in social ones. The collective's high degree of material utility nicely matched the "life-building" aims of the new consciousness.

Second, it was no accident that Ermolaeva's workshop focused primarily on works for children. The interest was twofold. One aspect was economic, since children's picture books were usually slender volumes, which meant inexpensive, which meant accessible, which also meant that in the lean years of War Communism they were still in demand. The other aspect was creative: since small books (these were usually only two double printer's pages, or eight pages in all) took less time to produce, the artist could work without losing interest, and make not only frequent changes in formal aims and methods but some profit as well.

Third, children's books are aimed at a readership whose artistic tastes and philosophical views are only beginning to take shape. The Today group began its work in 1918, at the dawning of a brave new world, and its participants undoubtedly counted on making a long-term social and artistic impact. The work of today would lay a foundation for tomorrow.

Their books featured linoleum-block text as well as illustration. Books made in this fashion included *Zasuponya* (illustrated by Lyubavina, written by Sokolov-Mikitov), *Evergreens* (*Khvoi*; illustrated by Turova, written by Vengrov), and a series of books by Ermolaeva, including *Rooster* (*Petukh*) and *Bunny* (*Zaichik*). Their style was expressionist and primitivist. The new artistic thinking was visible mainly in their emphatic simplicity (that is, in their aesthetically underscored poverty of means) and in their markedly graphic quality, its laconic and angular cuts introducing a note of displacement, abruptness, unease. The dominance of unstable diagonal lines over the usual spatial coordinate axes would soon become a commonplace, although in considerably exaggerated form, in the Constructivist image of a world struggling against static existence and inert gravity.

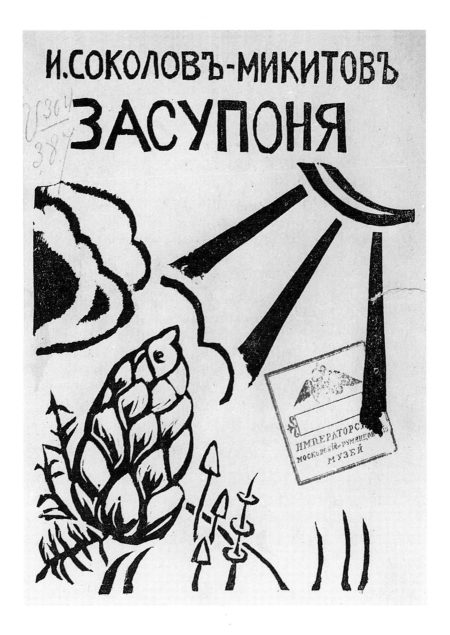

N. Lyubavina. From *Zasuponya* (Ivan Sokolov-Mikitov). Petrograd, 1918.

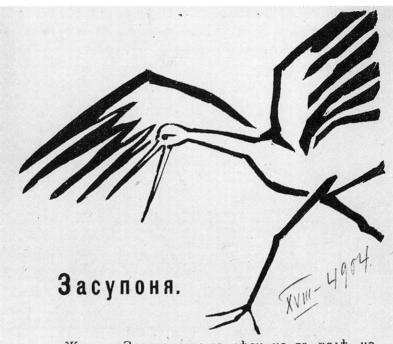

Засупоня.

Живетъ Засупоня не въ лѣсу, не въ полѣ, на моховой кочкѣ живетъ, а кочка посередъ болота. Ночью курлыкаетъ,—слышали?—жа-лоб-но.

Похожъ Засупоня на еловую шишку, о трехъ глазахъ, глаза, что бисеренки.

Прилетѣлъ весной журавель отъ теплой рѣки, и прямо на Засупонину кочку.

—Ты кто?

—Засупоня.

—Пошолъ вонъ, я тутъ гнѣздиться стану.

N. Lyubavina. From *Zasuponya* (Ivan Sokolov-Mikitov). Petrograd, 1918.

The texts themselves were done with this unaccustomed sense of displacement, though here fairly mild and unforced; but on the whole, their thematics were typical of the early days of the Revolution. So, for example, Sokolov-Mikitov's mysterious Zasuponya, who resembles a three-eyed pinecone, chases a crane from its swampy home, smashing its eggs and ruining its nest. Zasuponya was just one of many creatures in a neopagan mythology taking shape in the works of Russian writers—and there was quite a range, from Fedor Sologub's Nedotykomka to Georgy Ivanov's Razmakhaichik, and of course, Alexei Remizov's extensive teratomorphic menagerie. It is only at first glance, and a superficial glance at that, that this bestiary might seem alien or directly opposed to the textual strategies of avant-garde technicists and, shall we say, mechanizers. The dual nature of the avant-garde—archaism combined with futurism—has already been pointed out. Neopaganism, whether it be "Zasuponian" or mechanistic, is united in its rejection of the Judeo-Christian anthropocentric vision of the world. Two complementary currents were joined in the business of destroying the classical humanist tradition—one from the factory, the other from the swamp.[2] The work of the Today group accentuated the formalist-primitivist element in the greater avant-garde project; their publishing plans included, among other things, a picture book entitled *The Children's Lubok* (*Detskii lubok*).

Another little book put out by Today was a truly collective effort: *Beasties* (*Zverushki*), a volume of poems by Natan Vengrov with illustrations by Al'tman, Annenkov, Ermolaeva, Lyubavina, and Turova, came out in Petrograd in 1921. Al'tman's drawing (on page 12) for the poem "The Sun Bunny" ("Pro zaiku solnechnogo") is perhaps particularly worthy of note. It shows a series of mirror surfaces reflecting the long rays of a sun placed in the upper left-hand corner; the rays end in real rabbits. (This is not just a poetic image. The Russian name for this type of reflection is *solnechny zaichik*—sun bunny.) The dynamic play of broken planes is reminiscent of Suprematist compositional method, which in this case is perfectly justified by the subject matter, the refraction of light. Interestingly enough, the very last rabbit, having hopped through all the mirrors, lands right in the

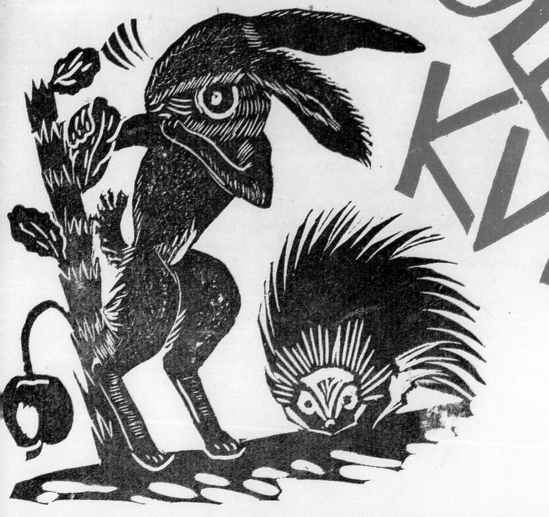

ЗВЕРУШКИ

РИСУНКИ и КЛИШЕ
ИСПОЛНЕНЫ
АРТЕЛЬЮ ХУДОЖНИКОВ

Н. Альтманом, Ю. Анненковым, В. Ермолаевой,
Н. Любавиной и Е. Туровой.

jaws of a wolf. As the poem says: "Right into the wolf's teeth—hop! . . .
he's gone." This rather unusual fairy-tale finale, with the sun's reflection
personified in a real rabbit who subsequently falls prey to a wolf, is worth
at least a moment's pause.

Apparently, though, it was neither excessive bloodthirstiness on the part
of the artist nor the cruel ways of wartime that lay at the heart of the plot.
Ermolaeva, who was working right alongside, also opted for a surprise end-
ing—though a happier one—for her own *Bunny* (*Zaichik*): "Bang-bang,
ay-ay-ay, the bunny's run away, good-bye."[3] What sealed the fate of the two
Natans' unfortunate rabbit was most likely not the sad lot of rabbits in
general (ending life as a wolf's breakfast), but the fact that this was a *sun*
bunny.

Segodnya (Today) logo in *Beasties*.

(*opposite*) Elena Turova. Cover for *Beasties* (Natan Vengrov). Petrograd, 1921.

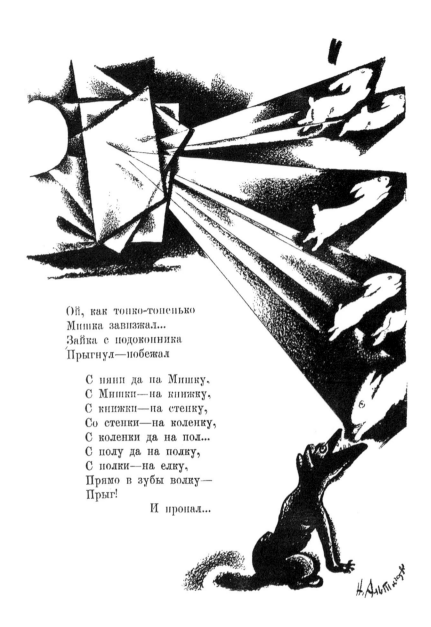

Ой, как тонко-тоненько
Мишка завизжал...
Зайка с подоконника
Прыгнул—побежал

С няни да на Мишку,
С Мишки—на книжку,
С книжки—на стенку,
Со стенки—на коленку,
С коленки да на пол...
С полу да на полку,
С полки—на елку,
Прямо в зубы волку—
Прыг!

И пропал...

Natan Al'tman. "The Sun Bunny," from *Beasties*.

(*opposite*) Vera Ermolaeva. *Bunny*. Petrograd, 1918.

Avant-gardist solarophobia, which had moved revolutionary artists to
challenge the sun (Mayakovsky) or celebrate victory over it (Kruchenykh,
Malevich, Matyushin),[4] struck a chord also in the humble Vengrov, who,
proportionate to his talent and his nerve, took on the sun's reflection rather
than the sun itself.[5] There are interesting associations between Vengrov's
sun-eating wolf and one of its contemporaries, the mechanical wolf from
Samuil Marshak's *Riddles* (*Zagadki*): in "Automobile" the machine has a
heart "heated by gasoline" instead of the sun, the "eyes are two flames,"
and its "wolfish howl scares folks at night." But we'll return to Marshak
later, and to the heliomachy motif as well.

The Today workshop's books are somewhat reminiscent of Futurist litho-
graphs done around 1910 and after. The experience of workshop members
in printing both images and text from the artists' own linoleum blocks or
lithograph stones was soon put to use in the Petrograd ROSTA (Russian
telegraph agency) office, where Vladimir Lebedev and Vladimir Kozlinsky
were working at the time. This flat, poster-like style, with its accent on
black and white, or on bright, monotint flat color, would later become one
of the hallmarks of Lebedev's work in children's book illustration.

This first association of Soviet artists specializing in children's book de-
sign lasted only a short while, until March 1919. The Today group broke
up soon after Ermolaeva, Narkompros (People's Commissariat of Enlighten-
ment) documents in hand, left for Vitebsk and its Institute of Practical Arts.

Vitebsk, a provincial little town on the western edge of the former Russian
Empire, had unexpectedly become one of the leading centers of artistic
activity in the young Soviet republic. "Vitebsk has swollen," wrote Viktor
Shklovsky in 1922 in his *Letters Not about Love* (*Pis'ma ne o lyubvi*),
and indeed the flowering of cultural life in the town did resemble a sud-
den "swelling." Quite a number of major Russian artists were working in
Vitebsk at the time—we might name Chagall, El Lissitzky, Malevich, Fal'k.
Then again, it was all rather short-lived.

Twenty-six-year-old Vera Ermolaeva was the institute's director for a
time; she also took an active part in the cultural life of the city, and was

a founding member of the UNOVIS group (Utverditeli novogo iskusstva, or Affirmers of New Art). Lazar Lissitzky, soon to produce several books crucial to the development of children's literature in the 1920s, also played a conspicuous role.

Lissitzky, a major Constructivist and an artist of unusually wide range, did a good deal of work in children's literature, although most of it has remained relatively obscure. This work consisted of sixteen books in Yiddish published between 1917 and 1922. Because these require separate consideration, I won't dwell on them in detail, but we should not overlook Lissitzky's uniform method of constructing images, something that links his religious and folkloric motifs to the most "avant" of his avant-garde work.

For Lissitzky, the book served both as a link to the past and a symbol of the present. We might say book with a capital B here; it is indeed significant that Lissitzky, himself a representative of the People of the Book, chose books as the very symbol of revolution/reconstruction of the world. In a short programmatic article entitled "The New Culture," published in 1919 in the Vitebsk journal *The School and Revolution*, he wrote: "At the moment books are not themselves forms that correspond to their content. Yet at the moment books are everything. They are to our time what cathedrals, with their frescoes and stained-glass, were to ages past. . . . Books have become the monuments of modernity."[6]

In this article, Lissitzky maintained that architecture was the basis of all the arts and called for the application of tectonics to book design. Design that corresponded to architectonics and, later, outright draftsmanship (which made Lissitzky a key figure in the emerging Constructivist movement) was for the artist a natural consequence of his architectural and historical research on temples and churches of the western regions. One of the fruits of this two-year endeavor was an article published under the name "The Synagogue in Mogilev" ("Bet ha-knesset be-Mogilev") in two Berlin Jewish journals, one printed in Yiddish, one in Hebrew.[7] Other fruits, more crucial to book publishing and avant-garde Constructivism, grew out of Lissitzky's own work in book design.

In its inner power and epic sweep, Lissitzky's design and illustration

work for children's books is often compared to temple fresco. We might recall his famous *Goat* (*Had Gadya*; Kiev, 1919), in which the eleven illustrations suggest a larger-than-life fresco composition. The impression that they have some sacred meaning is intensified both by the arc of ribbons crowning the image and by the letterforms, which seem to be cut from stone—all of which brings to mind synagogue arches inscribed with sacred texts. Lissitzky's graphics turn this artless tale (of how the little goat is eaten by a cat, the cat eaten by a dog, the dog killed by a stick, the stick burned by fire, et cetera, all the way up to the butcher who perishes at the hand of the angel of death, who himself is then struck down by the right hand of a wrathful God) into an eerily grotesque story about the progressive sacrifice of each and every character, about death and retribution—none of which is built into the ancient Aramaic song sung during the Passover Seder. Lissitzky's entire composition is imbued with a triumphant, eschatological pathos. It is a sort of requiem, a prayer for the dying of the old world, with its goats and angels, its chain of unredeemed deaths. It may well be that in *Goat* Lissitzky did indeed build one version of a "monument of modernity"—a monument to the past.

And here we might again quote from that same article: "He [*the artist*— E. S.] must take this work upon himself, and here he will be forced to set aside his old tools, his little pens and brushes, his little palettes, and take up the chisel, the engraver's tool, the printer's leaden army, the rotary press, and all this will soon begin to turn obediently under his hand."[8] And so Lissitzky likens this new type of artist (that is, himself) to the builder and demiurge devising a marvelous new world that will turn obediently under his hand.

It was to the chisel and to the printer's leaden army that Lissitzky himself would soon turn, enriching his times with unprecedented subtleties of typographic skill. The words "leaden army" appeared at a time when the entire country lived and thought in terms of great masses of people—the army as such, the labor army, the food army, the army of the victorious class, and finally the army of the arts, to which, as Mayakovsky reminded everyone,[9] orders might be issued. This mentality was not merely *akin* to

Lissitzky's own. He himself was actively engaged in creating that mentality in artistic form. Before finally arriving at the equation "the human race is a printer's case," he had already approached it once, but from the opposite direction. At that time, in 1919, his books (*Yingl, Tsingl, Hvat,* for example) featured large, hand-drawn letterforms interspersed with tiny human figures. The letters have human proportions; the humans look like part of the alphabet. Here we can already see all the elements of a design style that employs artificial, formal signs—a prototype of how those signs would come to replace people.

The illustrations for Ya. Fishman's book *Shabes in wald* (*Saturday in the Wood*), published in Kiev in 1920, are done in the same spirit. Here trees—truly natural forms—represent letters. The figurative treatment of abstract alphabetic signs, as the natural forms dissolve into conventional degenerative-hieroglyphic graphemes, removes any contradiction between culture and nature. These spatial constructions hint at things to come— Lissitzky's own geometric Prouns and Malevich's Suprematist constructions. (The latter had arrived in Vitebsk at this very time.) Just how both human figures and all the other forms occurring in the natural world were progressively replaced by typographic elements is something I will deal with later, in connection with a work done by Lissitzky in 1928, but in the meantime let us turn to his famous book about the two squares. Lissitzky's crossover into a world entirely purged of objects, a world of bodies plotted with ruler and T-square, was the final step toward that "monument of the modern," the temple of the new faith that had become a sort of Sibylline Book for the "new type of party," if we can use here Lenin's expression.

As symbol of an era, and credo of Constructivism in its pure form, *A Suprematist Tale of Two Squares in Six Constructions* (*Suprematicheskii skaz pro dva kvadrata v shesti postroikakh*) is mentioned in virtually every work devoted to El Lissitzky. The artist did the book in Vitebsk, in 1920. One cannot really say he "wrote" or "drew" it: Lissitzky himself placed a note reading "built 1920 Vitebsk" on the last page, next to the UNOVIS logo. The book is a model of geometric abstraction that presents, with the help of brief captions, a symbolic, stripped-down, and concentrated image

про

2

эл Лисицкий

of revolutionary struggle and the remaking of the world. In the crucible of that remaking, all the towns and hamlets from Moscow to the far provinces were already simmering away—not to speak of Vitebsk itself, where enthusiastic artists had long since, following in the footsteps of prewar Petersburg, celebrated their own victory over the sun,[10] and where Lissitzky and Ermolaeva had done graphic series on that very theme.

A Suprematist Tale was called to serve as a new type of fairy tale, one that told of the confrontation between good and evil in the most generalized of forms. It is a story of dynamic struggle between two squares—one red, one black. The struggle is demonstrated rather than described. On the first page the author issues his call: "Don't read: get paper and posts and boards. Put them together, paint, build." The text is set in letters of various sizes; the words, free-floating in the space on the page, are linked only by thin lines showing the order in which they should be read. Hence the type page takes on a dynamic, flashy look; it startles the reader into active perception. The artist's construct of the collision between opposite poles of force, the red and the black, serves as a kind of model, a game to encourage a certain approach to life itself—effect, transform, prevail.

Significantly, before the red square's ultimate victory, the earth is represented as a chaotic mass of black-and-gray rectangular shapes piled one on top of another, all pointing in different directions. This disorderly arrangement conveys an atmosphere of instability and anxiety that is confirmed by the caption at the bottom of the page: "everything is black, anxious." On the following page the picture changes. A corner of the red square slices into the black-and-gray chaos. "One blow," comments the caption, "and it crumbles." Next we see victory approaching for the red, and in the next combination "red sets itself over black." On the last page we see a small circle representing the earth, out of which grow slender azure constructions. They lean in different directions—pressed down by an enormous red square, the corner of which (a rhombus) has buried itself in the earth/circle, parting and bending the inexpressive growths on the surface. "It's all over," concludes the caption.[11]

In Lissitzky's work, the battle between colors and forms is cosmic in na-

(*opposite and following pages*) El Lissitzky. *A Suprematist Tale of Two Squares.* Berlin, 1922.

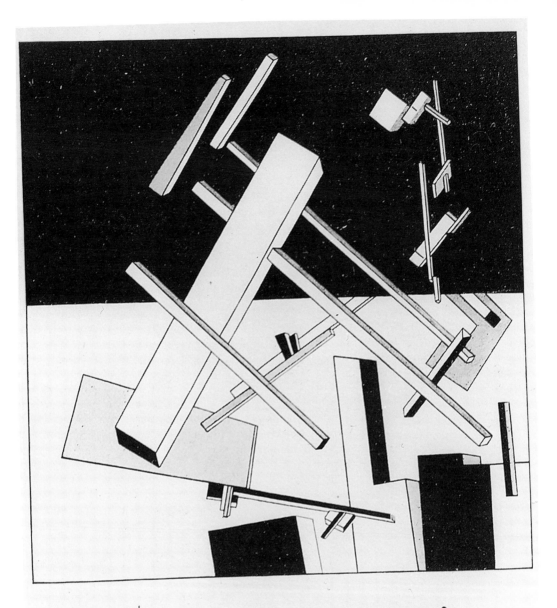

и
ВИДЯТ

черно
Тревожно

и **По** черному

установилось

Кра
Я — сно

ture. In this potent Suprematist mix, the square order-of-things is not lim-
ited to the Soviet one-sixth of the earth, nor even to the earth itself. The
red square appears as a visitor from space, come to the world of inert and
unorganized matter to establish a harmony of simple, measured correspon-
dences. The supraplanetary reach of Supre-Constructivism can be looked
at as one specific redaction of the cosmic mode of Russian thought preva-
lent at the time, of a gestalt that manifested itself in cultural phenomena
bearing no outward resemblance to one another at all—in the teachings
of Nikolai Fedorov or Vladimir Vernadsky, the paintings of Vassily Chekry-
gin or Konstantin Yuon (*Birth of a New Planet*), or the paraverbal writings
of Velimir Khlebnikov. The mythmakers brought their new world order
down from on high, and thereby made it sacred and legitimate. The earth
and the material transformation of earth (work with material, with "the ob-
ject," work to which Lissitzky will eventually come) became part of the
overall cosmic order. Orthodox Suprematism and "construction-oriented"
Constructivism might disagree on details. Thus the black hole of the black
square with its zero-space and absolute nothingness is replaced by a posi-
tive "red" demiurge—the red square, a sort of worker-god who has over-
come the transcendental, otherworldly black square (as cosmic center and
first cause) and descended to earth. To pursue this interpretation, then,
we might mention also the motif of rebellion against God-the-father char-
acteristic of the revolutionary-constructivist mindset in general: the cos-
mic struggle of the red demiurge-and-son against the black, nonmaterial
divinity-and-father who wishes neither to build nor to shape any world
at all.

One cannot deny Lissitzky's *Suprematist Tale* its graphic eloquence and
perfect correlation of linear contour to color mass. The page composition is
quite attractive and artistically convincing. Convincing, too, is the victory
of the powerful, solid, rectilinear red square (no extravagances, no tints,
no shades) over the hodgepodge of thin, incoherent grayish constructions
tilted in all directions. It would be a bit much to assert a direct correlation
between these shaky and inexpressive forms and "the rotten intelligentsia"
(that expression wasn't yet in vogue in 1920), but the association does sug-

gest itself. That is, it might suggest itself to adults, who knew precisely who and what the intelligentsia was—rather than to children (if we believe that the artist actually took children into account). But children whose books tell them that what's thin, what shakes and tips, what won't stand to order or in order, is something bad, or hostile, will have little difficulty evaluating a similar phenomenon in real life. And conversely—a red square calls up entirely different associations. It's not just that the color red is symbolic (as the children's song goes, "It's after all the color of our banner") but that the laws of optical perception posit red as a bright rather than a deep color like dark blue, purple, or black. So on the preconscious, purely physiological level of color perception, red overrides black—let alone black's watered-down grayish tones. The notion that red *must and should* prevail over black seems inarguable, irrefutable.

As for shape—that too is a conscious choice. A square is not some mere circle or triangle, symbol of harmony or celestial wholeness. The red square is the incarnation of precise measure, active force, and solid power. The value connotations of "square" and "squareness" are part of the fabric of language itself; and so Russian, like English, has expressions like "square jaw" and "square shoulders." At any rate, Lissitzky had his reasons for designing his penultimate construction as intricately as he did—setting the letters KRA apart, with the YA underneath them, then lining them both up with SNO—which taken together graphically illustrates that what is KRASNO (red) is also YASNO (clear), and vice versa.

In his *Suprematist Tale*, Lissitzky made the fullest possible use of his "Proun"—his shape of the future, the most characteristic features of which were a rejection of any kind of axis and, where possible, of any vertical or horizontal lines, plus dynamism and freedom of movement. Later such compositional methods were to become typical of cutting-edge graphic design and, correspondingly, of Suprematist-Constructivist oriented children's book illustration in the 1920s.

This is a work of indisputable artistic merit. It defined, with all the clarity and precision of a mathematical formula, that "something new" which would also define Soviet graphics for the next ten years. Such program-

matic clarity—the idea pared down, stripped down to a purely abstract model—was a phenomenon that children's literature (actually, literature in general) had never seen before. But the result was inevitable: Lissitzky had gone too far. For all its stunning simplicity, his Suprematist brand of political agitation was too sophisticated, too elitist, and hence unsuitable for mass consumption. Other artists would later use selected elements of the Constructivist system without going to abstract-Constructivist extremes. Still, a world made up of regular, geometric planes, evenly lit, with no shadows, shadings, or architectural embellishments, was gradually becoming a reality in both art and popular consciousness.

Lissitzky also laid the groundwork for graphic style in the 1920s—using typefaces as an element of book design. The most popular Cyrillic typeface of the time was named Grotesk; all the elements of its letterforms were of equal weight, with no rounding, and no serifs. This blocky typeface—unbending, unwavering—devoid of all those curlicues and complications that even "the best poet of the Soviet era" (Stalin on Mayakovsky) couldn't decipher, had conquered the field of display type. Moreover, it was frequently used for body text, in children's literature as elsewhere. See Daniil Kharms and Vladimir Tatlin's *Firstly and Secondly* (*Vo-pervykh i vo-vtorykh*) as an example.

This obsession with Grotesk and other sans-serif typefaces was, of course, no accident. The reader's perception of a text set in such characters was fundamentally different from that created by one set in older, classical typefaces with serifs. Human consciousness is immanently drawn to a visual connection, a tying together of individual elements into a single whole. In script, the letters of a word were connected to one another by serifs, which created an impression of wholeness, or else a hint of some kind of backward movement along the chain of alphabet graphemes, a return to hieroglyphics.

The most telling example of this tendency was the whimsical typography of Art Nouveau, whose typefaces typically featured long serifs and complaisantly flexible descenders and ascenders that competed with a

multitude of vignettes and frames to weave the pattern of a page. But in Art Nouveau something very soon broke down, fell apart. And in place of the inspired ambiance of the *style moderne*—its sense that everything was somehow interconnected—came a sense that all connections had been torn asunder, and that whatever pieces remained existed in a void, isolated, separated. (This is discussed in more detail later in the chapter.) It is hardly likely that the avant-gardists were conscious of this, but, yielding to the feeling of being orphaned in a world they never made, they ripped the slender connective serif-threads from their letterforms. The letters came out clean, slab-like, without serifs, and the words themselves were split into characters. On a purely visual level, letters in a variety of sizes, aligned at different angles, capered about within a single word. On a quasi-semantic level, or rather a poetic-phonetic one, Khlebnikov, Kruchenykh, and others performed re-volutionary re-construction on this flotsam and jetsam of words and sounds by adding different prefixes or suffixes to certain roots. And on the political-ideological level, words with their marks of inflection ripped off at the root were soon stacked into Babelesque barracks the likes of "Narkomvnudel" or "Glavsevmorrybkom" or any of the other acronyms designating government agencies and departments.

But back to Lissitzky and his typographical games. In 1922 the book *Mayakovsky for the Voice* (*Mayakovsky dlya golosa*), designed by El Lissitzky, came out in Berlin. It is notable not only for the whimsical and expressive play of typefaces (actually, of sizes), but also for its inventive use of the decorative potential of typesetting. This was the moment when Lissitzky's catchword about commanding the printer's army indeed came to life. The artist took the lead type elements of the compositor's case and assembled them into simple, geometrically regular pictures (a flag, a boat, etc.) that gave the impression of simple children's drawings on the one hand, and on the other made them seem mechanically regular, assembly-line identical.

But now let us consider Lissitzky's lesser-known final work in children's illustration, done in 1928 and, for a number of reasons, never published. In

it we see a further development of the principles contained in *Mayakovsky*, and a sort of grand finale to children's book design—apotheosis of this particular Constructivist method.

The unpublished book was to be titled *Four Arithmetic Operations* (*Chetyre arifmeticheskie deistviya*). Its purpose was to teach children about addition, subtraction, and other such boring things in a popular and entertaining fashion. In his sketches for the book (now in a private collection), Lissitzky introduces an element of play, thus not only devising a highly original way of enlivening the rules of arithmetic, but endowing mathematics—a discipline that would seem to be quite unrelated to the objectives of Communist construction—with a certain ideologically meaningful pathos.

Addition, for example, is illustrated in the following way: the number 1 and its corresponding figure, an upper-case P with arms and legs drawn in (the explanatory caption underneath reads Рабочий, or Worker), are added (plus sign) to another 1 and its corresponding figure, an anthropomorphized К (the caption reads Крестьянин, or Peasant), which is followed by yet another plus sign and another number 1 and character, this time a К for Красноармеец, or Red Soldier. Then, finally, comes the equal sign, and the amazed reader sees "3 Comrades." In all likelihood it was important to Lissitzky to demonstrate right from the start just who qualified as a comrade, and this sort of political agitation in the spirit of strictly defined sets (such as the workers', peasants', and soldiers' soviets) is frightening, to say the least. As far as purely graphic expression goes, the illustration is quite insignificant. It requires a good deal less time to take in the whole picture than it does to describe it. Moreover, replacing human forms with letterforms makes no sense here, since the characters form no words, and hence no text with any sort of content. His experiments with setting type had taken Lissitzky to the ultimate reduction of a text's semantic level. The human body, plastic and individual even at its most basic, was supplanted by conventional signs, which deprived it not only of any semblance of an individual but also of any semblance to a type. Without their captions of "worker," "peasant," "friendship of nations," et cetera, these

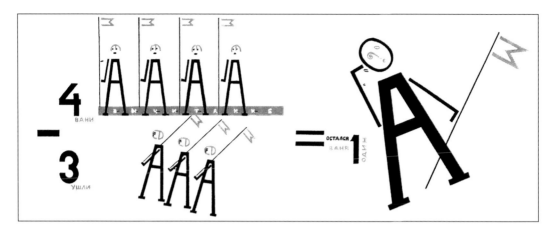

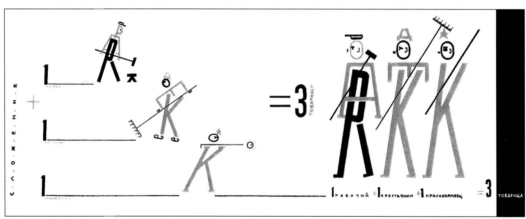

signs are indecipherable. No longer letters, they have left the verbal realm, but have not yet entered the pictorial one. They cannot be read as normal components of the alphabet, nor can they be seen as independent, free-standing images. We might term Lissitzky's typographic compositions "pictograms"—for example, a sideways M on a stick means a flag (⅀), a K rotated clockwise 90 degrees represents an anvil (⊼), an upright K is a human profile, and so on.

(*above, and following page top*) El Lissitzky. *Four Arithmetic Operations*. Berlin, 1928.

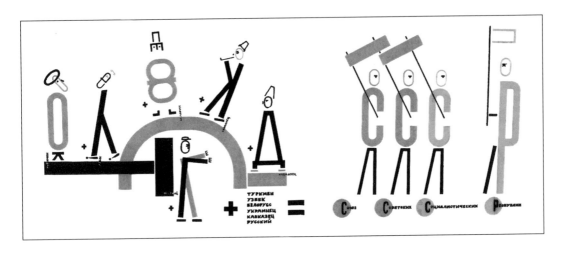

СКАЗКА о КРАСНОЙ ШАПОЧКЕ

• • •

Жил да был на свете кадет,
В красную шапочку кадет был одет.
Кроме этой шапочки, доставшейся кадету,
ни черта в нем красного не было и нету.
Услышит кадет — революция где-то
шапочка сейчас-же на голове кадета.
Жили припеваючи за кадетом кадет
и отец кадета, и кадетов дед.

Поднялся однажды пребольшущий ветер —
в клочья шапченку изорвал на кадете.

И остался он черный, а видевшие это,
волки революции сцапали кадета.

Известно какая у волков диэта:
вместе с манжетами сожрали кадета.

Когда будете делать политику, дети,
не забудьте сказочку об этом кадете.

КАДЕТ

КУМА

ЛЮБОВЬ

К ЛОШАДЯМ

СОЛНЦЕ

(*above, and opposite page bottom*) El Lissitzky. *Mayakovsky for the Voice.* Berlin, 1922.

These simple pictograms are just code, signs with exceedingly meager semantic content—a crude flag, a stick figure without the slightest detail or hint of personality. The artist's inventiveness, his bold associative leaps, had led him paradoxically to a visual poverty, to a poverty of expression. The heroic attempt to create a new sign system based on mechanical, regular pictographic forms—laconic, unequivocal—had spawned something resembling traffic signs, or those international symbols for "No entry," "Food," "WC." The pictographic quality of Lissitzky's uncomplicated signs differs radically from that of hieroglyphs, which while keeping their pictorial quality, also have a precise geometric structure composed of simple elements and individual graphemes, as well as (and this is the most crucial of all) a connection with natural language through rules of grammar and phoneticization. As for Lissitzky's "3 Comrades," the only language they might have any link with at all would be Newspeak, the language of a society with no need for nuance, complex communication, for any means to express individual feeling or point of view—a society where all one needs to know is contained in four arithmetical operations.

The language in which Lissitzky made up his texts was, for all the seeming richness of the page composition, an exceedingly poverty-stricken system; its signs pointed toward the very simplest of concepts (a flag meant celebration, an anvil meant work, a hammer-and-sickle meant both the above plus everything else, and so on) and also indicated direction of movement—backward-forward, right-left. It wasn't that a step *sideways* was exactly punishable in this system; it was simply impossible. A new, stark realism stripped of any bourgeois, World of Art furbelots had resulted in bare, quasi-proletarian simplicity. Just as when Andrei Bely had remarked that the victory of materialism had led to the utter destruction of matter, the apotheosis of Constructivism in artistic practice (in social practice, too, for that matter) had now led to the triumph of destructivism. The world was in ruins, razed to the very last brick.[12] And in general, rationalistic Constructivism and visual minimalism are inseparable. The total, ultimate victory of Constructivism would have to lead to the depiction of nothing at all.

38

In the end, Lissitzky's potent avant-garde mix, in which the leavening was perhaps some echo of cabalistic personification of letters and the culture was some dream of a precise and manageable world where human actions and relations could be calculated in functions of A, B, C . . . , produced results that far outstripped any possible aesthetic impact on reality. Curiously enough, Lissitzky's letter-workers and letter-peasants as well as his letter-Khazakhs and letter-Uzbeks perfectly match the letter-names in the anti-Utopias (or, as we now say, dystopias) of Evgeny Zamyatin's *We* (V-125 et al.) and Aldous Huxley's *Brave New World* (beta-plus, gamma-minus).

This unequivocal, unambiguous, and literal indexation of humankind was put to active use in a society to whose construction the avant-garde artists had dedicated their strength and their song. The truncated Newspeak of Utopia triumphant created new signs—KR, ChSIR, PSh (which were, respectively, Russian acronyms for "Counterrevolutionary," "Family member of a traitor to the Motherland," and "Suspicion of espionage") or occupations like Chekist, Tsekhist, or Osoaviakhimovets. Avant-garde and state efforts at language-building anticipated real life, and forced all of society into a rigid grid of functional classifications. The nonaffiliated (non-Party) avant-garde milled about somewhere off to one side, a little ahead—the left wing, the left front, agitating for all they were worth, haranguing, heading it all up.[13]

Lissitzky's method of replacing live drawings made with "old tools— little pens, little brushes, little palettes" with perfectly regular constructions employing the simplest of lead type elements was later taken up by a number of artists. First among them were Solomon Telingater and Mikhail Tsekhanovsky.[14]

Telingater was a master, a virtuoso of the art of typographic design. Particularly significant are the compositions he did (all in display type) for Esfir Emden's book *Immer bereit* (Moscow: GIZ, 1920), where the sense of struggle (class, international, generational in this story of Germany's Young Pioneers) is conveyed through the interaction of red and black letters, sometimes plain or boldface, sometimes narrow or squared. Taking

39

the various lines, arcs, and circles to be found in his printer's case, Telingater designed book covers depicting fairly complicated figures, humans included. Ovady Savich's *Floating Island* (*Plovuchii ostrov*) had just such a cover, with three front-facing, strictly symmetrical half-figures. Their mechanical, "assembled" quality is engaging and clever; but if we leave aside their purely formal aspects, such depictions largely reflect the notion that the human being is a mechanically regular and one-dimensional creature. Or rather, this was seen as the ideal human image, a sort of creative model of the man of the future, a model assembled from standardized parts—all of which made this Constructivist aesthetic of the 1920s genetically akin to the aesthetic of Socialist Realism to be articulated in the next decade.

One idea popular among artists and intellectuals of the 1920s was the notion of overcoming the inertness of the natural world, of replacing biology with mechanics. They never got around to experimenting on humans, though, and so instead of an Ivan Michurin[15] or a Trofim Lysenko bent on re-forming human raw material, we have fantasy writers like Alexander Belyaev,[16] or those engineers of human souls who sought to correct the errors of nature, or a prerevolutionary upbringing, in Gulag labor camps. But fantasies of a perfect human being with mechanically interchangeable parts (which can be traced back as far as Nikolai Fedorov's "Common Cause") were popular throughout society. So as not to stray too far from our topic, we'll limit ourselves to just one more example illustrating the vision of man widely held among Constructivist innovators, a vision common to very different art forms: this was the idea that humans were a known quantity, a calculable thing, and that, like unto a machine, they were programmable and manageable.

In 1922, at Petrograd's Museum of Artistic Culture, the Sergei Radlov Studio Theater Group gave several Sunday performances at an exhibit by artists from the Association of New Trends. One critic writing in the July 11 issue of the journal *Zhizn' isskustva* (*The Life of Art*) noted that "at the 'leftist trends' exhibit, [Radlov] demonstrated his group's underground, catacombic work" and described it in the following manner: "As one follows the movement of Radlov's actors, it is hard to shake the feeling that

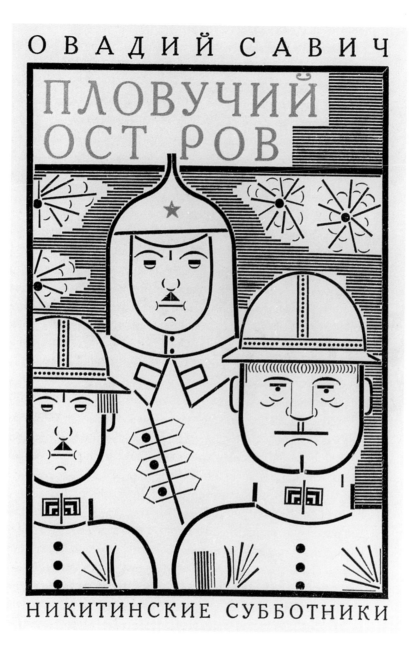

Solomon Telingater. Cover for *The Floating Island* (Ovady Savich). Moscow, 1927.

these are all animated figures, that they are the creatures of these so-called leftist artists." The studio actors sought the key to harmony in theater, which was of course a projection of harmony in life, in the laws of musical structure, harking back to precise and lucid Pythagorean numerical relationships. This manifested itself in their measured and precisely fixed gestures, in coordinated moves around the stage, and so forth. We might recall here, too, how in the following decade human masses were also coordinated, moved, marched out onto the streets, squares, parade grounds, railway yards, and prison yards—all to precisely Pythagorean music in a stirring martial mode.

This 1922 exhibit is interesting largely because, among the many prominent avant-garde artists (Malevich, Matyushin, Tatlin, and others) who took part, there were two who were destined to play a key role in defining the image of the children's book—Vladimir Lebedev and Nikolai Lapshin. Lebedev was showing the original prints for his illustrations to Rudyard Kipling's *The Elephant's Child*, published in Petrograd in 1922 as *Slonyonok*. As would soon become apparent, these pictures were the manifesto of a new approach to children's book graphics.

Lebedev's *Elephant's Child* has been the subject of numerous Soviet accounts and accolades (by Nikolai Punin, Vladislav Petrov, Yury Gerchuk, Ella Gankina, among others), but the very first response came from Lebedev's comrade Nikolai Lapshin, who wrote an article for *Zhizn' isskustva* entitled "A Survey of New Trends in Art," and in it gave his colleague's work high praise. This was expressed in the following quite elaborate words, which nonetheless are worth quoting as they stand: "The visible move [is] from expressiveness through *faktura*, toward *faktura*, as a revelation of the material and in the end arriving at a Cubist construct amplified into a relief on the 'block.'"[17] Before discussing Lebedev's illustrations themselves, it might be interesting to add a short commentary on the words of his artist-critic. The phrase is convoluted, and the idea makes its way somewhat painfully through the choppy, ragged syntax. And besides, the idea itself seems to have appeared to the artist "in a mirror dimly" (1 Cor. 13:12)—a not uncommon example of a statement's utter lack of

clarity being dictated by its yet unarticulated, phantom subject. Amusingly enough, the precise quality of the visual composition is not reiterated by any preciseness of verbal paraphrase. Reflexive Constructivist discourse, in essence, had yet to be worked out.[18] Nonetheless, it is clear that Lapshin's main emphasis is on notions sacred to the Constructivists—"*faktura*," "material," "construct," reinforced by the more concrete "relief" and "block."

The animal figures in Lebedev's *Elephant's Child* do indeed look like Cubist constructions, their lines rising off the surface of the page in clear relief. The artist made the background a virginal white, the images emphatically black, with virtually no halftones or shading. Parts usually merely lightened to show an object's natural contours are left entirely white, making the figures look as if they consist of separate segments or parts, like jointed marionettes. *The Elephant's Child* illustrations made an enormous aesthetic impression on Lebedev's contemporaries as well as generations of critics to come. Now, since the visual paradigm has changed many times over, it is difficult to understand their power of attraction, but their professionalism and expressiveness cannot be denied. Lebedev was deft at emphasizing the flatness of image integral to book graphics in general, and at using fine rhythmic accents to combine the decorative elements making up each page. Intended for children though it might have been, this was a quite serious rescension of major Constructivist graphic art. Lebedev's version of the style was less schematic than the all-out Suprematism of Malevich or Lissitzky (or rather, he never took it to the point of total abstraction), but the beasts with which he peopled what was supposed to be Kipling's jungle have a striking family resemblance to the sailors and Red Army soldiers he made for the windows of ROSTA.

The schematization of human and animal figures, as it isolated composite elements and discarded details and connections, revealed the body's structure—or rather, bared its skeleton. An audience lacking considerable experience of visual culture, or the ability to mentally clothe that Constructivist skeleton in its decorative but unimportant flesh and sinew, didn't

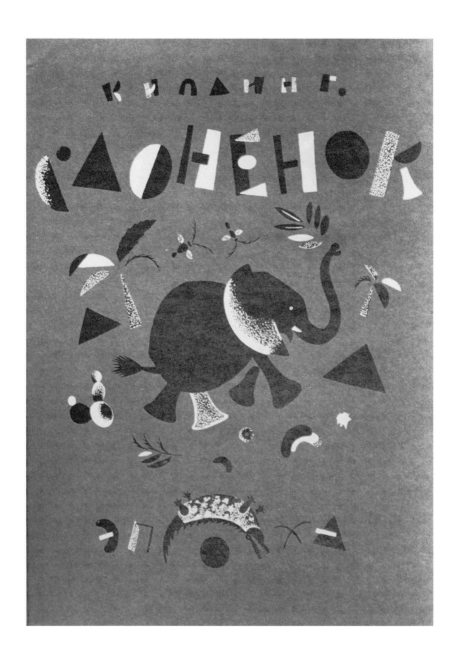

Vladimir Lebedev. From *Slonyonok* (Russian translation of
Rudyard Kipling's *The Elephant's Child*). Petrograd, 1922.

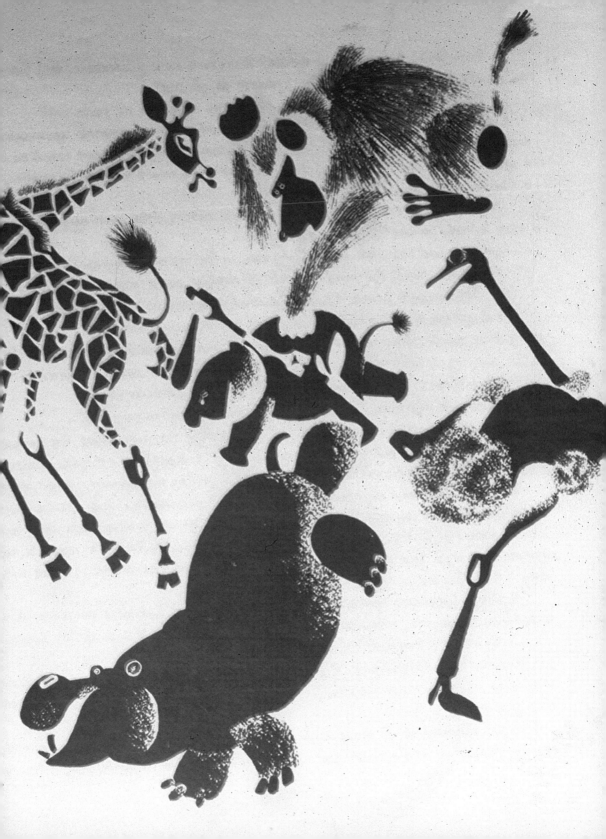

understand this sort of art. Unfortunately, the children for whom this art was at least nominally intended were just that sort of audience.

Some information on how children did perceive the illustrations to *The Elephant's Child* was recorded in the publications of *The Bulletin of the Children's Reading Institute Review Commission* (one of the many somewhat comical-sounding "pundit" institutions of the time). Data had been collected by surveying young readers. The children's reactions were remarkably homogeneous. All the figures were perceived to be either torn apart or cut apart, and the children looked at them mainly in terms of who got what torn off. The whole process of aesthetic perception seemed to be a lively one: "The ostrich's neck came off. The snake's cut up into little pieces. Hey, look, the giraffe's all cut up! Its tail came off. . . ."[19] Even more revealing, and severe, was their criticism of Lebedev's previous work, *Scare-Crow* (*Chuch-lo*): "Any image with gaps in it (stenciling) disturbs and irritates them. . . . 'The birds' heads came off. Why is everything all apart?'" Teachers observed that the smaller children did not understand the pictures at all. "And even some of the older children don't realize, for example, that this is an airplane: 'It's some rags or something' . . . 'it's pens and pencils' . . . 'I can't tell.'" A depiction of Chuch-lo hunting buffalo drew the following comments: "Are those mice, or what?" ". . . he got attacked by some dogs" . . . "those are baby chicks. . . ."[20]

Obviously, basing the aesthetic worth of a work of art on children's responses to it would be frivolous, to say the least. But I must repeat, again and again, that while giving these pictures their due, I am investigating not their aesthetic quality but their impact on children, and the long-term sociopsychological consequences of that impact. And one of the most critical consequences was that these pictures (and the better they were "aesthetically," the truer this was) instilled in their audience's subconscious a sense of the fragmentation, the essential torn-apartness of existence.

This feeling, already intrinsic to prerevolutionary avant-garde mentality, could not help but intensify a hundredfold after the October Revolution. It is hardly necessary to dwell on the fact that the "constructive" artistic activity undertaken to help restructure human habitat (regularly, rationally,

mechanically) was a kind of overcompensation for that very sense of frag-mentation. It was a reaction to the personality crisis, the excesses, of fin-de-siècle individualism; it was an attempt to deal with the overgrown bourgeois ego and the depths to which artistic willfulness had sunk.

But any attempt to rationalize this complex of the alienated, godless, unsettled, and limited individual existence, even when that attempt found its expression in the promise to build a bright future for one and all,[21] still revealed something hidden within, something unrealized—in other words, that same alienated, unsettled, and limited individual existence. And this sense of fragmentation, of disruption of the natural flow of organic life, itself flowed out of children's books and into children's heads.

These features of "twenties style" were not lost on contemporaries. "The pictures show parts of people, animals, machines—dismembered, fore-shortened, displaced. What a contrast with the old style of book, which al-ways presented us with a finished, closed cycle of intact impressions."[22] In essence, this was the final stage of a long journey, beginning with the Dutch "anatomies," passing through Romantic horrors and Goya's *Disasters of War*, and ending with Soutine's Expressionist dissected carcasses and their rationalist counterparts in Constructivist illustration (first and foremost, the locomotive—the principle of movement laid bare).

Children didn't like it. Their sober, primal realism (we might recall here the relationship of ontogenesis and phylogenesis) rose up against these dis-united parts of people and animals. "Why's everything all apart? Who drew this? He oughtta have his arms busted."[23] And in fact they did have their arms busted, these honest Suprematists and Constructivists—some ten or twelve years later, when the "human raw material" had, like Socialism itself, been built "on the whole and in general."

Then again, these pictures might have appealed to some children— not because of any aesthetic notions they had, but because the pictures per-haps struck a sadistic or destructive chord in children from families un-touched by any sort of education—children from, like it or not, proletarian or peasant families. There are records from the late 1920s of rural children's reading preferences, horrific and ingenuous in equal measure:

Vladimir Lebedev. *Chuch-lo*. Petrograd, 1921.

49

"I'm looking for something about murder . . ." (age 12); "about how somebody gets executed"; "so when somebody gets run down by a car and their legs get torn off, that's the scariest"; "they should write about chopping somebody's head off, I'd read that"; "I like it when somebody gets stabbed or killed—it's sort of too bad, but I like the stabbing or killing part" (age 14); "the best stories about Zinka and Comrade Musya (from the collection *Power to the Soviets*) are when she blinded one guy with iodine and then stabbed somebody else in the chest with scissors. . . . it was interesting, how she killed twelve whole people" (age 13); "*Mumu* was a boring book,[24] I thought it would be like how the Komsomols said at the last holiday . . . about the serfs and how they got killed and tortured and had big hunks of flesh ripped out . . . but this was boring" (age 14); "but there's this book, look, I'll tell you about it . . . they would kill the village bull or something, or some animal, you know, or *a tramp* [My italics—E. S.] . . . in fall I always kill the roosters, I sharpen up my knife, or maybe the axe and . . . whack, it's all over. . . . when I get big I'll get to stick pigs all by myself, that's good."[25]

With this eleven-year-old peasant boy's declaration of his fondest hopes, our sampler ends. Of course, it never occurred to the Constructivist intelligentsia and avant-garde "arriving at a Cubist construct" to think about what might happen should some young Jack the Ripper stumble into it as well. It may well be that none did, but there is an astonishing affinity, typological if not genetic, between those builders (*konstruktory*) of the new, who were fed up with the old culture, and those quite elemental destroyers (*destruktory*) untouched in any sort of culture at all. Perhaps it was some sort of destructive/revolutionary zeitgeist that simply took over opposite poles of society. And here we should remind ourselves of the "infantile resentment complex" that indeed seemed to make the avant-gardists not unlike children who know not what they do.

Sometime later, the truth which had heretofore issued out of the mouths

of babes and artist-visionaries was to take on the shape and scope of state policy. Leftist agitators proclaimed with Mayakovsky, "Your turn, Comrade Mauser," and peasant children followed suit: "I get scared when they shoot off pistols but I'm not scared to do it, they should let me shoot."[26] So is it any surprise that in this play, as in Chekhov's, the third act came very quickly, and all those first-act guns hanging on the walls began firing indiscriminately not only at the "daubers" but at all the rest of "progressive humanity," and also at folks who had simply tagged along on the great march to socialism?

But putting our generalizations aside, we should get back to Lebedev and his work. Chronologically, his work in children's publishing comes later, on the heels of Lissitzky's early experiments, but the latter's place in Soviet children's illustration does not compare with Lebedev's. In terms of impact both as an artist and an administrator, Lebedev's role was considerably greater. His influence in many ways defined the poetics of cutting-edge Soviet illustration in the 1920s.

The man himself is the very model of the leftist Soviet artist. His work over a thirty-year span, from the early 1920s to the early 1950s, reflects a complex inner evolution that, as a rule, corresponded precisely to fluctuations in the Party line. Many of his pieces are so dissimilar as to seem the work of different artists.

As it happened, Lebedev had a hand in making the very first children's book to come out under Soviet rule. This was *Fir Tree* (*Yolka*),[27] a collection published in Petrograd in 1918 but put together before the October coup. It was neither particularly well integrated nor artistically interesting, its craftsmanship and production values fair-to-middling at best, but Lebedev's drawing of a chimney sweep stood out against this generally mediocre backdrop. Here is what a sympathetic critic wrote some ten years later: "The first realistic image in children's books in many years was Lebedev's white-toothed, sooty-faced chimney sweep. Lively, jolly, constructed of plain, sturdy lines, broom under one arm, bagel in one beautifully-drawn hand, he is stunningly concrete—especially when set against the meager designs on the book's remaining pages."[28]

51

One cannot really say that the other pages were all that meager in design, but Lebedev's subject did indeed have the capacity to stun. In his own way, he heralded the arrival of a new era, the coming of the *chumazye* ("dirty, sooty-faced, swarthy ones," i.e., lower-class rabble). Everything the critic has to say about him is emblematic of nascent revolutionary-Soviet mentality: his white teeth and blackened face presage the passion for "the Negro theme" so typical of Comintern mythology; his jolliness and plain, sturdy lines almost exhaust the definition of the new positive hero; there is also the revolutionary's broom (the better to clean house with). Even the bagel in his "beautifully-drawn hand" (or rather, the hole of the bagel) points to the subsequent development of avant-garde discourse along both artistic and social lines. Lebedev's chimney sweep appears to be the triumphant heir of "His Highness the All-Russian Proletarian," that horrifying tabloid drawing from the days of the Revolution of 1905.

During the Civil War, Lebedev worked on Petrograd's ROSTA windows, creating 600 of the 1,000 posters printed and displayed there over two years' time. Thanks to this work, and the general trend of the times, his artistic manner acquired a poster-like laconicism, a primitivist Cubist quality. Of the roughly 100 posters by Lebedev that have survived, the one that gives the most insight into their style and ideological content is a composition titled "Oh my heart it's on fire."[29] Childlike, *lubok*-style pictures go along with a childlike ditty sung by a soldier returning from the front: "I'm so tired and I'm so worn, sweet darling, keep me warm." His sweet darling, however, with true revolutionary fervor replies, "Let the Cheka warm you up like you deserve." On yet another level, the ragged, jagged-edged texture of these posters reflects the breaking off of human ties; several years later on, the mature phase of this style was to produce the fictional Lyubov' Yarovaya, who betrayed her husband to Bolsheviks, and the all-too-real Pavlik Morozov, who reported on his own father.[30]

In 1921 and 1922, Lebedev was close to the Association of New Trends in Art, and kept company with Malevich, Matyushin, Tatlin, Lapshin, and Punin. The formal principles he had learned in his poster-making now took on a concreteness and edge they had hitherto lacked. The torn-apart

bodies and objects, the absence of any background, landscape, or other, purely decorative, elements of page design now convey, in *The Elephant's Child* and subsequent works, a feeling of airlessness, homelessness—the subconsciously sensed consequences of revolutionary rupture. Putting the scattered chips and shards back together on a virginal white ground was something that remained to be done.

With the end of the Civil War and the beginning of NEP, children's literature had begun to recover somewhat. In 1922 the magazine *Sparrow* (*Vorobei*) first appeared (soon to be renamed *The New Robinson*), and continued publication for another two years. Established prerevolutionary authors like Maria Beketova and Poliksena Solovyova (Allegro) were involved, but it was put out mainly by newcomers who were later to define the look of Soviet children's literature—Samuil Marshak, Boris Zhitkov, Vitaly Bianki, Mikhail Il'in, Evgeny Shvarts, and others. Art director of the magazine was Nikolai Lapshin, one of the key figures in the Constructivist production-book publishing in the twenties.

The name of the magazine is intriguing. The editors apparently felt they, like Robinson Crusoe, were shipwreck survivors, castaways on some deserted island. Everything—every form of life, literature, art—had to be built from the ground up.[31] Then again, this "Robinsoniad" was not entirely forced on them. The quite conscious intention to "surmount old traditions in children's literature, to create an entirely new type of literature for Soviet children," informed the efforts of Marshak and his team. By the end of 1924 a Children's Section (Detotdel) had been created within the State Publishing House, and Marshak took over the Leningrad office. Shortly thereafter he hired Lebedev as art director, and began a working relationship that was to last many years.

Actually this relationship had begun earlier, at "Raduga," a privately owned Leningrad publishing house. It had published several books by Marshak and Lebedev in the mid-to-late 1920s, works which later came to be firmly ensconced in the annals of early Soviet graphic design.

In books like *Baggage* (*Bagazh*), *Circus* (*Tsirk*), and *Ice Cream* (*Morozhe-*

noe) both people and things are even more flattened and ripped apart than in the *The Elephant's Child*. Bright, geometrically precise shapes in solid color (lithoprints) formed schematized figures lacking any habitat, any context (acculturated space, that is) whatsoever. This too was a manifesto, a world vision diametrically opposed to the life-building aesthetic of turn-of-the-century *style moderne* with its thick, almost overpowering sense of context—the sense that the object was always pulled into a space criss-crossed, penetrated by the force lines of absolute interconnection. There are textual, semiotic, and also psychological reasons why the warm, biologizing, boastful, mystical, and irrational *moderne* came to be replaced by cold, mechanistic, and rational (rational at least in intent) Constructivism. This Constructivism cannot be understood outside the context of the levelers' war on bourgeois comfort, and the Marshak-Lebedev texts demonstrate this clearly.

In *Baggage*, outright mockery of holdovers from the bad old days of private property and the ancien régime comes in the form of a constantly repeated list—"The sofa, the suitcase, the traveling bag [*sakvoyazh*], basket and picture and box. . . ." In *Yesterday and Today*, the old Philistine "thing-ism" (*veshchism*) and the new Socialist "thingness" (*veshchnost'*) come into direct conflict. In this satiric dialogue a light bulb argues with a candle, a typewriter with a pen-and-inkwell, a waterpipe with buckets on a yoke. "The artist's and poet's intent in creating children's literature in the 1920s we may in a certain sense term programmatic," wrote art historian Vladislav N. Petrov in his monograph on Lebedev, and was quite right.[32] In the battle between the new and the old, both color (red and black, naturally) and line (or rather, thin, limp curved lines for the old, and solid flat planes for the new) take part, as does the juxtaposition of chaotic, disorganized graphics to powerful blocks of color. On the cover, representatives of the modern world stride energetically across the red letters of the word *Today*—precise, brightly colored figures of electricians, plumbers, girls with typewriters. They lack any individual features whatsoever; they even lack faces, and, of course, march to the left.

At this point we might recall a passage from an article by a sympathetic contemporary: "When you examine Lebedev's attitude to his work, when you observe him in his studio, you feel as if you're next to some kind of apparatus, a living machine that looks at the world around it, takes whatever material it needs and, as it processes it, turns out a product in artistic format that is just as lifelike as the world from which it took its beginnings."[33]

This same critic, Pavel Neradovsky, was the first to note another important aspect of Lebedev's poetics—seriality, by dint of which each individual composition loses its singular value and meaning: "Torn from one another, separated, his drawings lose the meaning that they acquire en masse."[34] In this denial that the individual, the singular, has a value of its own, in this consistent rejection of the singular in favor of the mass, we can see a typological correspondence, on several levels, between Lebedev's textual poetics and the overall strategy of avant-garde discourse. Moreover, in becoming one element in a mass of elements, the individuals lose their faces, and gain a contour and movability that real humans do not possess. Children's comments on *Baggage* have survived from the twenties: "So there's this lady, bigger than the wagon even, but she's not sitting there, she's climbed out but she's made out of wood." "Look, her feet got torn off." "Who drew this? It's so bad. . . ."[35]

It is quite telling that in those same years—the second half of the 1920s—Lebedev created hundreds of prints for his *Ballerinas* (*Baleriny*) series. On a basic visual level neither the technique (ink, lampblack, brush) nor the plastic features bear any resemblance to the flat, geometry-dominated lithographs in his children's books. Nonetheless we can still consider these two types of text varieties of a single Constructivist poetic discourse. In the ballerina Lebedev had finally found his long-coveted mechanism. This remark by one critic and apologist is so eloquent as to require little commentary:

The slender, plastic body with its nimble frame, its play of musculature, its capacity for quick turns, flexible resistance . . . is perhaps developed a bit too artificially, but is, for all that, regulated and

Vladimir Tatlin. From *Firstly and Secondly* (Daniil Kharms). Leningrad, 1929.

precise in movement; one can rest assured that this perfected model
will have more to say about life than any other, because it has less
of everything formless, unfinished, subject to chance.[36]

Seemingly very different illustrations, done by artists such as Pyotr
Miturich, Boris Grigoriev, and Vladimir Tatlin, do in fact resonate with
Lebedev's flat color lithoprints. While quite different from Lebedev (and
from each other) in their artistic manner, they display a profound kinship
in what might be called the "style of the times." Miturich's *A Tale for
Clever Children* (*Skaz gramotnym detyam*), Grigoriev's *Children's Island*
(*Detskii ostrov*), which featured poetry by Sasha Chorny (Berlin, 1922), and
Tatlin's turn-of-the-decade illustrations for Kharms all share this "leftist
primitivism."

Miturich's precise and laconic pen-and-ink line resonates with Grigori-
ev's simplified one, done first in ink and then enlivened by rubbing the flat
of a pencil along it, to mimic the grainy texture of charcoal.[37] Figures and
objects are all done in silhouette, with no spatial modeling. Out of all the
possible foreshortened forms an object moving in space might take, Lebe-
dev combines certain mannequin-like, schematic, "averaged" poses and
forms. Tatlin's figures show the same traits to an even greater degree; they
lack the usual plasticity of the human body and anatomy, and are instead
emphatically angular and stiff. Their faces are frozen, absurd, their expres-
sions indefinable; all represent a single schematized, lifeless type. These
images are reminiscent of Tatlin's experiments in the years after 1910, when
he was painting cubist figures without faces. Typologically, they are close
to Giorgio de Chirico's characters, angular mannequins strolling through the
airless space of dead cities, or to certain pieces by Picasso; in general, they
fit quite easily into the mainstream of international visual art strategy of
the time. Tatlin's characters (or, rather, his graphic paraphrase of characters
out of Kharms) live in a world with neither stability nor the usual spatial
coordinates. No one is strictly vertical, but neither is anyone horizontal.
Breaking all the laws of gravity (which is of course irrelevant in this artistic
system) people and telegraph poles lean in all directions, at all angles, as

if caught in an eternal state of fall. One can see something not unlike this spatial system in Kuz'ma Petrov-Vodkin's paintings as well.

Here it would be appropriate to recall Petrov-Vodkin's own quite revealing experiments in his drawings for children's books. He illustrated Marshak's *Riddles*, mentioned earlier in passing, in fairly traditional fashion. The pages are identical in design, all bordered in blue, all thickly strewn with yellow six-pointed (!) stars. Inside the frame is a white field with text, but tucked into the corners of that field are small figures, partly cut off by the inner frame. They seem to be depicted at the moment of disappearing inside the visible frame; their bodies lean backwards more often than not, as if shown in the midst of falling. Their faces (those that can be made out, at any rate), are mournful, animal-like—as for example in the illustrations to the poems "Telephone" and "Stove." The latter is particularly revealing in that its vertical lines (the stovepipe and the stove itself) are slanted sharply to one side, the left, while the real human in the picture, a little girl, seems to be moving off to the right, falling backward over the edge of the composition. People and things appear to be in a state of mutual repulsion, of collapse. And the text itself follows suit. Marshak, later famous as "a kind and jolly friend to all children," here is busy scaring them with riddles like the earlier mentioned "Automobile":

I wait, so silent, patient
At the gate outside. But
You know, my wolfish howl
Scares the folks at night.

This automobile, by the way, appeared the very same year as Mandelstam's "angry motor," that "speeds by in darkness, and like the cuckoo cries." The eschatological image of a mechanical creature with fiery eyes and a gasoline-fired heart, lying in wait outside the gates, prepared children's minds for the realization that the inhabitants of this new world didn't necessarily need hearts—what they needed, of course, was a fiery motor.[38]

Есть в избе изба.
На избе труба.
Я лучинку зажег,
Положил на порог.
Зашумело в трубе,
Загорелось в избе.
Видит пламя народ,
А тушить не идет.

Petrov-Vodkin's illustrations, their people squeezed into corners and their objects on what seems to be an entirely different plane, convey a latent sense of a world in which people's usual surroundings are somehow out of joint and in which their settled, "cultured" space—their psychological comfort zone—has ceased to exist. And even artists who were in principle quite distant from classical Constructivism seemed to share this framework. For example, for poet Vera Inber's *Carpenter* (*Stolyar*), published in Leningrad in 1926, artist A. Suvorov did a number of rather mediocre color lithographs for the text itself, but designed a quite expressive cover showing a positively antigravitational, spatially discrete furniture arrangement. The circular tabletop is shown from above, while the table's single (pedestal) leg is shown from the side, and leaning at a slant. The chair stands tipped on one leg, as if part of a circus act, and the stool, its far edge noticeably wider than its near one (as in reverse perspective) tips in the opposite direction, its angle mirroring that of the leaning chair. Objects are estranged from one another, their traditional habitat—homogeneous and undistorted space—is gone. One can't help but think of the similar behavior of objects in Kornei Chukovsky's *Moidodyr*, the story of a crook-legged sink who teaches a small boy to wash behind the ears, or else:

What's happening?
What's going on?
Why is
Everything around
Whirling,
Twirling,
Wheeling round?

Within this system of dynamically unsettled relationships between objects, their position in space, and a chaotic multitude of spaces, the humble carpenter seems to stand forth as the First Master (God) just beginning his work of creation, tossing things into an unfinished world—one in which things have not yet lost their original momentum.

Kuz'ma Petrov-Vodkin. From *Riddles* (Samuil Marshak). Leningrad, 1925.

A. Suvorov. From *Carpenter* (Vera Inber). Leningrad, 1926.

Another example from what would seem to be the non-Constructivist camp is Vladimir Konashevich, who in his drawings for Yakov Meksin's *How Alla Was Ill* (*Kak Alla khvorala*; Moscow: GIZ, 1926) imperceptibly and unexpectedly turns ordinary domestic scenes into extraordinarily un-domestic ones. His interiors have no backgrounds, no walls, no floor. All that remains of the room is a kind of schema consisting of isolated pieces of furniture—a bed, a chair (which is located on an entirely different plane), a little table. The child's bed sits at an angle of at least 45 degrees relative to the edge of the page, thus tilted precariously upward. In the absence of any of the usual spatial coordinates, this sharp diagonal makes it look as though the floor itself is rearing back, and that poor Alla is likely to be ail-ing for a long time yet. Records show that this absence of acculturated space was something that children, the book's contemporaries, perceived in un-equivocally negative terms. Eleven- and twelve-year-old logic refused to mentally fill in the missing pieces—seeing the bed upended, shown from such an unaccustomed point of view, they couldn't even imagine it being in a lived-in, closed-in world of peace and security, in a house. Here is one eleven-year-old boy's spontaneous response: "You can't figure out where the bed's supposed to be, whether it's inside or outside, or where she's sup-posed to be, inside or outside, or whether she's just sprawled out on the floor there." Another boy, slightly older, simply and wistfully summed the whole thing up: "They could have at least drawn some walls." [39]

So, without taking on any further examples, we can conclude that in the 1920s a number of quite dissimilar artists [40] saw (whether they wanted to or not, whether they were consciously building new textual models or murk-ily transposing a psychological reality into a visual one) a world of dy-namic angles, shifts, collisions, movement.

This sense of dislocation in all its manifestations and forms gave rise to a new sense of space itself, and of its new relationship with man and with the world of things. The new archetypal symbol of unstable, fickle exis-tence (either shooting off in one direction or falling in another) was the diagonal. Diagonal constructions, drastic foreshortening, whether in Male-vich's Suprematist compositions, in Lissitzky's Prouns, in Petrov-Vodkin's

visual system, in Tatlin's *Monument to the Third International*, or in Rod-chenko's photographic compositions—these are the hallmarks of the visual-plastic embodiment of this phenomenon. Tellingly enough, the regime, itself an artist of social relations, recognized the existence of a metaphysi-cally hypostasized concept, *uklon* (in politics, a deviation; in other realms, a slope or declivity), but in its capacity as supreme ruler thought it neces-sary to oppose it.

This predominance of diagonal composition over vertical-horizontal is expressive of a typological similarity to Japanese visual texts. European *japonisme*, which first began acquiring the vocabulary of Japanese visual form in the Impressionist discourse of the 1870s, found here a new way to make itself felt—through postclassical flatness, through the rejection of centered compositional symmetry, through seriality. During the Construc-tivist era, the logic of development in the Western semiotic sphere gave birth to, poetically speaking, "unsquare texts." The carpenter's gravity-bound plumb line and level were banished from the semiotic reality of a world stood on end, a world being simultaneously torn down and built up all over again. In Japanese terms this corresponded to the Buddhist notion of *ukiyo*—the floating world, everflowing, changeable. Its most elementary graphic representation was the diagonal, while the school which most fully developed this notion of instability and flux was that of the *ukiyo-e*, the late medieval "pictures from the floating world" so beloved in the West.[41]

Something else deserves attention here. Underlying such avant-garde explorations was an attempt to express the feeling of uninterrupted time and space by filling a single composition with discrete movements—that is, various stages of movement, in all different directions, seen from differ-ent vantage points. The new artistic universe, patently (though not reflex-ively) non-Euclidean and non-Newtonian, was the figurative hypostasis of the new scientific one. This was the universe of Lobachevsky and Riemann, Einstein and Minkovsky.

The direction such explorations took runs parallel to that of artists who made *moving* pictures—cinematographers. In a cinematic picture the unin-terrupted ribbon of movement consisted of individual pieces that captured

Vladimir Konashevich. From *How Alla Was Ill* (Yakov Meksin). Moscow, 1926.

4

Идет берлинский почтальон,
Последней почтой нагружен.

Одет таким он франтом:
Фуражка с красным кантом,
На куртке пуговицы в ряд
Как электричество горят,
И выглажены брюки
По правилам науки.

Кругом прохожие спешат,
Машины шинами шуршат,
Бензину не жалея,
По Липовой аллее.

Заходит в двери почтальон
Швейцару толстому — поклон.
—Письмо для Герр Житкова
Из номера шестого!
—Вчера в одиннадцать часов
Уехал в Англию Житков!

each still phase of that movement. But in a picture that was painted, drawn, or printed, the movement had to take place in the mind of the viewer, who saw isolated stop-time moments portrayed in dynamically slanted human figures. The movement was moreover broken down, its natural rhythm and

Mikhail Tsekhanovsky. From *Mail* (Samuil Marshak). Leningrad, 1928.

flow replaced by an angular, mechanical staccato that reduced the living body to a flat, hinged marionette.

This breaking through, this incursion of dead matter into live being, which became obvious first in Cubism and later in triumphant Suprematism and Constructivism, found perhaps its most characteristic expression in the cinematic image of Charlie Chaplin, making him one of the most popular figures of the 1920s—not only with the simpletons rolling in the aisles at every jerky wooden move, but also with ultrasophisticated avant-garde artists. Fernand Léger, for example, even planned on making an animated film to be called "Charlie the Cubist," using plywood cut-out marionettes.[42]

One Soviet children's artist, Mikhail Tsekhanovsky, managed to carry out a similar project (a rather successful one, in its own way). In the late 1920s, using his drawings for Marshak's *Mail* (*Pochta*), he produced an animated film of the same name that forced the principles of marionette-mechanical movement to their very limits. In his own way Lebedev, too, had sought just such an ideal—human movement perfected.

Bergson's aesthetics, with which most artists of the twenties were more or less familiar, posited that one source of humor was the mechanical projected on the human. But it is hardly likely that the masses who laughed at this mechanical principle saw it as something that turned people into things, into objects.[43] In Russian and Soviet reality, which had long been characterized by a variety of reckless attempts to apply borrowed theories and frameworks, this sort of approach was convincingly taken up and implemented by the "leftist" avant-garde. And after the elite and the avant-garde had developed this principle and made it their own—in all those jolly ROSTA windows, in *Circus*, in FEKS (Fabrika Ekstsentriki), and other stage-and-screen antics—the idea of turning individuals into objects, of manipulating the masses by pulling a string here and tightening a screw there became a principle not of mechanics, or comedy, but of social organization. Of course, a direct analogy would be too crude here, but if we proceed from the almost indisputable thesis that the development of ideas is anticipated by developments in art, then the conclusion suggests itself

that the avant-garde was quite literally leading the troops. We might recall words written by theoreticians Evgeny Poletaev and Nikolai Punin in their work *Against Civilization* (*Protiv tsivilizatsii*):

> The mechanization of social life, the achievements of natural science and technology, the spread and reinforcement of a scientific worldview among the masses, in tandem with the de-Christianization of society and the freeing of minds from the nets of scholasticism, will bring man and nature close together. . . . The more perfect individual of the highly cultured society of the future will feel that he is one of the crucial links, one of the crucial engines of a natural world that he himself has put in order; he will be as automatic nature itself.[44]

In the light of all this, Soviet songwriters' lines about "steel arms-and-wings, and a fiery motor in place of a heart" are not mere poetic fancy (or rather, nightmare), but unreflexive intent. To all appearances this was some kind of attempt to get beyond the collision of biology and mechanics, to relieve the fear of the Machine. One way to achieve that was through laughter; the other way was through voluntary identification with the machine (switching onto the "industrial track" as they called it) and with the class born of the machine, the class closest to it—the proletariat. Playing at the edge of subconscious phobias (old man Freud does insist on cropping up!), Constructivist strategy tried to get rid of them by making the technicist vocabulary of form very familiar (*o-svoenie*), and classical visual form very alien (*o-stranenie*). Freud, in a 1919 article in *Imago*, had written that one of the most reliable ways to arouse feelings of alarm and strangeness in a person was to create uncertainty about whether the figure standing before him was a live being or an automaton. The domestication of automatons was something leading artists took up from the moment such mechanisms appeared. Toys, which by virtue of their semiotic status were conditionally considered real beings, were ideal objects for the modeling of various forms of interaction between what was live and what was not. The vast number of

stories written about "the revolt of the toys" is just the children's version of "the revolt of the machines."

The era's drive toward mechanization of the natural world combined with an opposite tendency—the anthropomorphization of the mechanical world. As a result, traditional consciousness and traditional stories were resolutely banished from the scene. In place of the fairy-tale hero, the new protagonist, promoted and imposed, was a child of the industrial era— a machine endowed by the mythologizing folk mind with anthropomorphic traits. Little children were read books on gadgets, mechanisms, and steam engines, while adults (or big children, yesterday's peasants who hadn't quite sloughed off what Marx termed "the idiocy of rural life") divulged the secrets of the heart to an iron-plated pal in songs like "My lathe, my little lathe. . . ."

And here it is time to move on to a new aspect of our theme—the so-called production book. In formal-pictorial terms, the best work by illustrators in this genre further pursues the stylistics of the pillars of the early 1920s avant-garde mentioned throughout this chapter. Regardless of the numbers—and there were not that many of these books—their significance far outweighs that of the standard quasi-artistic books for children produced in those years, which I do not touch upon here at all (piles of hackwork turned out by V. Komarov, V. Andronov, V. Denisov, and others).

That very drop of mechanistic-technicistic starter in the dough of mass-marketed children's "production" books in the 1920s and early 1930s will be the subject of our next chapter.

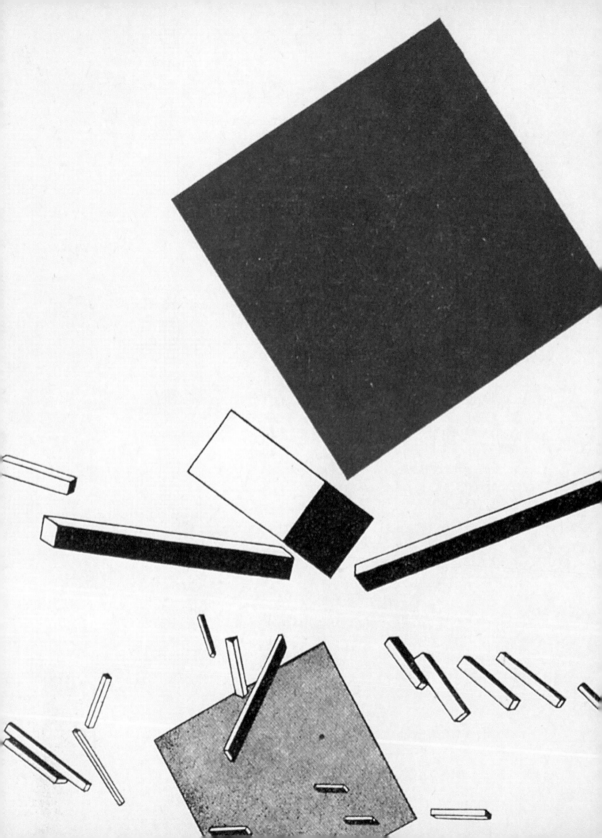

NEW TALES

And so, in terms of quantity and overall significance, the production book took the lead in children's books somewhere in the mid-1920s. We can break this large genre down into several smaller thematic groups.

The first consists of stories about how things are made, such as *Where Dishes Come From* and *How Chocolate Came to Mosselprom*.[1] The second group includes stories about trades. Typical titles, for example, are *Vanya the Metalworker, Vanya the Blacksmith, Vasya the Tanner*, and *Carpenter*.[2] The third group consists of books on a variety of industrial topics, such as *Blast Furnace, How the City Was Built*, and the like.[3] The fourth includes stories about various sorts of machines. The fifth I have set aside for the chief literary hero of those years—

ELEMENTS OF THE CONSTRUCTIVIST PROJECT

the steam engine. And the sixth group—small, but characteristic of the genre—is made up of books written about mass kitchens.

This is merely a working classification, hardly intended to serve as a fixed or finished canon. These themes, which are also present in some degree in the children's literature of other contemporary societies, loom disproportionately large in the early-Soviet social model. Production and industrial books were supposed to take the place of old-time folk and fairy tales.

The revolutionary struggle waged in the second half of the 1920s against traditional tales is well documented. Articles and speeches such as E. V. Yanovskaya's rhetorically titled "Does the Proletarian Child Need the Fairy Tale?" argued persuasively that indeed the proletarian child did not. "We are quite concretely approaching the day when tales, indeed bourgeois children's literature in general, will be destroyed."[4]

What the brash revolutionary educators took for the total destruction of the tale, however, was merely an exchange of one set of plots and characters for another no less fantastic. The conscious propagation of a class-defined ideology inevitably, unconsciously, turned into the procreation of a new social mythology. It is hardly likely that the mindset of all those fighting for the brave new world and its brave new tales had undergone any radical change; they were still grounded in the same old folkloric, mythopoetic models for creating a text. These were in turn based on an uncritical and (in its own way) religious faith in the triumph of social reorganization by means of correct theory plus cutting-edge technology. And just as any religion needs its miracles, so too the Constructivist-Socialist faith hailed as miraculous all those wonderworking machines and devices meant to hasten the advent of the materialist paradise, in which all people would receive all things "according to their needs" (or initially, "according to their labor").

A characteristic example of this sort of book (and a quite traditional one in terms of title) is Samuil Marshak's *The Seven Wonders* (*Sem' chudes*; Leningrad: Raduga, 1927). The marvels it describes are as much out of folklore as the wondrous mill that ground salt, or the pitcher that never ran dry,

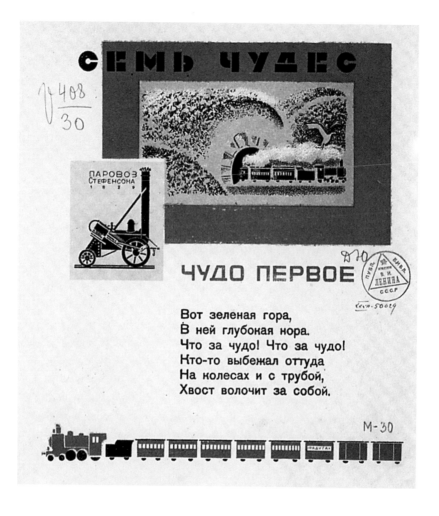

СЕМЬ ЧУДЕС

ПАРОВОЗ
СТЕФЕНСОНА

ЧУДО ПЕРВОЕ

Вот зеленая гора,
В ней глубокая нора.
Что за чудо! Что за чудо!
Кто-то выбежал оттуда
На колесах и с трубой,
Хвост волочит за собой.

М-30

or the flying carpet. Equally characteristic is the number seven, part of the canon since ancient times. Among these wonders of the modern world, it is the locomotive (later to be discussed in detail) that is, of course, given pride of place. Among yet other techno-Constructivist marvels we should note Marshak's number six—the typewriter. Mikhail Tsekhanovsky's illustration shows a girl typist (*pishbaryshnya*) poised coquettishly over her

Mikhail Tsekhanovsky. From *The Seven Wonders* (Samuil Marshak). Leningrad, 1927.

"Mercedes" typewriter. What sets this illustration apart from the others in the book is that the figure of the typist—silhouetted against a yellow background—is reproduced in triplicate. This lineup of multiplied images disposes of any last remnants of individualism in the portrayal of human beings; it looks like the apotheosis of machine-tooled anonymity. In a funny sort of way, these girls are prototyp-ists of pop-art irony, anticipating Andy Warhol's multiple Marilyn Monroes.

Tsekhanovsky uses the same technique in *Topotun and the Book*, where his three printers leaning over their presses look like a single, faceless figure reproduced in triplicate. We will come back to this curious work in more detail later, but in the meantime we should point out that Tsekhanovsky's mechanical reproduction of figures has two implications: on the social level, it is a Constructivist attempt at Americanized, assembly-line labor methods; on the semiotic level, it is one stage in the move to animation, a transition that Tsekhanovsky was to complete several years later.

To round out this section, we should mention the two remaining subgenres of children's literature that we intend to deal with, albeit in briefer fashion. These are books on revolution and social struggle (this group includes tales of battle with the bourgeoisie, and also "the revolt of the toys") and on the international theme, which to some extent replaces fairy-tale heroes' voyages to enchanted kingdoms and their feats in foreign lands and somewhat overlaps with the theme of social struggle and the import of revolution.

THE POSITIVE HERO

Along with demonstrations of wonderworking machines and their faceless operators, a great deal of space in these books is given over to depicting the positive hero. The creation of such a new hero, whose actions were both forceful and socially-politically correct, was an essential part of the poetics of the day. The new hero's image was based on his ancestry, his name, his physical features (variations on a type), his feats and/or adventures, and

ЧУДО ШЕСТОЕ

Пишут барышни в конторе
Без чернил и без пера.
Для тебя писанье — горе,
А для них одна игра.

Пишут барышни печатно,
Поглядеть на них приятно, —
Без помарки, без пятна,
Все страницы, как одна.

Mikhail Tsekhanovsky. From *The Seven Wonders* (Samuil Marshak). Leningrad, 1927.

physical features (variations on a type), his feats and/or adventures, and his everyday activities or behavior (sports, games, etc.).

The new positive heroes of children's stories were usually politically aware youngsters the likes of previously mentioned Vanya the metalworker, or Mai and Oktyabrina,[5] or Vladlen the athlete (new saints, new names),[6] or perhaps Comrade Chumichka. This last character is born not just into a working family, but into the workshop itself—the smithy where papa has been forging the keys to happiness (but apparently also managing some time off for private life).[7]

> Worker Semyon
> And worker Matryona
> Had no child
> For thirty-eight years.
> But one night by the forge
> Where black coal lay scattered
> Blacksmith Semyon heard
> A soft little moan.
> Maybe a mouse, maybe a chick,
> Maybe a small wee baby. . . .[8]

His marvelous arrival in this world (we shouldn't forget the standard folklore motif of the hero born to aged parents) is later matched by his marvelous adventures, which serve to convince the reader of the superiority of this mini-proletarian sprung from the sparks of revolutionary labor. This brash, sooty-faced homunculus exists to carry out the will of the one who sent him: that is, he resembles an automaton programmed for a limited set of operations. So declares his literary progenitor Volzhenin in this rousing call to action:

> To work and to study,
> Bold grandsons of Ilich!
> Precious his behest to us—
> Nothing else.

Here, by the way, the mythic image of aged parents is superimposed onto the equally folkloric image of the childless "grandpa." The telltale concluding sentence, a brashly cheerful but no doubt unconscious slip, betrays the religious underpinnings of revolutionary construction (behest, or *zavet* is also "testament"—as in Old and New). Carry out his behest (his will and testament)—nothing else. Anything else is the devil's work. The Comrade Chumichkas of the day (the "spinoffs" of this character, that is) played an enormous role in all of this. Their job was to fill the order, meet the social demand/command—as this passage from a programmatic article entitled "Children's Literature during the Reconstruction Period" makes plain:

> In this era of socialist reconstruction, in this era of fierce and in-
> tensified class struggle, as our enormous country witnesses the
> final liquidation of all remnants of capitalism and sees the radical
> restructuring not only of all branches of our economy but also of
> the *human material* [My italics—E. S.] that will restructure this
> economy—in such an era the education of cadres, the builders
> of Socialism, has particularly great significance.[9]

In discussions on "human material," the reader will recall, the education-and-enlightenment brigade relied heavily on earlier Constructivist mani-festos and programs.

The Constructivist attitude toward actual children (children are human material, children must be educated to function as builders of Communism) presupposed the Constructivist approach to art for children—precision, smoothness, unity of tone, no psychologizing, no individualizing. These features can be traced through the entire gallery of children's portraits, which are not actually portraits at all, but studies in type.

Children's figures are often monumentalized—shown from below, against a low-lying horizon. Such, for example, is the cover illustration for *At the Plant* (*Na zavode*), with lithographs by V. M. Kaabak.[10] The children, chunky peasant types, are depicted against an industrial backdrop of build-ings, tall archways, machines, smokestacks. The hyperbolization of the im-

age is achieved not by its absolute size on the page, but by foreshortening, perspective, composition, and placement, all of which is reinforced by the story line. The hero of *Housepainter Sidorka* (*Malyar Sidorka*), for example, is "snagged by an aeroplane" and accidently flown off to India.[11] And there in India

> Everybody saw Sidorka
> With his bucket and his brush,
> And bowing low, they said to him
> "Paint us red too!"

The animals' wish (it is the animals who ask to be painted) is motivated by both their revolutionary consciousness and their weariness at life in the pre-Socialist jungle.

> Here's the elephant who bows his head
> And says "Please paint me too!
> I'm scaly and I'm dirty gray
> Paint me the color of the USSR!"

Twice in the space of two quatrains the animals address Sidorka, and twice they bow. This scenario of native wildlife down before the white Socialist sahib is paradigmatic for the international theme in children's literature during the 1920s, a theme we will take up later. Brash as Lebedev's jolly chimney sweep, Sidorka takes his enormous brush and paints five-pointed stars on the animals' foreheads. Such an act might be seen as a kind of revolutionary anointing, a new rite of initiation into a new world. Descended from above (from on high!), Sidorka represents a higher order; he is a builder of the new life, although he doesn't so much build it as *draw* it. Thus, in this, he is acting in the capacity of the Constructivist artist! His lower aesthetic status—housepainter rather than artist—reflects the relationship between the spontaneity of the untutored child and the professionalism of the adult.[12]

78

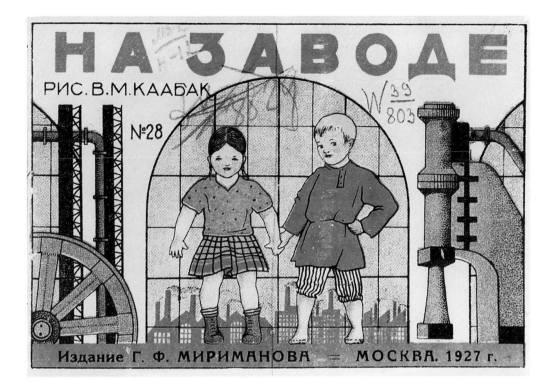

НА ЗАВОДЕ
РИС. В.М.КААБАК
№28
W 39/803
Издание Г. Ф. МИРИМАНОВА = МОСКВА. 1927 г.

Child characters in general provided a convenient excuse for the explication of revolution-and-creation theories that in their practical application were, more often than not, utterly destructive. Clothed in childlike ingenuousness and mischievous play, the typologically similar but deadly serious adult modeling of life looked a little less frightening. Thus in tandem with the song "We're Blacksmiths and Our Spirit's Young," the doughty figure of Vanya the blacksmith was trotted out. The text by Ivan Mukoseev is both more interesting and more eloquent than the illustrations by Konashevich, whose subsequent Soviet fame was not quite on the same scale as his talent. In Mukoseev's verse tale, the young lad takes hammer in hand and

V. Kaabak. Cover for *At the Plant*. Moscow, 1927.

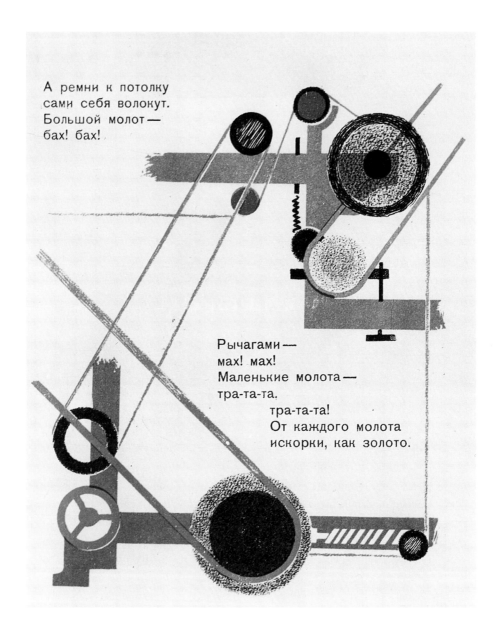

А ремни к потолку
сами себя волокут.
Большой молот—
бах! бах!

Рычагами—
мах! мах!
Маленькие молота—
тра-та-та.
 тра-та-та!
 От каждого молота
 искорки, как золото.

V. Vasiliev. From *How Senka Hedgehog Made a Knife* (Ivan Mukoseev). Moscow-Leningrad, 1926.

The hammer fell like thunder,
Sparks showered down like rain
People ran for cover,
Bam-boom! Slam-bang!

They can run, but they can't hide, and Vanya's sparks light a revolution-
ary fire under everyone, from the sheepherder (the former leadership of the
dull-witted People) to old grandma Fyokla and granddad (the incorrigible
old world) to the billygoat ("such a beard at your age," apparently a jibe at
Russian Orthodox priests). The "fire over all the earth" engulfs yet another
smithy, "taken singly" (to borrow Lenin's words):

Vanya's hammering away—
And singing all the while.
Zing-bam! . . . Hey-hey-hey . . .
Step aside! Or you'll get burned![13]

The traditional mythic role of the smith, the builder, is here stood on its
head. This little smith is a destroyer, and he cannot stop destroying, for he
is following a plan: "down to the foundations, then . . ." ("Internationale").
 A year later this same Ivan Mukoseev wrote another story about a young
craftsman, this one titled *How Senka Hedgehog Made a Knife* (*Kak Sen'ka
Yozhik sdelal nozhik*).[14] This little book belongs to the "how things are
made" genre, and describes the process of manufacturing a knife. (Knives
were a popular item in children's literature back then—one example is
Mikhail Il'in's *Pocket Comrade* [*Karmannyi tovarishch*], with illustrations
by Tsekhanovsky.) V. Vasilev's illustrations for *Senka* are solidly Construc-
tivist—flat lithographic surfaces, an abundance of mechanisms and ma-
chines, a snaky tangle of drive belts, small proletarian figures boldly
marching in step. First comes a detailed description of how the boy makes
himself a knife at the factory, and then the concluding lines ring out in a
triumphant Wagnerian finale:

81

Hedgehog may be black as pitch
But—he has himself a Knife.

Here the hero's sudden blackness, unmotivated by context, can be read
as content, as a basic mythologeme of the revolutionary text—the ground-
work for which was laid by Lebedev's chimney sweep. Poet Alexander Blok
had already heard the motif of the knife—bloodletting, violence, hoodlums
out on a spree—in the subterranean drone of revolutionary 1918 ("so I'll
slash with my knife, with my knife, / let a little blood, a little blood").[15]
It is from the opposite end of the poetic spectrum of those years, though,
from *chastushki*, that Mukoseev borrows his uncomplicated rhyme. "We're
a bunch of hedgehogs [*yozhiki*] / In our boot-tops we've got knives [*no-
zhiki*]." As for the intelligentsia's further contribution to the theme, we
might note that Lebedev, along with his work in children's publishing, did
several watercolors between 1925 and 1927 for a series called *Hoodlum
Love* (*Lyubov' shpany*). Here is what V. N. Petrov's flattering monograph
has to say about the work:

> Sometimes they dance wildly, sometimes they get into brawls and
> smash streetlights, now and again a knife pops up in the hand of
> some shaggy-haired dandy. . . . But there is a spark and a boldness
> to them, a violent strength and a naive sort of passion, a youthful
> spark and a unique lyricism. The artist poeticizes his subjects, even
> admires them, without ever trying to mask his ironic grin at their
> doings and feelings.[16]

These words perhaps require no commentary. The revolution's poeticiza-
tion of "black rage, holy rage," as Blok put it, of criminal license and the
thrill of violence, was the basis, and in a sense the sine qua non, of the
Constructivist project. Some excerpts from *The Pioneer's ABC* (*Azbuka
pionera*), which came out in 1925, might be apropos here: "We issue a
bold challenge—hack down the old world," "We paid in blood and gained
our joyous freedom," "The hammer and sickle, welded with blood,"

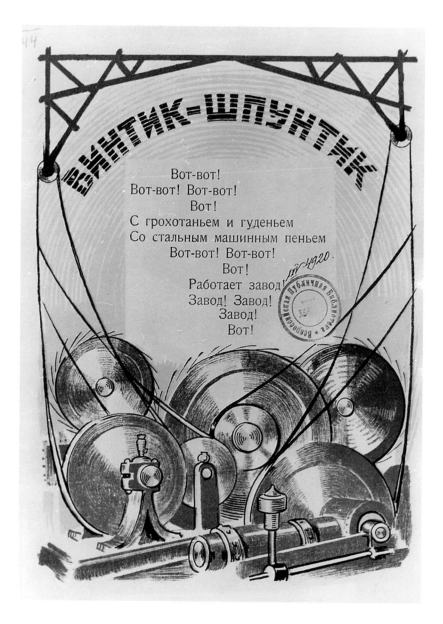

V. Tvardovsky. From *Vintik-Shpuntik* (Nikolai Agnivtsev). Leningrad, 1925.

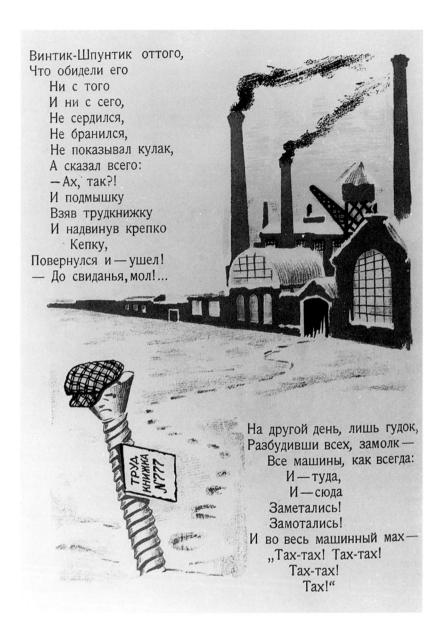

Винтик-Шпунтик оттого,
Что обидели его
 Ни с того
 И ни с сего,
 Не сердился,
 Не бранился,
 Не показывал кулак,
 А сказал всего:
 — Ах, так?!
 И подмышку
 Взяв трудкнижку
 И надвинув крепко
 Кепку,
Повернулся и — ушел!
— До свиданья, мол!...

ТРУД
КНИЖКА
№777

На другой день, лишь гудок,
Разбудивши всех, замолк —
 Все машины, как всегда:
 И — туда,
 И — сюда
 Заметались!
 Замотались!
И во весь машинный мах —
 „Тах-тах! Тах-тах!
 Тах-тах!
 Тах!"

V. Tvardovsky. From *Vintik-Shpuntik* (Nikolai Agnivtsev). Leningrad, 1925.

"Remember our banner is bloody, October's red blood," et cetera.[17] At the same time it is quite telling that children's literature clearly established the complex of the "insulted and injured" in revolutionary con/de/struction.

In Nikolai Agnivtsev's highly popular *Vintik-Shpuntik*, a whole multitude of wheels, bearings, and other mechanical thingamajigs (all wrapped in a welter of drive belts much like Vasiliev's illustration for *Senka*) stop work because little Vintik (lit. "small screw") is insulted and goes on strike.[18]

> Work papers under one arm,
> Cap pulled down low,
> He turned his back and left.

In V. Tvardovsky's illustration, touchy Vintik, proletarian-hooligan cap cocked low over one eye, is no longer just the "little man" tearfully celebrated in nineteenth-century liberal Russian literature. He is the former naught who has now felt some vague inner call to be all. It doesn't take much—all he has to do is keep score of his grievances. And so Agnivtsev's *My Little Bricks* (*Kirpichiki moi*; Moscow-Leningrad: Raduga, 1927) depicts the causes of social revolution:

> But now the simple folks
> Are mad! Look there—
> They've started settling
> The score.

The rather nondescript picture that goes along with the text shows a factory in the background, and a crowd wielding clubs and bricks. Further,

> Angry on this fine spring day
> The bayonets are bristling!
> And, moving on the palaces,
> The trucks roar ahead!

85

The utopian mentality of these artists of the new life derived from the necessity of destroying some people and reforming others. "These *can* be reformed," declared the famous pedagogical slogan, the official line on nonproletarian (said about criminals) but "socially close" elements of the population.

The destructive-revolutionary strategy in its Constructivist guise meant a reformation of classic folklore plots. The new folk hero dealt with traditional characters in a brand new way. Take, for example, the plot of M. Sandomirsky's *The Pie* (*Pirozhok*).[19] An old countrywoman is baking pirogies to welcome her soldier son home from the front. The new artistic vision of granny's hut (here in pictures by artist M. Purgold) dispenses with vertical walls and upright oven forks. The pot won't make kasha because it's sliding off a listing stove onto a bucking and rearing floor. The train on which the son is riding is made up of cars bouncing this way and that, leaping over hill and dale, homeward-bound soldiers clinging to its sides. Meanwhile, with fairy-tale logic, one of the old woman's pies has jumped off the windowsill, where she set it out to cool, and runs away. But this 1920s version of the gingerbread man doesn't get very far. When the pie meets the old woman's son on the road, the soldier isn't about to be fooled by any sly little pie songs. He takes swift and decisive action:

Our marksman takes his carbine
And targets the pie:
A bulls-eye through the middle,
Through the filling!

The illustration to the text shows the pie flat on its back, spindly limbs sprawled out like cockroach legs, as the highly unappetizing filling oozes from the rip in its belly.

The revolutionary violence requisite to the building of the new life and new society was shaping a new, activist personality. Some characteristic images of children-as-builders were created in the book *Let's Build* (*Davaite stroit'*), by G. Solovyov, where lithograph illustrations by Evsyukova, a

Ай, да бабушкин сынок,
Лучше выдумать не мог!
Завертелась бабка Дарья,
Дни и ночи куховарит;

У растопленной печи,
Словно войско — рогачи.

M. Purgold. From *The Pie* (M. Sandomirsky). Leningrad, 1926.

Снял винтовку наш стрелок,
Взял на мушку Пирожок:
Пуля — в серединку,
В самую начинку!
Ребятишки прибежали,
Всю начинку подобрали,
Только корочки кусок
Скушал бабушкин сынок.

M. Purgold. From *The Pie* (M. Sandomirsky). Leningrad, 1926.

little-known but fairly representative artist, show a sort of model-exemplar of the new child-hero.[20] Stiff mannequin-like figures with frozen, animal-like faces strike grand poses and gesture dramatically. Many of them raise their arms skyward, as if in prayer, or a trance. A low horizon emphasizes their hieratic, statuesque quality. One figure bestrides a stream like young Gulliver in the land of capitalist Lilliputians (in a popular children's film adaptation he led a revolution):

> . . . curly-topped Igor
> Laid out his ditches
> His fences, bushes and factory.

Tellingly enough, the new Gulliver lays out absolutely everything except a place for people to live: ditches (a foundation pit[21] with runoff), fences (so outsiders can't get in and insiders can't get out), bushes (to sit in), and a factory (to work in). The concluding phrase of the book expresses, in a nutshell, this mentality of fences, ditches, and mass activism:

> They've split into groups,
> Dug into the sand
> And each little tot works like mad.

Judging from the illustration, little Vanyatka's way of working like mad is particularly impressive. He plants his legs sturdily apart, as if leading a political rally, and extends one hand in Leninesque fashion. The foreshortening gives the figure a commanding, monumental quality, while the gaping mouth adds the finishing touch to the iconography of the street-corner orator. This iconographic schema came into being at virtually the same time as the classic Lenin statue; it is the latter's semiotic parallel, axiologically lowered and translated into a different social status. There were many such illustrations in children's books of the time: in *Engines Rampant* (*Parovozy na dyby*), for example, Young Pioneer Vanya, here a chubby,

pompous little tyke, stands atop a pedestal, making a speech to all the locomotives.[22] So the stereotypes of social behavior, as well as the revolutionary-rally plastics of the characters' bodies in Constructivist-oriented discourse (visual and verbal alike), are isomorphic with (though at times almost caricatures of) serious-Soviet-art discourse of the time.

Yet another facet of the positive hero's image is reflected in *Vladlen the Athlete* (*Vladlen-sportsmen*; see note 6 of this chapter). The enthusiasm for sport and fitness—bringing up builders-and-makers strong in body and healthy in spirit—is a particularly distinct aspect of the "man-building" idea, which was in texts of various semiotic sets, from military and sports parades and other such fads to the poetics of the Soviet body advanced by the artists of OST (Society of Easel Painters), or by Lebedev and his ballerinas. In the final analysis, the athletic physicality of the 1920s was slightly camouflaged by manifestations of *anti*-physicality. Through exercise ("Temper yourselves like steel!" went the song) one could bring something born imperfect ever closer to something perfectly created, the biological organism closer to the constructed mechanism, and achieve a body "whose heart runs like clockwork."[23]

A. Burmeister's illustrations for *Vladlen* are crude, grainy, *lubok*-style lithographs showing various phases of the healthy, sports-oriented lifestyle of the Soviet child—exercises in the morning, cross-country skiing in winter, swimming in summer. Both the style of the drawings and the quality of the verse text ("He wants to go to school, this year / To be a bold Young Pioneer") relegate this book to the opportunist, mass-culture category of contemporary Constructivist poetics. David Shterenberg's flat, primitivist manner in *Physical Fitness* (*Fizicheskaya kultura*; Moscow: GIZ, 1930) and *Bobka-fizkulturnik* (with text by Anatoly Mariengof; Moscow: GIZ, 1930) strikes a more purely Constructivist note.

At the same time, in their thematics, graphics, and typographic design, in their anthroponomics, books like *Vladlen* were fairly timely—in contrast to that trickle of children's books that still gave off a telltale air of ancien régime or NEP. We should mention them too, lest the reader get the

E. Evsyukova. From *Let's Build* (G. Solovyov). Leningrad, 1928.

И прутья и щепки
Всем нужны для лепки,
И камешки в стройку идут.
Доволен Ванятка:
Рукой и лопаткой
Он вырыл огромнейший пруд.

Он хочет в школу поступить
И пионером смелым быть.

impression that in the 1920s the Constructivist-revolutionary style was the
only style to be had.

One curious example is Maria Solovyova's *Boats* (*Korabliki*),[24] with the
mannered, outrageously "grown-up" long line and the feminine and
dactylic rhymes typical of melancholy fin-de-siècle epigones of Blok:

> *Iz kirpichikov i kubikov razkrashennykh*
> *stroim my zheleznuyu dorogu.*
> *Vot vokzal s vysokoi krasnoi bashenkoi,*
> *sinie i zholtye vagony.*

> Out of little painted bricks and blocks
> We build a railroad.

A. Burmeister. From *Vladlen the Athlete*. Kharkov, 1929?

Here's the station with its little red tower,
blue and yellow cars.

Another variation on mid-twenties NEP style poetics can be found in
Little Girl Ida and Teddy Bear Midya (*Pro devochku Idu i pro Mishku
Midyu*).[25] M. Morozova's black and white drawings feature "elegant" fash-
ions, striking hairdos, coquettish ladies, and well-groomed children, plus
typical bourgeois interiors. The characters' names, too, are quite telling,
from Ida to Midya—which in itself forms a striking contrast to the standard
Soviet list of positive character names. Among the latter, Vanya is solidly
in first place (see also *Vanya in China* and *Red Army Soldier Vanyushka*),[26]
followed by Sidorka, Egorka,[27] Katyushka, Marishka, and the like.[28]

As children grew, these edifying descriptions of the legendary class-
struggle feats performed by sundry Vanyushkas and Chumichkas grew with
them. In books for slightly older children, the wild, almost magical adven-
tures of the tot were replaced by the realistic and thoroughly hooligan es-
capades of the adolescent. Actually, more to the point than the hooliganism
itself are the catchwords and slogans that egg the hooligans on—for ex-
ample, those to be found in a little book with the utterly fantastic title of
Let's Catch Up to the American Chicken (*Dogonim amerikanskuyu kuritsu*),
by a certain A. Boretsky. Some of the headings are direct calls to action
("Let's lob an egg at Chamberlain's head"), while some of the instructions
are straight out of Andrei Platonov ("Every Pioneer and schoolboy should
start a chicken diary to keep his chicken-raising accounts").[29] Such slo-
gans might serve as titles, as in "Children—join the production-technology
march!" (why not a Children's Crusade?), or as cover material, as in excla-
mations (horrifying in form and nightmarish in Crusade content) like "Fight
for polytechnism!" or "Let's mobilize our Pioneer battalions for the tech-
nological front!"[30]

To conclude our description of the positive hero, we should return to
his classic image. In our earlier description of Lebedev's groundbreaking
posterly poetics we discussed the discrete and localized color masses that
constituted the visual image of the character. Such stylistics were em-

ployed by many of the most "consciously Constructivist" artists. Nisson Shifrin's cover drawing for the Yiddish journal *Junge Wald* (*Young Wood*; Kiev, 1923, no. 1) is an excellent example. The square, stylized figure of the woodcutter is placed at the composition's center. His ax is swung high to get that truly revolutionary reach; felled trunks lie scattered around him. In the background rises the geometric bulk of a new city. The combination of title and illustration now looks almost ironic, though it is hardly likely that the author had such irony in mind. More probably he assumed, in the new Russian cultural tradition, that a new forest couldn't be planted until the old one was hacked out at the roots.

Yet another prime example of the style is to be found in Evgenia Evenbach's *Market* (*Rynok*).[31] Her flat, faceless figures are assembled out of single-color blocks resembling precisely angled, geometric paper cutouts. Many of the figures are shown running or falling—dynamically tilted and angled, their body parts dropping away. The most expressive of the group depicts a boy running (we'll assume he's running, not falling), and is accompanied by the words, "Everybody out of the road / If you want to have any feet left!"[32]

Fairly often, though, artists drew the faces in. Lines serve for eyes and other facial features, brushwork for chiaroscuro—that is, for dimension. But so done, the natural roundness and "irregular" handmade quality of the face clashes strikingly with the mechanical-looking color blocks that make up the rest of the figure. In this respect Georgy Echeistov's illustrations for several books published in the mid-1920s are particularly revealing.[33] Because of the concession that Echeistov's fully articulated Constructivism makes to the classical brushwork manner of portraiture, the impression produced by the pictures is an ambivalent one. Their aesthetic quality suffers noticeably for lack of stylistic integrity. The consistently Constructivist strategy pursued by artists Lebedev and Tsekhanovsky did not allow for such "all too human" concessions, and did away with faces altogether. In certain extreme cases they did away with more than faces.

The apotheosis, the ultimate-in-all-respects expression of Constructivist

Vladimir Lebedev. From *Ice Cream* (Samuil Marshak). Moscow-Liningrad, 1925.

Отличное
Земляничное

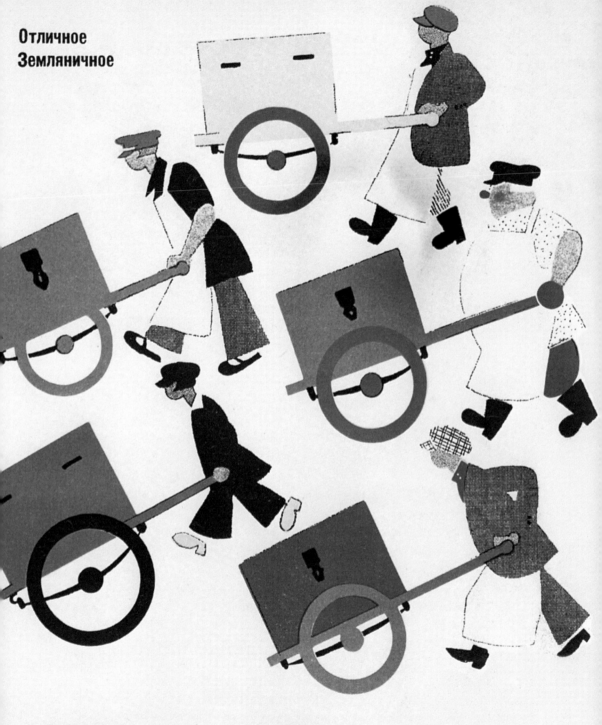

Прекрасное
Ананасное

Именинное
Апельсинное

Мороженo!

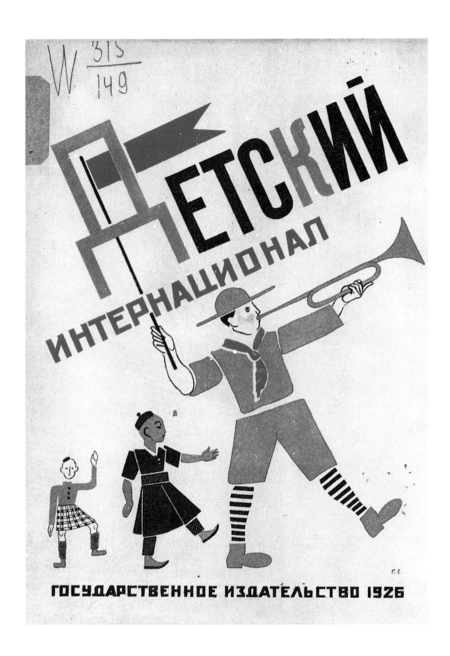

Georgy Echeistov. From *The Children's International* (Yuri Gralitsa). Moscow-Liningrad, 1926.

principles in the portrayal of the new man, is a barely noticeable illustration by Tsekhanovsky for *Topotun and the Book* (*Topotun i knizhka*).[34] To depict new Soviet books for children, Tsekhanovsky drew a cover with the title "Soviet Kids," and underneath the title drew a Young Pioneer with a bugle.[35] Everything in the illustration is done with painstaking geometric precision—the standard-issue Pioneer shorts, the matching blue helmet, triangular red kerchief, black shoes, shoulder-strap pouch, horn—but betwixt and between all these there is nothing but empty space. The clothes have no emperor. The helmet, kerchief, and pouch hang from some invisible framework. Live flesh-and-blood, as something too crooked, too changeable, too biological and raw, is banished entirely from this ruled-and-measured, plane-and-angle-dominated visual world. There is an eerie symbolism in the combination of the title "Soviet Kids" and the empty uniform representing them. Having set out to depict what was permanent, objective, essential, in the human body, its structure, its skeleton, its organizing principle, the Constructivists ended up doing quite the opposite—completely eliminating the body from their maximalist project, inasmuch as reducing the living to the nonliving turned out to be an impossible task. In the end, the most precise, regular (and therefore the only permissible) visual description of a character was its social shell—its uniform. This uniform casing became the fixed constant. The biological "filling," the annoying variable, had to be removed from the equation. The removal strategy was essentially the same, whatever the semiotic level: typologize, depersonalize until the person is denied altogether. Or, at the social-design level: bull's-eye, through the middle, through the filling (to borrow a line from *The Pie*).

The opposite number and complement to Tsekhanovsky's zero-hero appears in the same book as the title character, the robot Topotun. Here is yet another incarnation of the Constructivist positive hero. Unlike clothed human bodies, this mechanical mannequin is made of discrete, translucent segments and couplings. Neither drawn nor drafted, he is *assembled* out of typographical elements like dashes, parentheses, leads, and other mysterious geometric characters. The absolute regularity of his appearance is

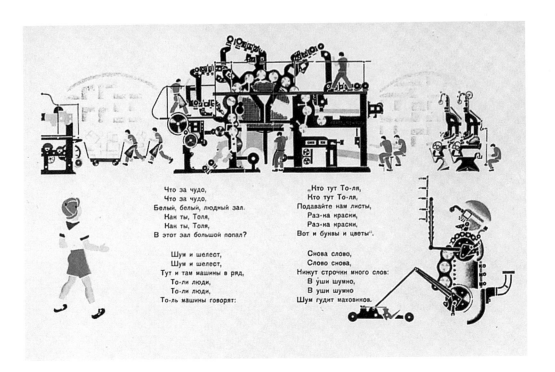

Что за чудо,
Что за чудо,
Белый, белый, людный зал.
Как ты, Толя,
Как ты, Толя,
В этот зал большой попал?

Шум и шелест,
Шум и шелест,
Тут и там машины в ряд.
То-ли люди,
То-ли люди,
То-ль машины говорят:

„Кто тут То-ля,
Кто тут То-ля,
Подавайте нам листы,
Раз-ка краски,
Раз-ка краски,
Вот и буквы и цветы".

Снова слово,
Слово снова,
Нижут строчки много слов:
В уши шумно,
В уши шумно,
Шум гудит маховиков.

unmarred by any random or imprecise human touch. These are ready-made graphics, invariable, identical—the triumph of the draftsman over the arbitrariness and unpredictability of the creative artist.

Topotun the robot opposes the live boy not only on a visual level, but on a plot level as well. He is the rational, right-thinking character who teaches a messy little slob how to take care of his books. The plot of *Topotun* turns on the same device as that of Chukovsky's *Moidodyr*, which pits another messy little slob against the "crook-legged, lame sink" Moidodyr, the cleaner, the corrector, the instructor of dirty and disorderly human material.[36]

We should note in passing that one constant in the characterization of anything animate, anything organic, is *dirt*. Whatever is made dirty, whatever is polluted by chance-ridden, disorganized life, must undergo ritual

Mikhail Tsekhanovsky. From *Topotun and the Book* (I. Ionov). Leningrad, 1926.

cleansing—with the aid of a nonbiological but animate (in its own way, at least) force, a kind of alternate divinity. This god moreover is no longer simply some deus ex machina (Moidodyr came out of Mama's bedroom, after all—a hint at parental superego) but itself a machine. Il'ya Ionov (the author) and Tsekhanovsky took Chukovsky's plot find and rather artificially squeezed it into the "how things are made" genre, which in this case meant "how books are printed." At the same time, Tsekhanovsky took Chukovsky's barely developed theme of the mechanical teacher (the frightening and punishing teacher) to its logical limit. This was, by the way, characteristic of Tsekhanovsky, who in various versions of his overall text had demonstrated the extremes of Constructivist strategy, moving from multiple images on the page to multiplication on film (the Russian term for animation is *mul'tiplikatsiya*—cartoons are called *mul'tiki*), from facelessness to bodilessness, from mechanics and graphics to the creation of fantastical mechanical characters. His characters represent the utopian pole toward which children's literature had been moving throughout the 1920s in its attempt to create the positive hero.

KIDS OF MANY COLORS

The international theme (this meant primarily the oppression of blacks and Chinese and the fairy-tale or epic adventures of Soviet children who come to their aid) merits separate, if brief, consideration. For the positive hero of Soviet children's books, adventures in Africa, China, or other exotic places were one way to affirm his legendary powers in an almost realistic and class-consistent way, without resorting to enchanted kingdoms or battles with evil spirits—all of which had been discarded for lack of verisimilitude.

One can tentatively divide children's books about Africa into two groups. The first comprises quite traditionally inclined authors whose attitude toward natives is all too clear from their rather shameful caricatures of them;

99

paradoxically, this fits hand in glove with the new covenant of proletarian internationalism. The other group tended to identify issues of race entirely with issues of class.

To the first group belong books such as S. Poltavsky's *Kids of Many Colors* (*Detki-raznotsvetki*; Moscow: ZiF, 1927). The texts all sound more or less like this:

> There's the little crybaby boy
> As black as soot
> From head to foot.

The illustration, by Sergei Chekhonin, is even more grotesquely indecent than the text. The character is made to look repulsive, but spit-and-polish Vanya has this reaction to the crybaby:

> Vanya laughed and laughed.
> He thought: "Well then,
> Give me a yellow one,
> I'll start again."

Chekhonin promptly supplies Vanya with a Chinese boy who looks even more repulsive than the first. Then a red boy comes along and they all sit down together to eat bananas. No class-struggle slogans here. These illustrations are done outside the framework of strictly Constructivist discourse, but in them Chekhonin has wandered far afield of his old "World of Art" principles. His "kids of many colors" have nothing in common with Meyerhold's sweet and sexy *arapchiki*. This was instead a step in the direction of pop-culture kitsch, a parade of carnival freaks and foreigners to keep the crowd entertained.

However, in Lev Zilov's *Mai and Oktyabrina* there is more than enough revolutionary agitation to go around. The Soviet children's round-the-world flight ("The *mop* started spinning like a propeller"!) proceeds to the refrain:

Sergei Chekhonin. From *Kids of Many Colors* (S. Poltavsky). Moscow, 1927.

посмотреть,
Что за новый народ
В этих
Диковинных странах живет.
Смотрят —
Сидит негритёнок-плакса,
С головы до ног
Чорный, как вакса.

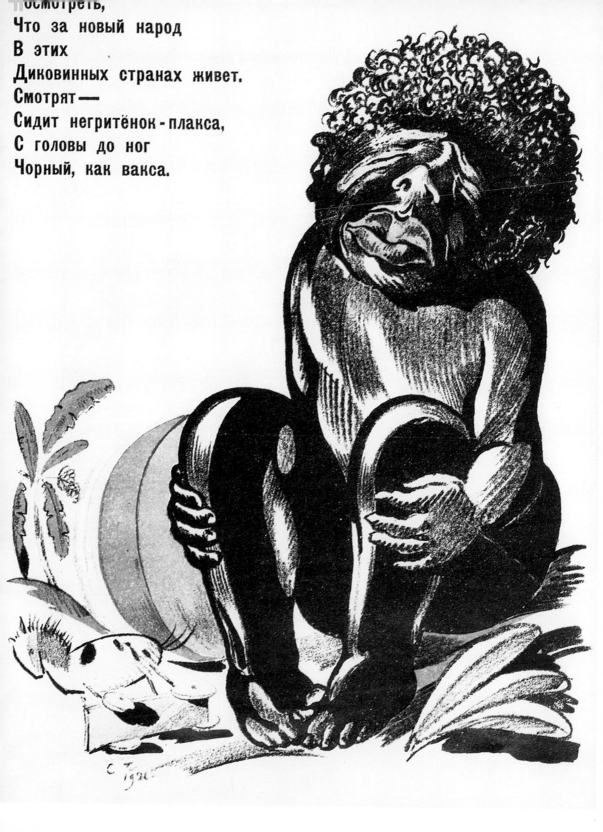

The children will help
The Negroes, Indians, Chinese.

To Japanese children (presumably so that their samurai mettle wouldn't
rust), Mai declares, "the only thing that will cut through the door / to free-
dom is a sword" (p. 33). But the most interesting episodes are in Africa. In
several of the illustrations, V. Orlov depicts terrifying, beast-like natives
in the form of impenetrably black, writhing silhouettes who move with in-
human plasticity. Underneath the pictures is a verse caption that is quite
remarkable in its own way:

And the Negroes, gleaming, glossy
Threw themselves into their dance.[37]

V. Orlov. From *Mai and Oktyabrina* (Lev Zilov). Moscow, 1924.

The black circle of dancers bears an amazing resemblance to Matisse's *Dance* (1909)—or perhaps not really so amazing. Zilov's verses from time to time sound suspiciously like Mayakovsky.

The exploits of the little boy in the Red Cavalry cap presuppose his obvious primacy over all the natives in word and deed. In another book, *Komsomols in the Wilds of Africa* (*Komsomol'tsy v debryakh Afriki*), the heroes declare (about a native leader they are fed up with), "We'll overthrow this princeling and form the Negro Soviet Republic!"[38]

Ridicule of "savages" was a standard feature of many books of the period, not just those mentioned here. For example, there is *Letters from Africa* (*Pis'ma iz Afriki*) written by Beyul (N. Zabolotsky) and illustrated by Nikolai Lapshin (Moscow-Leningrad: Molodaya Gvardiya, 1928), or *How Chocolate Came to Mosselprom* (*O tom, kak priekhal shokolad v Mossel'prom*). In the latter, a verse narrative of the process of manufacturing chocolate (a production book), Elena Tarakhovskaya also shares a good deal of information about ethnography and proletarian internationalism:

Little Negro Sammi
(This you know yourselves)
Lives far, far away.
He's a good little boy
But his belly is black
As your galoshes.
He doesn't go to school
He runs around naked
With little redskin Joe.
By nature Joe's a dandy
He's dressed up in high fashion
Looking very nice.
With feathers on his head
And bangles in his ears
A bracelet in his nose.
The wild little boys

The parrots and the monkeys
Go running through the jungle.[39]

The boys and the monkeys (*mal'chishki i martyshki*) pick cacao beans,
which they send off to Moscow, to the Red October factory. It is revealing
that the author, out of concern for the proletarian children's chocolate,
gives advice to all those who have bellies blacker than galoshes and brace-
lets in their noses:

Everyone to work!
You have to cut the fruit up
Not stick it in your mouth!

The illustrations themselves are quite professional, and not bad in their
own way—color lithographs with bright flat planes à la Lebedev. Then
again, artist Yuli Ganf simply may have liked the little boys and monkeys.
One can sense a certain paternalistic sympathy in his depictions of them.
As for the young proletarians back home, the illustration on page 7 shows
them lolling around under the "Red October" sign, angular, animal-like
mannequins with a touch of the hoodlum about them.

In general, the "Negro theme" (or the equally popular "Chinese theme")
had a dual subtext. While allowing for expressions of class solidarity and
sympathy, it also provided an opportunity to express, in camouflaged form,
a need for sadistic discourse. As we have seen earlier, this was characteris-
tic of children and adults alike. Thus the village children would ask their
librarian, "Give us something about Negroes, how they got tortured, you
know, by the English, tied to a tree and whack—slices 'em in half and
that's it. . . . I want a book like that to read. It gives me goosebumps."[40] In
Tale of a Negro Boy (*Povest' o negrityonke*) the tortures inflicted on blacks
in America are recounted in passionate ballad style. However, the blacks
in the story give as good as they get. To the same rhythm as the old song
"Comrade, I Cannot Stand Watch This Night," the epic tale of an old black
man's class rage unfolds:

And his twisted mouth trembled
Blood rushed to his head,
As the trees, meadows, cornfields flashed by.
He gasped for breath
And his hands shot out toward the giggling miss
And suddenly grasped her throat.[41]

This particular strangler (who, unlike Othello, grabs the neck of a miss who wasn't his to grab) is in the authors' class-conscious view fully justified, and they go on to recount with great sympathy how the little boy, aggrieved on the old man's behalf, decides to "set the white mansion on fire."[42] Having done the deed, he takes refuge on a Soviet ship, and the captain proceeds to teach him that

. . . the thing isn't really
To burn down one hateful mansion!
No! You've got to wage all-out war
And to the trill of machine guns
See that every last one of those cursed mansions
Burns to the ground.[43]

After this lesson on the ABCs of political economy, the little boy happily sails away to the USSR. If we were to mix this happy ending with that of yet another book, we would discover that

Tua lives in the USSR
Tua's a sooty-faced pioneer.[44]

The illustrations in both books are rather uninteresting, with the exception of the lively cover (by L. M.) depicting a little black boy with a red kerchief, grotesquely exaggerated lips, and teeth half the size of his face. In general, it was popular to draw a Pioneer kerchief round the necks of natives "close to the working class." Thus in Maria Shkapskaya's book *Alyo-*

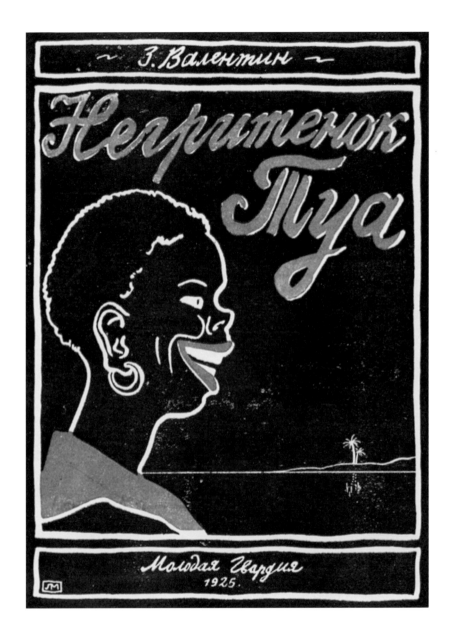

L. M. Cover for *Little Negro Tua* (Z. Valentin). Moscow, 1925.

sha's Galoshes one sketch by artist Alfons Zhaba shows ideally black, naked Africans with a drum, a red banner, and Pioneer kerchiefs round their necks. The verse that goes with it reads:

> Soon there arose an occasion
> For the Pioneers to go to Asia,
> And from Asia on to Africa,
> And under them there were united Africans.

A provincially artless and far-fetched combination of all the various aspects of the international theme appears in *Vanya in China*.[45] The crude, bright lithographs by A. Kalinichenko have, strictly speaking, nothing to do with Constructivist stylistics and are interesting perhaps only for their typically AKhRR (Association of Artists of Revolutionary Russia) jauntiness. The plot line involves a Pioneer's dream on the eve of May Day. In that dream he is flying, not to Mt. Brocken, but to China; and in China (that is, in his dream), Pioneer Vanya manages to indulge two complexes at once—power and sadism. In one illustration "the terrible Chang-Dzo-Ling / An evil Chinese mandarin" is shown quite graphically chopping off his bound compatriots' heads with a bloody sword; and in another (the last one, a major-chord finale), Vanya in his kerchief, paramilitary jacket, and boots shakes hands with Chinese kiddies half his size. The commandments of fraternity and equality, it seems, presupposed no democratic isocephaly in respect to the working people of the Far East. The elder brother, the youthful apparatchik from the provinces—not the avant-garde figures of Constructivist discourse—is the sort of character that will typify the coming decades. Party leaders and functionaries didn't fit into revolutionary or avant-garde stylistics particularly well, and at the beginning of the 1930s this clearly and directly affected the initial project and required its correction.

The notions underlying this peculiarly Soviet brand of internationalism, established in the 1920s, were refracted through children's literature specifically and pointedly, undisguised by any "adult" politesse or diplomacy.

That refraction lived on through several Soviet generations in the form of a deep-seated contempt for "gooks" and "chocolate bars" on the one hand, and on the other, as a sense of mission—to love, to help, to save, to civilize. In other words, the job of the big brother.

A. Kalinichenko. From *Vanya in China* (G. Shaposhnikov). Rostov-on-Don, 1927.

And so, in books whose texts and heroic, captivating pictures would train children, from toddlerhood on, to believe that labor (and factory labor at that) would, according to the slogan, soon be master of the world, we have seen a forceful antithesis to classic (i.e., feudal and bourgeois) themes and characters. "Production literature opens up a new way for work with the populace and for engagement of the broad masses of working people to build our kindergarten," wrote educators, rejecting also, in their struggle for the people's cause, standard Russian usage.[1]

THE PRODUCTION BOOK: LOCOMOTIVES AND ALL THE REST

It is crucial to note, with as much objectivity as we can muster, that not all these books were unequivocally bad. The best of the production books fit into a popular-science framework; here we might mention talented popularizers of science and technology such as Mikhail Il'in,

111

Boris Zhitkov, and Yakov Perelman. But in many cases the texts were the products of either cynical hackwork or simpleminded naïveté, both of which now look by turns frightening, unexpectedly amusing, or almost contemporary. Vera Il'ina's verse tale *Chocolate* (*Shokolad*), which came out in 1923, is a good example of how illustration served as a visual paraphrase of both the literary and everyday fundamentals of those years.

Chocolate begins by relating just how badly off proletarian children were under the tsar, and how the hungry children dreamed of that lordly chocolate. Later all those "bourgeoises" are driven out, and the workers and their children move into their apartment. But

The longed-for, cherished chocolate
Is just a dream once more.
Other places all have lots.
But . . . they're across the border.

Somehow, when the bourgeois and the oppressor disappear so does all the chocolate, and proletarian children are again left to dream of other people's riches, which as a result of the social revolution are even further out of reach than before. Fanning the flames of that "fire over all the earth" seems, at first, a solution to the chocolate situation. But when world revolution appears not to be working out, the children resolve to make their very own Soviet chocolate. And magically:

So "Tsentrshokolad" is born—
Departments, subdepartments.
They're working hard. Who wouldn't want
To serve in such a cause!
Vanyusha—he's head commissar. . . .

It's amusing to read that even in the 1920s, production started with the creation of a centralized, bureaucratic body that would gradually become

a monopoly so top-heavy that it crushed its entire product under its own weight. Moreover—and this is something that the Soviet economy experienced in full measure during the blessed years of Brezhnevian "stagnation"—this enormous bureaucratic apparatus began living a life of its own from production and product; it grew, sent out branches, sprouted new buds—departments, subdepartments . . .

But in the story neither the departments nor the subdepartments, nor even Vanyusha's proletarian roots, can supply the market with enough chocolate, and all the head commissar can do is shake a fist across the border: "You'll get yours!" In the meantime, socialist construction is apparently enjoying more success on other fronts. Hence

. . . the Soviet land
Is packed with plenty.

What exactly this is supposed to mean, in 1922 or 1923, is hard to say. Perhaps we might count these words prophetic, and envision future reports on the fulfillment of the five-year plan in four years, on the building of Socialism "on the whole and in general," or "fully and finally" (whichever), or perhaps simply the ur-form of that deathless phrase coined by Stalin himself: "Now life's better, now life's gayer." After all, this was an insider's view. To the outside observer, perhaps, it was clearly high time to send in the charity and humanitarian aid. Whatever the case, here begins the most interesting part:

Suddenly the foreign wave
Rolled up to us with news:
"The world has been at odds too long."

In contemporary political parlance,[2] the Western countries declare the existence of a common European home; and the Country of the Soviets, in the spirit of the new political thinking (but let's remember that it is still six

113

and a half decades until Gorbachev), opens its borders to them. Opens its borders, but not without calculation. If we have a common home, then be so kind as to share the wealth:

> Our enemies are now our friends,
> Paths beaten to our door,
> And boxcar after boxcar
> Comes bearing precious freight.

This was what, even at the dawn of the new world, would guarantee that the country of workers and peasants would enter into the European and world community—precious freight. Thus chocolate reappears in the USSR, and

> A blissful "ah" resounded
> From all the little chests.
> And breathlessly they stuff themselves,
> They prate, confer and parley.

"Breathlessly"—how neatly and prophetically this sums up the immanent, anxious Soviet urge to stuff oneself as quickly as possible, to grab, to snatch, to gulp it all down while they're still handing it out, while they let you, before they take it all away.

In the story, meanwhile, events take their course, and the children's appetite keeps on growing:

> Nyushka's fingers and her cheeks
> Have lots of smeary patterns,
> Kostya just can't take his eyes
> Off his sticky piece,
> A chunk from Grishka's third whole bar
> Makes his lip stick out.

And so it goes. Curiously, Kornei Chukovsky's withering review of the book mainly emphasized how bad the poetry was. This particular solution to the food-supply problem didn't seem to disturb him.[3]

Artist Georgy Echeistov's illustrations for *Chocolate* are full-page inserts done in a middling Constructivist style. They are fairly restrained and geometric, unemotional and thoroughly de-psychologized, all the dramatic vicissitudes of the battle for chocolate notwithstanding. In one illustration (between pages 40 and 41), Vanya stands in front of the Freedom Obelisk at the Moscow Soviet (city hall); the composition's formal features make it hard to imagine a place for chocolate in this context. Another illustration (between pages 12 and 13) shows an aeroplane and a locomotive bringing the foreign chocolate to Soviet children. Indeed it was the rare book that lacked a locomotive, and it is to a consideration of the latter that we now turn.

A NEW TYPE OF PROTAGONIST FOR THE LITERATURE OF THE VICTORIOUS CLASS

The hero of the production book, and indeed of all children's literature of the 1920s, was the locomotive; one could put together a whole sorting yard out of the titles alone.[4] And scrupulous investigation of all the various interpretations of the topic would show a wide spectrum of attitudes among those Soviet artists who had taken up this socially approved initiative. The locomotive's widespread popularity did not go unnoticed: "A fashionable topic—steam-engines, for example—is developed for all ages, in all modes: pictures and verse, fairy tales and stories, as biography, history, technology, guidebook. . . . But steamships? There are scarcely any books on them done with children in mind."[5]

It's no accident that to Marshak and Tsekhanovsky the locomotive numbered first among their seven wonders. This was where everything had started. But why did the locomotive enjoy such particular favor among the construction-minded promoters and populizers of the new world? Appar-

На митинг ли с отцом пойдет,
заговорит в Совете:
все растолкует, разберет,
а тих и прост, как дети.

Georgy Echeistov. From *Chocolate* (Vera Il'ina). Moscow, 1923.

Для них не чудо паровоз.
И пусть аэропланы
по воздуху, как рой стрекоз,
летят в любые страны.

ently because the mythopoetic mentality of these ideologues of revolutionary change saw it as a kind of magic carpet, iron horse, a Socialist *vahana*,[6] that divine bearer on which the broad masses of working folk might comfortably set out on the journey from dark past to bright future. Since the Bolshevik paradise admitted everyone (everyone with socially correct lineage, of course), the *vahana* had to possess the mythic strength sufficient to pull such a load, the power of a thousand horses and more. Only the locomotive could pretend to such a role. Revolutionary songs like "Fly Onward, Our Engine" sounded like ritual incantations, and the selfless clearing and cleansing of the road ahead by heroes like Nikolai Ostrovsky's Pavel Korchagin (who ruins his health clearing track in *How the Steel Was Tempered*) smack of sacrifice and self-immolation.

These quasi-religious, Romantic notions of a rapid transition from past to future in a "historically short period" evoked visions of dynamically accelerated time. The idea of acceleration, made possible by both technological progress and scientific discovery, was anticipated and reflected in art as far back as the Futurists. Einstein's discovery that mass was relative to acceleration found a curious reflection in Soviet state-building policy; for as the march toward Communism picked up its pace, the masses seemed to shrink in importance. And it wasn't just importance that was shrinking. As class warfare intensified, the masses shrunk in number as well. To borrow a term from Vladimir Paperny,[7] we might call this epoch soon to be symbolized by the locomotive "Culture 1." Its fundamental feature is constant movement—eternal struggle, permanent revolution, total replacement, a world stood on end.[8]

Daily life stood on end (*na dyby*) meant that people became virtual nomads, constantly on the move. In many books the characters are endlessly transferring from one form of public transportation to another—for example, in Vvedensky's *Journey to Crimea* (*Puteshestvie v Krym*), Ostroumov's *Train* (*Poezd*), Smirnov and the Chichagovs' *Akhmet in Moscow* (*Akhmet v Moskve*) and *Charlie's Journey* (*Puteshestvie Charli*), in Tarakhovskaya's *Railroad* (*Zheleznaya doroga*), Zak's *Nina and Vanya Go to Ryazan* (*Nina i Vanya edut v Ryazan'*), and finally in Marshak's famous

Absentminded (*Rasseyanyi*)—"Once he took a streetcar to the station. . . ."[9] The train station becomes a virtual symbol of life in the Soviet state, in its most typical and concentrated form. In their depictions of the station's hubbub and confusion, artists and writers were offering up a model of life so unadapted for life that, had it not already existed, would have been impossible to invent. Then again, this fascination with the railway bazaar was probably quite unreflexive, with only the occasional, surreptitious hint of an "up yours."[10] In any case, just as theater starts at the cloakroom, to use Stanislavsky's expression, the railroad starts at the station. And so with the trials and tribulations documented in children's books, we begin our deconstruction of locomotive discourse.

The following descriptions of the beginning of a railway journey are typical:

> With their suitcases and packets,
> With their trunks and with their sacks,
> Left or right, or just wherever,
> People run to catch a train.[11]

What we find in this setting are two things that aren't there: porters and information. A lack of both was still a characteristic of Soviet railway stations long after the 1920s were over. True, such scenes did have their requisite class-struggle subtext. Representatives of the old world—bourgeois gents, ladies with luggage (already duly ridiculed in Marshak's famous *Bagazh*), or, in a pinch, peasant women with milk cans—were the only ones scurrying "wherever" with their suitcases and sacks. These were exactly the sort of characters depicted by artist Boris Pokrovsky in illustrations for Elena Tarakhovskaya's *Railroad*: the fat bourgeois (the bourgeoisie as a class were inevitably fat) with numerous suitcases, sacks, and parcels tumbling to the ground; the peasant woman (milk seller = private sector) madly clattering by with her milk cans; and everyone running helter-skelter. Simonovich-Efimova draws roughly the same picture in Ostroumov's *Train*, to illustrate the following text:

Пуф!.. И паровоз глазастый
Задышал вдруг часто-часто,
Застонал и „ох и ах"
Полетел на всех парах!

Carts with packages,
Women with bundles,
Arms a-waving,
Hurry-scurry.[12]

Sofia Zak describes her station this way.

Boris Pokrovsky. From *Railroad* (Elena Tarakhovskaya). Moscow, 1927.

Noise, tramp of feet,
People and things.
Shouting, running
At full speed.[13]

In all these texts (verbal and visual alike), the shouting and running are
an inseparable part of an invariant scenario of Soviet train-station behavior.
As Ilya Ehrenburg wrote, "the country's locomotives were at the breaking
point. A torturous wheezing issued from their breast: there was no way
they could keep up with people. People rushed off, carried away, and noth-
ing could stop them." People *were* carried away—some by con/de/struc-
tive notions, some by salvation from them. The apotheosis of universal
motion had won over the people of great projects, the epoch that lived
and breathed slogans like "Time, Forward," "The Five-Year Plan in Four,"
et cetera. Rhythm and dynamism filled the work of every at least somewhat
important artist of the twenties and early thirties, whether they worked in
children's literature or not. And they all shared a certain Romantic attitude
toward the man-made mechanism, the machine that sliced through inert
space. "Inert" meant traditional, humanized, stable, unwavering. The con-
fusion, fright, and haphazard running around ("left or right or wherever")
were absolutely natural products of the collision between *homo naturalis*
and technological civilization. In essence this is the very problem that the
Constructivists, like other avant-garde artists before them, were trying to
solve—the collision of human and machine. How avant-garde they were
could be measured by how radical was their apologia for the machine. The
more irreversible the switchover to the machine track, the more of those
arm-waving milkmaids would, inevitably, be run down. "The present"
meant technical, fast, industrial. In contrast to this stood the past—rural,
natural, warm, raw. But the avant-garde could never quite rid itself of the
archaic (all too human) fear of the iron absolute of the machine, and this
was the cruelest collision of all. It might be said that the Constructivists
and fellow-travelers[14] sang dithyrambs in praise and terror of this uncanny
and unhuman thing.

121

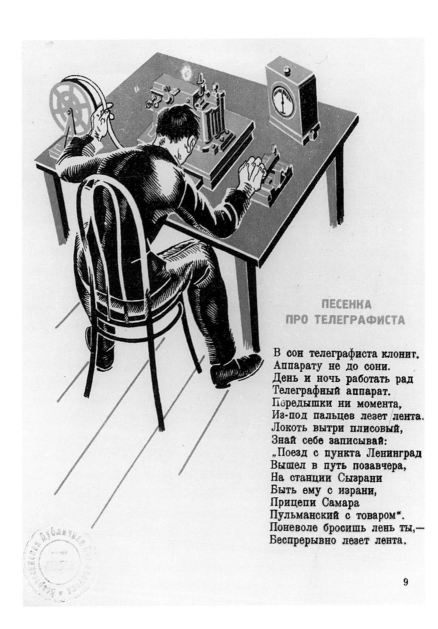

ПЕСЕНКА
ПРО ТЕЛЕГРАФИСТА

В сон телеграфиста клонит.
Аппарату не до сони.
День и ночь работать рад
Телеграфный аппарат.
Передышки ни момента,
Из-под пальцев лезет лента.
Локоть вытри плисовый,
Знай себе записывай:
„Поезд с пункта Ленинград
Вышел в путь позавчера,
На станции Сызрани
Быть ему с израни,
Прицепи Самара
Пульманский с товаром".
Поневоле бросишь лень ты,—
Беспрерывно лезет лента.

9

Boris Virgansky. From *What the Wheels Sang* (M. Ginzburg). Moscow, 1927.

The locomotive became a favorite for yet another reason, for it represented the principle of movement laid bare—exposed rods, flywheels, pistons, enormous wheels, and clouds of smoke. (We should recall that as early as Claude Monet, locomotives wreathed in smoke and steam were belching out what Venturi called "revolutionary energy.") In the end, the locomotive could hardly help but become the visible incarnation, the symbol, of the technological re-creation of the world.[15]

We will skip over those books whose illustrations were rather ordinary and not particularly avant-garde, and whose text simply told of a journey as such, without emphasis on the locomotive. Nor does our topic allow for a discussion of those books in which a scrupulously detailed description of all manner of railroad arcana served as backdrop for other topics. See, for example, Ostroumov's *On the Engine* (*Na parovoze*; Moscow: GIZ, 1927); Sergei Grigoriev's *Engine Et 5324* (*Parovoz Et 5324*; Moscow-Leningrad: GIZ, 1926). It is interesting to note the telltale signs of hermetically sealed technicist thought to be found in the latter book. At the end, the author explains words that might be difficult for children to understand: the problem is that his definitions are so full of technical jargon and non-Russian terms (*porshnevaya skalka, kreitskopf, sharnir*—piston rod, crosshead, and hinge, with the latter two taken from German and French respectively) that they themselves need glossing.

One work that combines the genre features of books about industrial trades and books about railroads is M. Ginzburg's *What the Wheels Sang* (*O chem peli kolesa*; Moscow: Molodaya Gvardiya, 1927). It describes, in verse, what the engineer and the brakeman do—and the fireman, the switchman, the telegraph operator at the station, et cetera. The figures and interiors in Boris Virgansky's three-color lithographs are drastically foreshortened, their dominant diagonals either falling forward or rearing back.

Most worthy of note are those books in which two fundamental lines may be consistently traced: first, descriptions of locomotives and other machines as such; second, stories with plots (such as those new fairy tales) featuring anthropomorphic iron characters. We'll begin with the second, more traditional, variety.

As a rule, it was those who had reached artistic maturity before 1917, outside of the Constructivist strategy, who, their long train of sentimentality and humanity dragging unfashionably behind, were guilty of all the anthropomorphizing and fantasizing. Progressive critics rightly scolded artists and writers alike. Nadezhda Pavlovich was criticized, for example, for a romantic verse tale entitled *The Gadabout Engine* (*Parovoz-gulyaka*), as were Boris Kustodiev's drawings for the same book (Leningrad: Brokhauz i Efron, 1925). "The drawings are murky, detail is heaped upon detail, but the main problem lies in its absolutely unnecessary anthropomorphism," wrote critics "M. Kalmanson, R. Rudnik and Sheinina."[16] As a matter of fact, these drawings are not among Kustodiev's best. The industrial theme was perhaps not his strong suit. He portrayed the gadabout locomotive, who is "sick of all the ties and engineers and stations," as a sort of dandy with bowler hat and cane, strutting along on spindly, bowed legs. The educators and critics pronounced their verdict: "The book, in light of both its plot and its drawings, should not be made available to children, inasmuch as it muddies the preschooler's experience."

It is difficult to say just what sort of experience with locomotives a preschooler might have had, but the rebellion of a machine in which something human had awakened was a theme not quite in tune with the times. Still, this particular aspect of the "machine theme" is quite revealing. The story of an engine who "suddenly remembered . . . about the open air" and "had the urge to go somewhere," who then ran away from his engineer and got lost, only to return abjectly home, can be read in several ways. The first way that comes to mind is social and political. The ancien-régime individualist's floundering attempts to go his own way lead to no good; without his engineer he cannot survive, and in the end, the hookey-playing engine almost gladly surrenders himself to the will of his engineer. But there is another possible reading of *The Gadabout Engine* and other such stories, more interesting (in terms of our theme) than the tragifarcical flounderings of the old intelligentsia.[17] That is the "revolt of the machine" plotted in such a way that the machine—cogs, flywheel, and all—undertakes to live its own life, but is forced in the end to submit to the guidance

Поезд отправляется,
Город удаляется.
Вот стоит машинист
Ничего не говорит.
Он вперед глядит,
Чтобы путь был чист,
Чтобы не было на рельсах
Никого и ничего,
Что мешает паровозу,
Что задержит его.

Alisa Poret. From *Railroad* (A. Vvedensky). Leningrad, 1929.

of humans. As it turns out, the engineer is more efficient than the machine, a circumstance that evokes undeniable sympathy in the authors of these stories and informs their texts with a certain ambivalence and tension; in the story of the gadabout engine we find both the personification of will and the desire to tame the dangerous, self-destructive excesses of irrational individualism. A highly characteristic image of the engineer can be found in Alisa Poret's illustration for Alexander Vvedensky's *Railroad* (Leningrad: GIZ, 1929). His face is both grotesque and horrific; it almost resembles Kharms's in a mask of frozen horror.

The plot of *The Gadabout Engine* is echoed in another book published in the same year, Osip Mandelstam's *Two Streetcars* (*Dva tramvaya*), with illustrations by Boris Ender (Leningrad: Raduga, 1925). Klik, the lost streetcar, "forgot . . . his number; it wasn't five, or three," and says, "Hey conductor, I'm tired out, drive me home." Only in the context of an all-too-familiar sense of homelessness ("in the black velvet of the Soviet night / in the velvet of the universal void," wrote Mandelstam in another poem) could such a counterpoint to the old romance "Coachman, Drive Your Horses Not So Hard" come to be. Mandelstam's Klik "stopped on a bridge"—apparently that final bridge that Nikolai Gumilyov's "Lost Streetcar," "having flown over three bridges," couldn't get across. It's no accident that the second streetcar, Tram (and these anagrammatic names are hardly accidental, either—Tram/Mandels*tam* and Klik/N*iko*lai *G*umilyov) says, "Tell me about Klik, the hard-luck streetcar, my brother. . . ." Where the lost Klik finally found peace ("was it on the sands of Golodai?"[18] mused Georgy Ivanov in his Paris emigration) remained a mystery; a decade or so later Tram himself went the same steep route.[19] True, Nadezhda Pavlovich lived well into old age, but wrote, "I'm like a tree in a chopped-down grove. . . ."

Other authors, better adapted to Soviet reality, still occasionally lapsed into the anthropomorphic habit and gave their locomotives eyes and a voice. For example, here is Elena Tarakhovskaya:

Pufff! . . . And the big-eyed locomotive
Started breathing faster, faster,

От стука и звона у каждого стыка
На рельсах болела площадка у Клика.
——

Под вечер слипались его фонари:
Забыл он свой номер; не пятый, не третий…
——

Смеются над Кликом извозчик и дети:
— Вот сонный трамвай, посмотри!

Boris Ender. From *Two Streetcars* (Osip Mandelstam). Leningrad, 1925.

— Возьми мою руку, вожатый, возьми,
Поедем к нему поскорее;
С чужими он там говорит лошадьми,
Моложе он всех и глупее.
Поедем к нему и найдем его там.

И Клика находит на площади Трам.

И сказал трамвай трамваю,
По тебе я, Клик, скучаю,
Я услышать очень рад,
Как звонки твои звенят
Где же розовый твой глаз? Он ослеп
Я возьму тебя сейчас на прицеп:
Ты моложе — так ступай на прицеп!

Boris Ender. From *Two Streetcars* (Osip Mandelstam). Leningrad, 1925.

Started groaning, "ohh and ahh,"
Flew off full steam ahead.[20]

Images and rhymes often seem to migrate intact from book to book:

Like a big-eyed dog,
And panting just as fast.[21]

A curious and almost parodic example of how engines were humanized is Pyotr Orlovets's *Engines Rampant* (*Parovozy na dyby*). This is neither the dandified locomotive of the fellow-travelers nor a direct folklorization of the industrial theme. Orlovets's text is more an example of how to liven up a socially approved theme, make it flashier. His verses are rather delightful in their own way:

Well hurry up, get ready,
Locomotives to their places!
Get dressed up and wash your faces,
Vanya's coming to inspect.

Artist Nikolai Ushin's engines are jolly, plump, and self-important, sporting not only faces but elegant little arms and even, on one occasion, a mustache. The latter image bore an amazing resemblance to one of Comrade Stalin adorning a locomotive in Andrei Khrzhanovsky's animated 1988 film *Landscape with Juniper* (*Peisazh s mozhzhevel'nikom*). In general, Ushin's illustrations are an example of what we might call the middle style of the mid-1920s. They are professionally executed lithographs, skillfully printed in three colors. The simplification of form and compression of volume hark back to high Constructivist style, but without the latter's rigidity or consistency. Ushin's figures aim primarily at comic effect, such as when Vanya the Pioneer makes a speech:

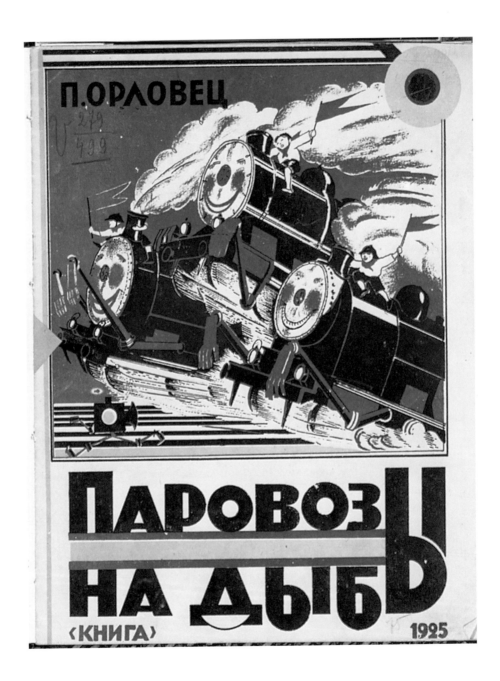

Nikolai Ushin. From *Engines Rampant* (Pyotr Orlovets). Moscow-Leningrad, 1925.

Now Vanya appears
With his Pioneer star.
He addresses the engines
In speech clear and simple:
Greetings, great transport,
We meet once again!
The Soviet land
Sends a kiss on the wing.

After the ritual embrace—the standard Party cheek-to-cheek-to-cheek—
the Pioneer turns to the steel herd with this fiery invocation: "Let the top
of your heads smoke / Let's get up some steam." Get up some steam, pre-
sumably, to keep that "fire over all the earth" burning away. The armored
train has stood around on the sidings long enough and the Leader, depicted
in purplish-crimson tones on the central turnaround, has willed that

Together we will close the link,
 At Ilich's behest.
 We'll build a new life
 On labor's foundation.

In the center of the turnaround stands a statue, ringed by attentive lo-
comotives.[22] Vanya the Pioneer is made to resemble the Leader giving a
speech from high atop a pedestal-like base. Sharply intersecting diagonals
and vivid color contrasts reproduce the usual clichés of poster graphics.
The final crescendo comes in the following verses:

Pounding, thunder, trembling earth—
At the sight of the youngsters,
A decrepit old engine
Laughs, full of joy.

Amidst this pounding and thundering and shaking of earth, the decrepit

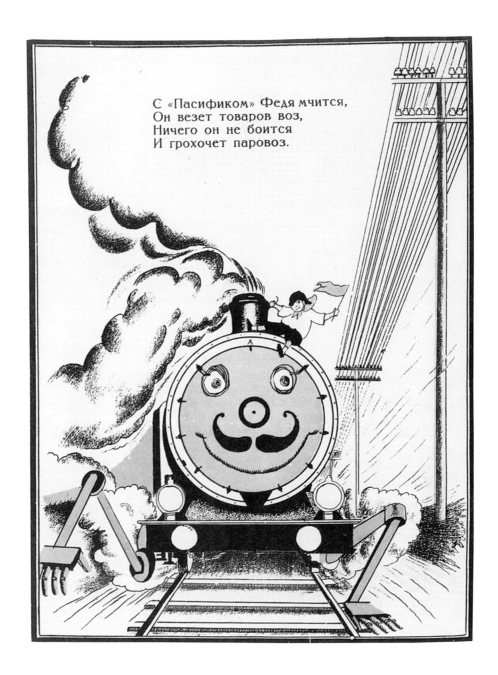

С «Пасификом» Федя мчится,
Он везет товаров воз,
Ничего он не боится
И грохочет паровоз.

Nikolai Ushin. From *Engines Rampant* (Pyotr Orlovets). Moscow-Leningrad, 1925.

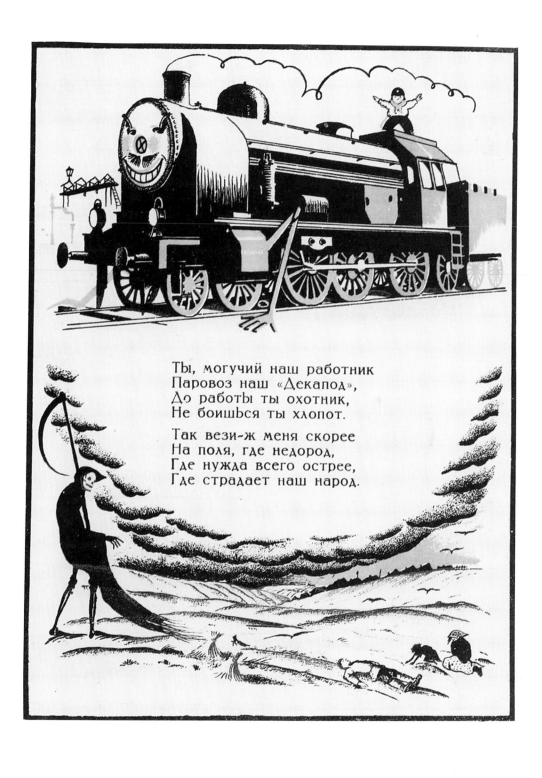

Ты, могучий наш работник
Паровоз наш «Декапод»,
До работы ты охотник,
Не боишься ты хлопот.

Так вези-ж меня скорее
На поля, где недород,
Где нужда всего острее,
Где страдает наш народ.

old engine undergoes a revolutionary transfiguration. And this engine epiphany is set in motion by the Great Initiative (Lenin's term for the first *subbotnik*), with, as we see once again, the ideologue-leader-engineer in the guiding role. Kornei Chukovsky's words on the children's literature of the time might serve as rather appropriate commentary here: "Never before, even in Borka Fedorov's times, have little children been fed such moldy, rotten garbage as that which is now being offered them."[23]

But there was more to come. *Vanya the Metalworker*, also by Orlovets (Moscow: G. F. Mirimanov, 1924), and also supplied with the requisite locomotives, is put together even more ineptly. The descriptions are sparse and incoherent: "Tractors, plows and engines! Surely we, the Russian workers, can make them work in harmony!!" cries Vanya in a passion (p. 18). There is little hard-core Constructivism, of course, in this text (although it does concern technology building), but examples of this sort are well worth citing, because the events of the next few decades were to show that what *Russians* perhaps could do, *Soviets* in fact could not. Once again children's books (even the easy-readers tossed off in a quick day's work) seem like mercilessly clear shards of the broken Soviet mirror. Orlovets's following passage could just as well have appeared in a Supreme Soviet agricultural report as in a children's book:

> The Sormov plant has almost entirely [almost!—E. S.] fulfilled its objectives in the construction and repair of locomotives and freight cars. Out of its workshops roll locomotives that even foreign engine-building yards might envy. "Our guys came through! Good job!"—the workers shouted.

The book's crowning illustration shows a locomotive, smoke billowing from its stack, speeding (just as in the popular song) nonstop to the commune: "Those foreign capitalists had better not think that we'll perish without their capital." In the workers' defense, we should note that they did perish rather purposefully and insistently.

The similarly inept, utterly nondescript illustrations for Kordeliya's *The*

Girl Who Stopped the Train (*Devochka, ostanovivshaya poezd*; Moscow: G. F. Mirmanov, 1924) were the work of the young Constructivist B. Ioganson. The final scene, done in color on the back cover, has a curious look to it. The locomotive, black with red highlights, is shown against a blackishbrown background and is so drastically, almost frontally, foreshortened that it looks like a fat kettle or a pot-bellied samovar. Profuse purplish-red smoke curls from an improbably slender stack like a decoratively twining ligature, bringing to mind both Art Nouveau and the Arabian Nights. The locomotive resembles some bronze vessel out of which, any minute now, in the smoke and flame of revolutionary renewal, the genie of industrialization will emerge. Such associations might not seem quite adequate here, but a certain sense of dismay and fright did slip through, even among the politically aware. For example, on the cover of *The Adventures of Travka* (*Priklyucheniya Travki*; Moscow: GIZ, 1929), by S. Rozanov, artist A. Mogilevsky depicts a locomotive flying along in a burst of speed, and underneath it there is a small boy. It is as if the locomotive is hanging over the child's head—yet this is meant to be simply "a production book about transportation."

Even more revealing are the Chichagovs' illustrations for a book done in collaboration with writer Smirnov, *The Way North* (*Put' na sever*; Moscow: Novaya Moskva, 1924). The locomotive on the cover is extremely conventionalized, a Suprematist monster made of sharp-edged, undetailed planes. The drawings for the text, spare and regular, resemble blueprints. The few people in them also form even lines—like the points out of which straight lines are constructed. Such is the drawing on page 15, which depicts laborers pushing wheelbarrows in single file, shrinking successively into indistinct dots as they approach the horizon in a perfectly straight line. This illustration might be considered prophetic: this *is* the way people went north, clearing, building iron roads at the will of iron commissars plotting the straight iron Party line, millions of people who became cogs in the great machine, or points on a map, or just prison-camp dust. The way north was cleared by tens of thousands, so that soon tens of millions could stream up that very same road. How characteristic and richly ambiguous, in the

light of subsequent historical experience, are the following verses from Ostroumov's *Train* (p. 12):

> Snouts poke out of livestock cars
> Horses, geese and bulls,
> And fool-rams.

Three or four years down the line, the livestock in those cars was human. Who knows—perhaps the children who once were taught that such cars hauled rams (that is, fools) took roughly the same attitude toward other kinds of idiotic (according to Marx) rural life?

Interestingly enough, children's books also described the traffic in the other direction:

> Heading to Moscow?
> "Yes." "Me too!
> I'm the sheepherders' rep
> To the farmworkers' convention."[24]

Even in dozens of books composed exclusively of dry descriptions of various mechanisms or histories of locomotive building, one hears notes that clash with the brave major-industrial key. Thus Boris Zhitkov, after taking up a full 150 pages with thoroughly technicist descriptions of steam engines from Carnot and Stephenson on, ends his *Locomotives* (*Parovozy*) with the following paragraph:

> Suddenly—bam! everything flew to pieces, the armor plate fell away like pottery shards and a column of steam curled up and around the cars. An enemy shell had hit the engine. The locomotive answered with an explosion of its own—it burst the boiler, ripped itself apart. It scattered the armor plate, the cab, the firebox, flung coal out of the tender, pitched forward and fell onto the pitted bank.[25]

Galina and Olga Chichagov. From *The Way North* (Nikolai Smirnov). Moscow, 1924.

Strange, isn't it? First they sang "fly onward, our engine" then suddenly "bam!—everything flew to pieces." It might be appropriate here to recall our earlier thesis on archaic stereotypes in avant-garde thinking, and to examine it in greater detail.

We might put forward the proposition, which borders on a certainty, that in the Soviet, indeed in the pre-Soviet, Russian intellectual mind (let alone the peasant mind) the locomotive had often been linked with destruction and death. The history of the Russian railroad began with the people's panicky aversion to using it at all. The test runs had to be done with soldiers as passengers. Belinsky, not without a certain admiration, early on compared Pechorin (Lermontov's *Hero of Our Time*) to a locomotive crushing everything in its path. Of all the stereotypical texts about the iron road,

Galina and Olga Chichagov. From *The Way North* (Nikolai Smirnov). Moscow, 1924.

Nekrasov's is the one that immediately comes to mind. The very first thing he singles out in his description of the railroad is this:

> The road runs straight: narrow banks,
> Narrow poles, rails and bridges.
> All along it there are bones, Russian bones . . .

Those Russian bones turn out to be the essential foundation of the railroad and of progress, for

> They called these barren wilds to life
> And gained themselves a coffin.[26]

So these bones pave the way to the bright future, which is where the railroad also leads. Nekrasov's "crowd of corpses" is a collective victim of the locomotive, this new god to whom the victims are inextricably bound even in death: "On this moonlit night / It's mighty fine seeing our work!" The locomotive in revolutionary ideology becomes a Juggernaut into whose path one must throw oneself so that one might enter heaven, and so that the Juggernaut itself might arrive there too, with all the deserving faithful on board. ("You die not in vain" intones man-of-the-people Nekrasov, "for the deed stands firm when blood is shed beneath.") This corresponds precisely to the Constructivist manifesto: "Bound fast by blood, the USSR stands firm."[27] And to bind things a little faster, people like Ostrovosky's Pavel Korchagin, or Vasily Gubanov (the hero of the famous movie *Communist*, who worked shoulder to shoulder with death to keep an engine stoked), or a host of others were regularly throwing themselves into the Juggernaut's path.

Tellingly enough, the first demonstration of model Communist labor took place in 1919 at the Moscow Sorting Yard, at the very first *subbotnik*—when workers volunteered their Saturday (*subbota* in Russian) to repair some old engines. In its own way, the fact that this was a *subbotnik* has a great deal of meaning. We might (only half-jokingly) say that in early-Soviet

sacral time and space the Sabbath day holy service was replaced by engine service, a sooty and oily Black Sabbath. "The transportation system is on track," artists of revolutionary Russia (such as Boris Yakovlev) noted in their titles. Freight hauling was getting on track too—relocating the masses.

Children's ditties like "We're Traveling, We're Traveling, to Places Far Away" turned into real-life, grown-up games of train, with Charon collecting one-way tickets. The official foundation was laid; the semiotic one clearly stated.

Religious or mythological consciousness is hierarchical, and so there had to be a lead engine carrying a lead passenger. Such an engine was found and, as "V. I. Lenin's Funeral Train," was placed in a museum at the Paveletsky Terminal in Moscow. Not surprisingly, this head passenger also became the head Soviet corpse, and so the Bolshevik Juggernaut took on additional associations with Charon's ferry. Given the laws of mythological polyvalence (the tendency to draw together a variety of functions in the person of the chief divinity), the head passenger-and-corpse might also play the role of guide-and-ferryman—or fireman-and-stoker, the better to outrun any possible pursuit. The locomotive that served as the fireman-and-stoker incarnation of the leader was also turned into a museum piece. Engine No. 293, which in August 1917 had secretly brought Lenin back across the Finnish-Russian border (in his particular situation, quite literally the borderline between life and death), was mounted on one of the platforms at Leningrad's Finland Station. A Charon who had driven the death-dealing chariot-juggernaut of fortune and had stoked the fires of world revolution might indeed be one invariant of the locomotive myth—in other words, a strategy for Constructivist-mechanistic reworking of life.

The engineer himself might well be scared, as is the Kharms-like figure in an illustration from Poret's previously mentioned *Railroad* (we should also note that in the Russian words *Kharon* and *Kharms* the sound of the first four letters is identical).[28] The illustration accompanies the following text by Vvedensky:

Г 42762

ЦЕНА 10 КОП.

ЗАКАЗЫ и ДЕНЬГИ НАПРАВЛЯТЬ:
Москва, центр, Тверская, 48.
Главная контора издательства
«ПРАВДА»

Типография «Рабочей газеты». Москва, Сущевский Вал, 49.
Главлит № А—47002. Тираж 25.000.

M. Kuznetsov. From *Steel Horses* (M. Klokova). Moscow, 1930.

People, birds and animals—
Every one is scared . . .
Except the train.

In this tense and dynamic relationship with the machine, in this battle
for primacy, the machine well might win. And in that case the locomotive
became Grigoriev's *Devil's Cart* (*Shaitan-arba*). In some texts the locomo-
tive's live, chthonic origin was expressed immediately and directly, as, for
example, in Maria Klokova's *Steel Horses* (*Stal'nye koni*; Moscow: Pravda,
1930), with workmanlike illustrations by K. Kuznetsov:

Like a black dragon,
Like a wind blowing,
The train speeds through the forest. . . .
. .
Through open field
Roaring, whistling . . .
Get out of the road!

In this at times naked fear of the industrial machine turned archaic dra-
gon, the Constructivists are the heirs to the authors of the previous era,
proud fin-de-siècle Romantic-Gothic.[29] The locomotive might take offense—
at the shot fired by Zhitkov's unnamed enemy, for example—and, rather
than run away, answer with an explosion of its own and blow itself apart.
It is no accident that what happens then is portrayed as the independent
and logical action taken by the locomotive itself. Like a wrathful ancient
hero or a chthonic god whom humans have offended, the locomotive de-
stroys everyone around it and sacrifices itself—a sort of mini-apocalypse.
It "scattered the armor plate, the cab, the firebox, flung coal out of the
tender, pitched forward and fell onto the pitted bank." And "down the
embankment, in the unmowed ditch," lies the sinful vestal crushed under
its wheels, watching as if alive.[30] The theoreticians of Constructivism
explicitly proclaimed the onset of a new, neo-archaic or post-human

(essentially the same thing) era. The highest, suprabiological forms of life belonged to the machine. "We must learn to regard the machine not as something dead, something mechanical, but rather as something animate, organic, alive. Besides, the machines of our day are more alive than the people who built them," wrote A. Toporkov in 1921. Interestingly, this same author justifies his pagan, animistic attitude toward the locomotive in terms of legitimate, popular religious need:

> Only in the eyes of the uninitiated does it [the locomotive] rest immobile. In fact, its form is in constant motion: this form is alive, and the life of the form animates the dead matter of the machine. And therefore there is nothing false or random in the way people regard the machines they work with as human. The engineer who is proud of his locomotive calls it "Mashka," and for him Mashka is a living being with whom he shares his joys and his sorrows. This personification serves as a substitute for primitive animism and fulfills entirely legitimate needs.[31]

Even after Soviet society had existed for decades, the mythologeme initially built into it—the locomotive as a live being with its own mysterious and obstinate ways—remained current. Witness, for example, this passage from a Penza newspaper called *The Lenin Banner*: "The electric engine is a beautiful creature. Whose heart doesn't skip a beat at that intelligent gaze from under yellow brows, at the quiet rumble that reveals all its hidden might?"[32] The locomotive remained the emblematic representative of the great project, a metonym for all the stages along the great journey. During that period of disarray called the sixties (the Soviet regime was almost forty—a mid-life crisis), lines like this could be written:

I pity the train
Rolling back.
The smoke and whistle
Unrealized.[33]

Interestingly enough, the only people to express any sort of antilocomotive sentiment were the "crooked" ones: thieves and other criminals. They alone dared to *not want* the fast ride, as in this song out of prison-camp folklore:

Stop, steam-engine, don't clatter your wheels.
Conductor, put on the brakes.

But as we all know, the engine wasn't just standing around on the sidings. It was rushing "through the tundra, along that iron road" from another prison song—the "Leningrad-Vorkuta" route.

The locomotive mythologeme remained current even in the final phases of Soviet life. Popular Soviet children's songs sometimes portrayed the locomotive not so much as a means of transportation or of flight, but as a way to escape psychological discomfort:

If you've hurt someone for no reason,
 Let the calendar turn that page.
Let's move on to new adventures, my friends!
 Hey engineer, get up some steam!

This variation on an eternal motif—in this case, leaving not because you're hurt, but because you've hurt someone else—was rather unusual, but then again, in its own way, characteristic of Soviet pedagogy. The confidant and helper here was once again the engineer, the engine-tamer.

By the mid-1980s the image of the locomotive had descended into travesty. Along with all the rest of the basic elements of the Soviet text it had become a mass-culture cliché, the object of postmodernist manipulation and *sots-art*. Igor Guberman's poem might serve as an example:

Our engine onward flies
To distances aforesaid.
There is no other way to go
And that seems rather sad.[34]

Or, to take a text from the sphere of visual art, we might mention Zakhar Sherman's painting *Red Train on Diesenhof*—a specter of revolution stalking the main street of Tel Aviv, home to some of the nearly half-million Soviets who have emigrated to Israel.[35]

OTHER WONDERS, WITH WHEELS AND WITHOUT [36]

Production books of the 1920s featured numerous minor figures as well, these Constructivist *dii minores*—all sorts of vehicles and mechanical marvels. Masters of this genre were the previously mentioned Chichagov sisters,[37] Tsekhanovsky, Lapshin, Shifrin, and others.

Why did Constructivist-oriented artists have such a compelling interest in books on transportation and machines that move? One reason was their love of documentary precision, laconic composition, restraint, and, at the same time, flamboyant color and dynamic treatment of images. Powerful modern machines that could overcome space also spurred utopian illusions of unlimited power over physical categories like space and time. For example, in the Chichagov-Smirnov book *The Travels of Charlie Chaplin* (*Puteshestvie Charli Chaplina*) we see all manner of automobiles, steam engines, and steamships. The same authors produced *How People Travel* (*Kak lyudi ezdyat*; Moscow: GIZ, 1925), a history of transportation that begins with reindeer-drawn sleds and ends with the usual wonders of industrialization. All these compositions are lithograph prints—precise, flat drawings with flat mechanical color. The people in them are simply filler. Even when figures are in the foreground, they are geometrically simplified, their faces lacking any individuality. Or they may lack faces altogether. This approach to figures is typologically akin to Malevich's. There were, of course, differences (differences visible to contemporaries in the thick of things, but by now largely unnoticed). If for Malevich the abstraction of the random and the reduction of psychologism served to lay bare the essence of things, for the Constructivist schematization and primitivization meant a reduction of the complex to the simple, the multifaceted to the unequi-

145

ПОЕЗД.

Поезд катит сквозь лес и горы
Так быстро, что его никто не догонит.
Поэтому теперь из города в город
Каждый норовит проехать в вагоне.
Под колесами у паровоза—железная дорога
Сзади—вагоны разных классов.
Паровоз сильнее слона на много:
Он тысячу человек перевозит сразу.

vocally functional—to what worked, what was useful. In terms of plastic forms, however, all these builders were chips off Malevich's block.

There is no need to enumerate all the examples of books with schematized and compressed depictions of automobiles and other vehicles. There were fewer pictures of these than of locomotives, but a sufficient number nonetheless. We should, however, consider one aspect already touched upon—fear of the Machine.

Like its big brother the locomotive, the automobile in children's books of the 1920s was endowed with all the features of a living creature—a creature both frightening and dangerous. In Maria Klokova's *Steel Horses*, already mentioned in connection with locomotives, there is a poem called "The Steel Beast":

Galina and Olga Chichagov. From *How People Travel* (Nikolai Smirnov). Moscow, 1925.

The automobile, like an angry beast,
Runs on fat, soft paws;
Enormous eyes wide open—
A roar, a howl, a smell of smoke.

Thus interpreted, the automobile is no longer such a convenient and at-
tractive vehicle but some kind of mechanical beast of the apocalypse, smel-
ling of smoke to boot. To somehow coexist with such a creature, humans
must become less human, and K. Kuznetsov's illustrations show exactly
that. His passenger consists of flat geometric segments, assembled into a
whole somewhat like a hinged marionette. Then again, even people like
this might be better off keeping their distance from the machine, as the
author warns:

Hurry, out of the road—
Anybody careless gets run down.

The same sorts of warnings could be found in train books as well:

Look out, look out! . . .
Move aside! Off the road![38]

The title *Steel Horses* did more than simply reflect a familiar practice,
during the 1920s, of contrasting the mechanical with the biological, couch-
ing that opposition in popular terms. "Steel horse," meaning tractor, was
a commonplace in that era, and the automobile embodied "horsepower."
A horse or a colt cowering in fear by the side of the tracks appeared in all
sorts of visual texts of the time. Perhaps the best known is the picture by
Pyotr Williams (Vilyams) in *Auto Race* (*Avtoprobeg*, Moscow, Tretyakov
Gallery, 1930); a children's-book paraphrase of this image might be "horse-
drawn carts waiting at a railroad crossing." See also Gennady Shevyakov's
How They Made the Locomotive (*Kak delali parovoz*; Leningrad: OGIZ,
1931). And the tiny figure of a horse flickers through Nikolai Kupreyanov's
thoroughly urban landscape in Alexander Zharov's *Adventures of Fedya*

147

Rudakov (Moscow: GIZ, 1926). Here we might also mention Sergei Esenin's classically drunken image of the sweet and foolish colt who goes chasing off somewhere, unaware that the iron horse has already won the race—and the war.

Yet another automobeast puts in an appearance in Nikolai Shestakov's *Automobiles on Rubber Wheels* (*O mashinakh na rezinovykh shinakh*; Leningrad: Raduga, 1926):

The beast runs,
Moscow to Tver.
Glass eye,
Wooden rear.

It's hard to warm a mechanical beast's behind with a slap of the reins, so driving becomes more complicated, and the beast less willing to be driven. It's no longer horsepower and human pluck that drive the chariot. Again, something like Mandelstam's "angry motor" emerges. There is an interesting text relating to the drive, the owner of the beast:

The motor speeds the carriage on,
Up front sits the driver,
Spinning the wheel,
Squashing pedestrians.

In Dmitry Bulanov's wonderfully done illustration, the driver is made up of brightly colored pieces: leggings, shoes, checkered trousers, cap, and a multicolored mask instead of a face. He seems like a ritually painted priest engaged in some kind of ceremony (the squashing of pedestrians) aimed at propitiating the "angry motor." We might mention here, too, that at the very beginning of the revolution Trotsky liked to don a chauffeur's leather jacket and pose beside an automobile.

It would hardly be an exaggeration to say that training children to be cautious by teaching them the rules of the road scarcely required such

Dmitry Bulanov. From *Automobiles on Rubber Wheels* (Nikolai Shestakov). Leningrad, 1926.

an overdose of primal fear. Here, as in many other instances, children's books provided the perfect opportunity to express, in the guise of jolly and clownish verses, the not entirely conscious phobias of the full-grown "little man" scared to death of "social and technological advances."[39]

Let us return briefly to the deindividualized figure of the Constructivist production book. Here, as in man's relations with the locomotive or the automobile, he was less an easy rider than an easy—and frightened—target. He was neither owner nor consumer, but rather producer or servicer.

A revealing example is Olga Deineko and Nikolai Troshin's *How Beets Became Sugar* (*Kak svyokla sakharom stala*; Moscow: GIZ, 1927). The large-scale lithograph prints are done in two colors, orange and black. One picture after another is a triumph of ruler-perfect straight lines and compass-drawn curves. The only nonlinear bodies are the small human figures bustling about the levers and wheels. They look like pygmies along-side the monsters of beet processing. The sweet life was hard work for the new Soviet man.

A similar approach—humans in either production or service—runs throughout the Chichagov-Smirnov books *Everyone Does His Job* (*Kazhdyi delaet svoyo delo*; Moscow: Zemlya i Fabrika, 1927), *Where Dishes Come From* (*Otkuda posuda*; Moscow: GIZ, 1926), and *To Children, About News-papers* (*Detyam o gazete*; Moscow: GIZ, 1926). This is also true of Tsekha-novsky's many books. The artist did not hide his admiration for the beauty of constructions and industrial forms. A love for the object and a sensitiv-ity to its material and its structure can be seen in all of his work. He went about his illustrations with an engineer-designer's zeal and expertise. For example, in Mikhail Il'in's *Pocket Comrade* (briefly mentioned in an ear-lier chapter), he portrays his main character, the pocketknife (and all its features—blades, files, rule, etc.), with documentary precision, from vari-ous angles and points of view. Just as befits instructions for beginners, the process from the unfinished blank to the finished blade is shown—eight stages in one drawing. In Boris Zhitkov's *Telegram* (*Telegramma*) the dia-gram for Morse's telegraph apparatus is sketched, while in *Hurricane*

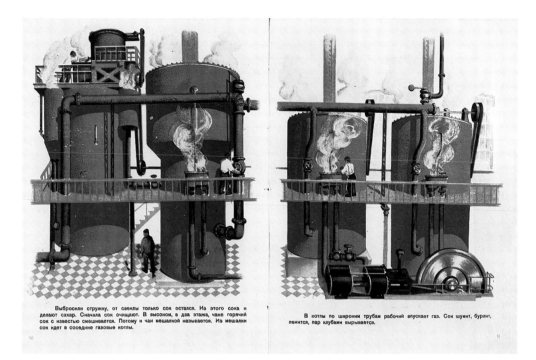

Выбросили стружку, от свеклы только сок остался. Из этого сока и делают сахар. Сначала сок очищают. В высоком, в два этажа, чане горячий сок с известью смешивается. Потому и чан мешалкой называется. Из мешалки сок идет в соседние газовые котлы.

В котлы по широким трубам рабочий впускает газ. Сок шумит, бурлит, пенится, пар клубами вырывается.

(*Uragan*; Moscow-Leningrad: GIZ, 1926), another book by the same author, Tsekhanovsky uses a Rodchenko-like montage of drawings, diagrams, and photographs.

In looking at Tsekhanovsky's production pictures one can see that his illustrations for children's books were part of the general upheaval in the aesthetic ideas and artistic culture of the time. This upheaval landed humans face to face with a world now calculated and changed by machines, a world with space that was both precise and subordinate to man, with time racing past ever more swiftly.

For artists of this circle of ideas, aesthetic mastery of the world was a mastery of things. It was "heavy, crude, visible" (using Mayakovsky's words). An analysis of the character of this "thingness" is quite revealing, because it eliminates the seeming contradiction between a lack of creature

Olga Deineko. From *How Beets Became Sugar* (Nikolai Troshin). Moscow, 1927.

comforts—the destruction of personal and intimate habitat—and the fixed attention focused on the object. Objects become fetishes not in their use, but in their manufacture. The factory-made object is the symbol of the new industrial society. Just look at the things (light bulbs, machine tools, locomotives) that we know how to make, and when there are more of them, everyone will start to live better. But until that moment when everything is built "on the whole and in general," the personal consumption of things (the products of society's labor) is to be regarded as something not entirely ethical. Here, we should recall these impressive lines by "the Soviet era's best poet" (as Stalin dubbed Mayakovsky) from *The Tale of Petya, the Fat Little Boy, and of Sima, Who Was Thin* (*Skazka o Pete, tolstom rebyonke, i o Sime, kotoryi tonkii*). The book came out in 1927, with illustrations by Nikolai Kupreyanov. The grotesque depictions of repulsive, profiteering Nepmen encouraged class vigilance on the part of the proletariat and loyal intelligentsia, and clearly demonstrated how they should regard the people who, given the advantages of the Soviet system, had turned those same advantages to personal profit.

For those actively engaged in the Constructivist re-creation of the world, the thing-as-such was good, in and of itself. Their reverence toward the machine was Platonic. The creation and promulgation of machines was a kind of art for art's sake. Therefore the object, for Tsekhanovsky and artists of that group, was a quotation from life, a cast and a document of life, a document alienated from both its producer and its consumer, a document in the public domain, untainted by personal greed. Hence the production books' factographic ("objective") precision, their starkness of design (approaching draftsmanship), their frontal orientation and total lack of habitat, environment—of lighting, depth, colorism. In Tsekhanovsky's work the object is pulled out of its habitat as well as its everyday operational context, and placed on the white field of a page, in a neutral display window. Children's books become sort of take-home VDNKh (the pompous Exhibit of the Achievements of the People's Economy—a kind of Soviet Disneyland for adults).

This quite specifically Soviet sentiment was noted by contemporary critics:

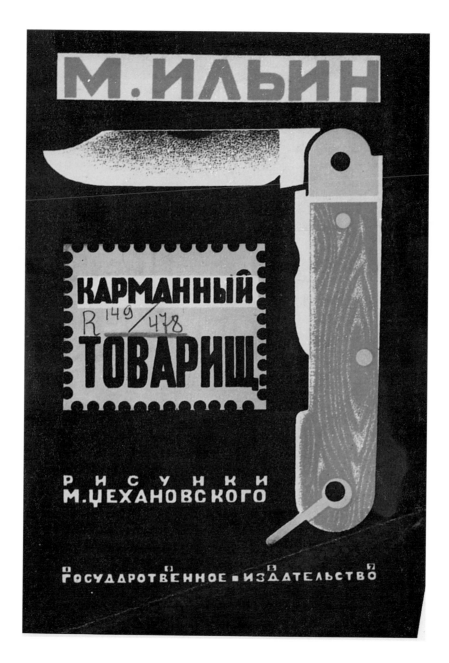

Mikhail Tsekhanovsky. From *Pocket Comrade* (Mikhail Il'in). Leningrad, 1927.

Factories, plants, railroads were being built long before this, but never before has this exciting sense of creating a new life been invested in the creation of material values. Because of this a new meaning has been revealed in things themselves, in the production process, things have been invested with an emotional tone, one put into them by man, who now approaches them in a new way.[40]

What has happened is an exchange of means for ends. The abstractly promoted ideals of the bright future were so distant, so vague, that what became the concrete representation of this future was the individual object itself, the designated harbinger of the new life. Take, for example, that exhibit catalogue/thesaurus of new Soviet things—Marshak and Lebedev's *Yesterday and Today* (*Vchera i segodnya*). On an official and ideological level, the theory that the construction of means of production took priority over all else supported the notion of "production for production's sake." Children's books served as visual propaganda for the coming materialist paradise in that they depicted all manner of mechanical-electrical components thereof. This propaganda mission was fundamental to nearly all the books we have examined, however different from each other they might have appeared—from Marshak's *Seven Wonders* to, say, Boris Uralsky and Alexander Deineka's *Electrician* (*Montyor*; Moscow: GIZ, 1930).

In the latter book, the central place in one of the half-page illustrations is taken up by huge lamps positioned like man-made suns lighting up the workdays of the new era, illuminating the factory buildings with their smokestacks and thick, impressive smoke. Another illustration shows an electrical worker on a power pole, arms spread-eagled as if he is hovering in the air. Then again, his pose could hardly be termed free flight, since he is crisscrossed several times over by wires that keep him from either falling or flying away. This composition now might be taken as a symbolic illustration of Lenin's dictum that Communism is/was indeed not only Soviet power but the electrification of the entire country.

This particular book was of course not the only one on electrification. There is, for example, the Smirnov-Chichagov collaboration *Egor the Elec-*

trician (*Egor-montyor*; Moscow-Leningrad: GIZ, 1928), with photographs by Zubkov. It begins with a country lad, a fisherman, suddenly discovering that his river—water, fish, and all—has somehow vanished. Egor's search leads him to the city, where he learns that all this has happened because of a dam built to produce electricity. He is shown all sorts of electrical marvels, and upon returning home to the village decides to let there be light, but short-circuits everything instead. After some more or less harmless jokes at the expense of the country bumpkin, everything gets back to normal—except for the fish, who are never mentioned again. The photo-illustrations to the book overlay a yellow (sunny?) background.

It was no accident that the builders of the new world were so enamored of electricity. The production of electrical energy was a liberation from inert and disorderly nature. "We expect no grace from nature, we must take it ourselves" (said the famous Soviet agriculturalist Ivan Michurin); and so on, according to the text.

Khlebnikov and others had proclaimed their victory over the sun back in 1913—their answer to the call issued by the previous generation (their fathers and rivals) to "be like the sun," an expression of Konstantin Balmont, Symbolist poet and brilliant *gentilhomme*. The younger poets "loosed an arrow straight at the sun" (Nikolai Gumilyov) and, then, once 1917 was behind them, dubbed it an outright "freeloader [*darmoed*], lolling in clouds" (Mayakovsky). Even before this, Malevich was describing a machine that with the help of electricity could "gobble up the sun." Appearing in the wake of the Futurist-Suprematists, the Bolsheviks also declared themselves the "power of the future" and sought to replace the class-neutral orb with "Ilich's little lamp"—the light bulb. A man-made source of light could be manipulated at will; it could be turned off, or perhaps left on all night in, say, the cells of enemies of the people. The Party, replacing the Old Testament demiurge, proclaimed "Let it be the Light," and announced that "Communism is the Soviet Power plus electrification of the whole country." To fulfill this statement, they had one hand on the throat of the epoch and one hand on the switch. The illuminati of the toiling masses were none other than the electrical linemen perched high atop their poles.

На Днепре сигнал горит —
Левый берег говорит:

Заготовили бетона
Триста тридцать три вагона.
Девятьсот кубов земли
На платформах увезли.
Просим вашего
Отчёта:
Как у вас
Идет работа?

Gennady Shevyakov. From *The War with the Dnieper* (Samuil Marshak). Moscow, 1932.

Marshak's *War with the Dnieper* (*Voina s Dneprom*; Moscow, 1932), a book famous in its own time but now prudently not mentioned, is also connected with the general enthusiasm for electricity. In it, the re-creation of the world in a Communist mode is expressed in victorious communiqués like:

Where river reeds once rustled
Now the engine runs.
Where fish were plashing yesterday
Dynamite blasts rock.

Gennady Shevyakov's illustrations suit the text. They are extremely dark, with a great number of machines, a great deal of smoke and fire, and tiny workers. The final illustration, depicting the bright future, is also quite telling—it is pathologically dark, with steam engines and steamships shuttling back and forth against a pitch-black sky.

In Shevyakov's pictures the pure Constructivism of the early twenties is diluted by OST-style creative sentiment. This is logical enough, since the illustrations were done rather later, at the end of the decade. By this time Constructivist building was spreading to the masses, taking them over, all the while being emasculated and adapted to the point of total transformation into the next stylistic phase—"Stalin's empire."

The artists of OST, who serve as a bridge between the acute phase of early Constructivist Sturm und Drang and the imperial pomp of the thirties, left some interesting traces in children's book art as well. Their most important work was in the depiction of the heroic, industrial pathos of time accelerated by human effort, of the dynamics of a life consisting of creation and the conquering of all obstacles. Machines and mechanisms in motion, or the world as seen by a person in motion—acute angles, quick rhythms, and ever-changing plans and arrangements—form the compositional basis for Deineka's *In the Clouds* (*V oblakakh*; Moscow, GIZ, 1932) and *Red Army Parade* (*Parad Krasnoi Armii*; Moscow: GIZ, 1932), as well

as Shifrin's *Here Comes the Train* (*Poezd idyot*; Moscow: GIZ, 1929) and
Moscow Is Being Built (*Moskva stroitsya*; Moscow: GIZ, 1930).

Plots connected with air travel (planes, dirigibles) and with the Red
Army appeared sporadically in the twenties; in the thirties their numbers
drastically increased. One such book from the second half of the twenties
is *Air Ships* (*Vozdushnye korabli*), with linocuts by D. B-ov (Dmitry Bu-
lanov). It combines three-color primitive/primitivist illustrations, and their
typological counterpart in verse, with swashbuckling Red Army content
like that once found in ROSTA window posters:

> Our work is peaceful.
> The world is wide.
> But the bourgeois maw is greedy.[41]

> Just let our flotillas show up
> And the "misters" flit away,
> Recoiling helplessly:
> Frightened, scared off,
> Run down, chased off
> By our wonder-planes,
> Our avio-herd.[42]

This view from above—at every possible tilt and angle—is also used
in V. Tvardovsky's illustrations for *Parade* (*Parad*), in a late (1930) Raduga
edition. His even ranks of soldiers and sailors, rising and falling like a
wave, are reminiscent of the columns of fighters moving out in Petrov-
Vodkin's *Death of a Commissar*. Caricatured bourgeois foes or brave sailor
lads disappearing over the horizon, though, ceased to figure in illustrations
of the latter half of the thirties. The mood had turned austere. Books featur-
ing parades became uniformly pompous, and now new characters were
making an appearance:

Portraits fly up to the clouds
That's Stalin up above you.[43]

But back to the apotheosis of everything mechanical and moving. The delight in a world filled with locomotives, steamships, streetcars, and autos, a world that never stood still, inspired a number of books about mail and mail carriers, among them Marshak and Tsekhanovsky's famous and frequently republished *Mail* (*Pochta*; 1st ed., Moscow-Leningrad: GIZ, 1927).[44]

The book is packed with movement: the letter whose story it tells rides on wheels, flies through the air, speeds around the world in pursuit of its addressee. The illustrations are composed as a montage of separate frames.

Dmitry Bulanov. From *Air Ships* (S. Vasa). Leningrad, n.d.

The envelope appears on various pages, each time with new postmarks, address corrections, stickers. The impression is of a single time-flow during which, fixed as fragments within that time, all the spatial relocations occur.

The visual texture, the *faktura* of Tsekhanovsky's *Mail*—this tale of a modern journey—expressed the artist's attempt to move beyond the usual fragments of stopped movement and interrupted moments in time. In the spirit of the general formal experimentation of the day, Tsekhanovsky tried to fill his works with real movement. The artists switched from book illustrations—with their conventional dynamic rhythm of a comic strip, in which the action is forcibly split into single-page compositions, moments of stasis—to what were called "movie-books" (*kinoknizhki*), flip books. These were printed on heavy stock. The same objects were drawn on each page, but were changed ever so slightly—made larger, for example—as if in separate phases of motion. Quickly turning the pages created the effect of animating the picture, the approach of a train (*Poezd*; Moscow-Leningrad: GIZ, 1927). This was cinematography without the camera, projector, or film—the pre-cinematic stage of cinema. From these flip books it was only one more step to kinetic art itself, and Tsekhanovsky eventually took that step. He moved on to animation.

His first experience with film—the transfer of static phases of movement onto a roll of film—was an animated version of *Mail* (1928), and brought him international renown. The conventional angular and mechanical quality of his flat, hinged marionettes, unavoidable in this method of animation, was not a drawback. As we noted earlier, it amounted to an artistic language in its own right. We might just add in conclusion that this mechanical quality, with the stop-motion jerkiness typical of the formal language of progressive Soviet art of the Constructivist-OST sort, was equally characteristic of certain contemporaneous tendencies in Western art. Oskar Schlemmer's "artistic machinism" was a declaration of this on the theoretical level.

The theme of socializing what was private, and industrializing what was handmade, the theme of depersonalized equality, was nowhere so clearly, frighteningly, and fully manifested as in the books about the so-called kitchen factories. Specialized books bearing this name are relatively few (compared with the number about locomotives, for example), but the theme of the Socialist food factory comes up in many books on quite diverse topics.[45] Thus in Esfir' Papernaya's *How the City Was Built* (*Kak postroili gorod*; Leningrad, 1932), with an interesting mock-up constructed by A. Poret and L. Kapustin, a mass kitchen appears just after the "glass factory."

The avant-garde project of freeing women for the tasks of socialist society-building required that they be freed from managing the household. Moreover, this household, this private, well-ordered family routine, was perhaps the chief obstacle to the formation of the deindividualized new man who was to fit into the pattern of regulated and typified behavior. Of course, the new social realities—communal apartments and the kitchens that went along with them—were a far cry from the traditional forms of private life, and to a certain degree their presence (that is, the absence of normal kitchens) stimulated the aggressive propagandizing of mass kitchens. And the public ingestion of food that was always served at the same time, by the same brigade of public nutrition experts, corresponded to the sense that the nation was a single, unified military camp, surrounded by enemies.

A yearning for real, homey kitchen warmth sometimes did find its way into children's books—but primarily in texts by authors already out of tune with the general chorus. Mandelstam's *Kitchen* (*Kukhnya*), coauthored with the artist V. Isenberg (Leningrad: Raduga, 1927), is a private world, the home-making fantasy of a homeless man dreaming of warm, homey smells: "We'll sit awhile in the kitchen, you and I / The white kerosene smells sweet. . . ." In an early article on the Symbolists, Mandelstam had remarked, "The pot does not want to cook the kasha." Their pot had wanted to cook up something exclusively symbolic and sublime; in the

Шесть тысяч рабочих! А у каждого еще есть семья, дети. Кто
накормит столько народа? Фабрика — кухня. Она готовит десять
тысяч обедов, завтраков и ужинов в день. А для детей еще от-
дельно — повкуснее да поздоровее. Вот это так кухарка!

Alisa Poret and Kapustin. From *How the City Was Built* (E. Papernaya). Leningrad, 1932.

Constructivist-Soviet project the pot categorically refused to cook anything at all:

> I'm tired of cooking,
> Frying, baking, boiling,—

says the kitchen stove in L. Borisov's *The Foolish Stove* (*Glupaya plita*; Leningrad: Raduga, 1925; illustrations by Yuri Cherkesov). Then again, in 1925 the masses were not yet won over to the idea of industrial-style food intake. Borisov's stove was "foolish" and its situation was in the final analysis unenviable, typologically similar to that of Pavlovich's gadabout engine.

But soon enough, the idea of the stove's self-emancipation from its natural purpose acquired a certain legitimacy on the government level. After all, it merely corresponded to the idea of socialist emancipation for women. In conformity with the global destruction of the old world, the private, individual-family household had to be destroyed as well.

> Let the housework go to pot:
> This kitchen is a wonder—
> > It cooks,
> > It fries,
> It serves the meal,
> Housewives haven't got a care.[46]

Under these verses in Orsky's *The Wondrous Kitchen* (*Chudesnaya kukhnya*), Boris Pokrovsky's picture shows a multitude of enormous tables inside an enormous hall; at them, in tidy rows, sit emaciated antlike little figures.

For the pauperized proletariat and their bards, these mass kitchens, with their massed, enormous electric kettles, represented a magical horn of plenty, or the magic tablecloth of folktale that both served the meal and cleared it away. Such burning interest in "a cook to feed the whole town"

could arise only in a half-starved country that, lacking bread, had need
of mythological bread substitutes.

> But papa's made a promise—
> That there'll be some kind of kitchen
> Without cooks,
> One that serves up meals
> For thousands, by itself. . . .

Tellingly enough, this edition of *The Wondrous Kitchen* is extremely
poorly produced.[47] For the utopian consciousness, the poverty of the real
thing merely sets off the grandeur and magic of the dream, the magic pot
that never runs out of kasha, with plenty for all. The technological equiva-
lent of this endlessly flowing stream of kasha was the ribbon of conveyor
belt that rolled meals out of the kitchen to the food-intake area.

Shevyakov's black and white illustrations for *A Cook to Feed the Whole
Town* (*Povar na ves' gorod*) are rather ordinary and uninteresting, but the
colored book jacket brings to mind Lissitzky's Prouns. The artist's indus-
trial food factory is represented by geometric constructions with unbroken
surfaces, solid reds alternating at times with gray. The rectangles, curves,
and extended verticals combined with the rhomboid arrangement (i.e.,
dominant diagonals) of the composition appear to be a precise reproduc-
tion of a Constructivist principle—the Proun.[48] And it is characteristic that
here these small, black, human figures, included solely to define the enor-
mous scale of construction, make it hard to believe that in this new world
a process as intimate and domestic as eating is possible without a good
deal of psychological distress and intestinal dysfunction. In essence, in
these illustrations (which of course simply conformed to architectural and
life-building projects as such) kitchen factories look like just plain facto-
ries, or factory shops. Humans working on a conveyor line take up, on the
scale of the whole, roughly the same space as the ones sitting at a mass-
kitchen lunch table.

The most consistent Constructivist illustrators even depicted private,

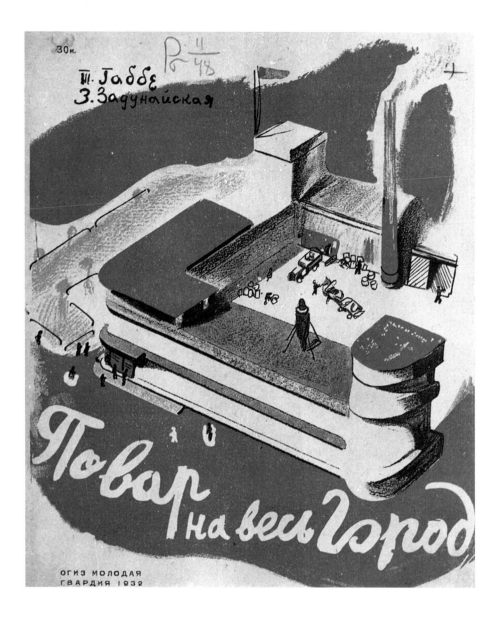

Gennady Shevyakov. From *A Cook to Feed the Whole Town*
(T. Gabbe and E. Zadunaiskaya). Moscow-Leningrad, 1932.

Примус, друг людей прилежный,
Всё шумит себе, шумит.

Nikolai Lapshin. From *Our Kitchen* (Nikolai Chukovsky). Leningrad, 1927.

home kitchens as production shops. Nikolai Lapshin, in his pictures for Nikolai Chukovsky's *Our Kitchen* (*Nasha kukhnya*; Leningrad: Raduga, 1927), reduced the interior decoration and all the kitchen utensils to a geometric line diagram drawn with ruler and compass. The kettles, oven forks, and pots are shown in multiples, lined up in strict rows, front-facing and lifeless. The slab floor and tile walls are done in checkerboard pattern. Against that background, at a projected point corresponding to no real location, are a sieve and a poker, so starkly drafted that they are difficult to identify. There is not even a hint of anything human in these compositions. The kitchen is as lifeless as if all the air had been pumped out of it. The hieratic ceremoniality of these even rows of two-dimensional pots (or rather, icon *images* of pots) makes one indignantly reject the thought that something raw or messy might be put into them. Nor do the pictures really conform to the text, which, for all its made-to-government-order clumsiness, features characters who care about people and don't shun work ("Our primus stove, the people's friend / Diligently hisses").

These lines are accompanied by a large illustration that depicts neither people nor diligence nor hissing (therefore what Lapshin contributes might be more appropriately termed not an illustration but an independent work): the schematically rendered primus is sterile and cold. In such a stove, kerosene can hardly smell sweet. These visual objects (and the rest of Lapshin's as well) superbly illustrate the Constructivist's Kantian, disinterested admiration of the primus. Cooking on such stoves would be almost as blasphemous as satisfying one's sexual needs by contemplating some fleshy "Bather" in a golden frame. The sacralization of factory-made, ordinary material things was the flip side of the Russian intelligentsia's notorious scorn for creature comforts. Never to sully an idea with personal greed, and to live catch as catch can—this was the strategy implicit in the life-building project undertaken by pure (of heart, at least) avant-gardists and Constructivists, the legacy they inherited from the *raznochintsy*, those revolutionary dreamers with cracked leather boots[49] and tea saucers full of cigarette butts.

ВТОРОЙ
ЗАКОН

Мы идем за рядом ряд,
Юных ленинцев отряд.

В бой готовый
К ним пришел
Сменой новой
Комсомол,
Чтобы старым
 Коммунарам
 Отдых дать,
И удар
За ударом
Шар земной перековать.

Бодрым маршем,
Дружно в ногу,
Братьям старшим
На подмогу

Комсомольцу младший брат,
Пионер вступает в ряд.
Мы идем на смену смене.
Нас ведет товарищ Ленин.

CONCLUSION

A s we now know from a variety of sources, the ideological reach of theoreticians of the new life, for reasons that need no explaining here, rather did exceed their grasp of the social and practical situation conventionally known as reality. Nor did this new formal avant-garde language of art act upon the masses in such a way as to evoke the hoped-for immediate reaction; nor did it bring forth any tangible socioeconomic fruit. Actually, it did bring forth something—but hardly what the artists expected.

The children of the 1920s barely had time to learn from their books how-good-it-will-be-when-things-are-good, when the brave new world arrived. With the onset of the 1930s, the particular character of the past decade's artistic forms, the profound semiotic quality that expressed itself in the metaphor and visual symbolism of primary, utterly simple color and line images, became an absolute anachronism. The new Soviet political leadership and apparatus needed artistic

legitimization of another sort—a utopian project that would not be rele-gated to some bright future, but would serve as a sacralization of the pres-ent, the new imperial age.

There is a subjective factor at work here. That cultural policy (within artists' groups and unions as well as without) was now being conducted by a different sort of person, by workers promoted up through the ranks, people with grade-school educations, utterly unspoiled by any idea of aes-thetics, but who had the lackey's powerful hankering for the high life. The techno-mechanicophilia of the artistic "left" was, in addition to its other sins (the penance for which would be paid in the thirties), something asso-ciated with the *intelligentsia*. And the intelligentsia had been sounding the call for the simple life for so long (the Constructivists had put that moral-ist cri de coeur on a formal and stylistic footing) that it finally had some effect—union-wide, of course (Union of SSR). They were shouted down. The new stage of Soviet mythological consciousness—a consciousness now grown strong and aware of that strength—demanded not ascetic, revolutionary, rectangular simplicity, but the trappings of empire. The locomotive was already well praised, the steel rails to Soviet mentality well worn. It was time to focus on the engineer. The Constructivists, un-comfortable drawing a real person with a real face, were ill-suited to the fast-approaching era of the personality cult.

The necessity of drawing faces, something even the most devoted fol-lowers of the Constructivist canon could not always avoid, resulted in works that were internally inconsistent and artistically (therefore politi-cally) unconvincing. Tsekhanovsky, characteristically, expressed this more graphically than anyone else. One composition in L. Savelyev's *The Pio-neer Charter* (*Pionerskii ustav*; Moscow: GIZ, 1926) shows not just the usual faceless mannequins marching in ranks or digging foundation pits, but also a red banner with a portrait of the leader (in 1926 this was still Lenin, not yet Stalin) placed over them. Lenin's features are of course done in standard, painterly brush strokes. This is in marked contrast to the rest of the human masses in the book. Within the framework of this formal sys-

tem, the leader looks not so much outstanding as out of place. The uneven features beneath the trademark cap clearly suffer compared with the meticulously drafted, abstractly perfect Constructivist figures.[1]

The thirst for absolute perfection, which found its fullest visual embodiment in the Constructivist project, was a revelation, a laying bare of the idea that the human condition as such was an incomplete and unfinished thing. Utopian-schizophrenic ideas[2] of the omnipotence of "right theory" were invoked to straighten out human nature (in book design this was done visually and graphically—with the aid of a ruler and a plumb line).[3] That is, the avant-garde poetics of visual form were the most fully manifested and consistently realized expression of a greater avant-garde utopian strategy—to move beyond the limits of the human. But in the new stage of project implementation, this de-anthropomorphized image was replaced by the sacralized, the sacred, icon. As had happened once in an earlier empire (Byzantium), the radicals and iconoclasts went down in defeat because they were too consistent, too elitist and abstract. The imperial icon-worshipers, who enjoyed popular support (be it in Byzantium or the Soviet Third Rome), needed visible forms to venerate and imitate.

Therefore, from the leadership's point of view (a leadership not nearly as stupid as the Soviet liberal intelligentsia later depicted it), it was perfectly natural to discern, beneath the buzz of ultraloyal slogans and superlatives, a supra-informative "political threat." There was talk of this as early as 1931, in a Central Committee resolution from December 29 of that year, "On the Molodaya Gvardiya Publishing House." In this first of many devastating resolutions on literature and the arts it was announced that:

> The Central Committee has pointed out the publication of a number of works constituting a political threat . . . and to the production of books which do little to facilitate the cause of education, mobilization and organization of young people around the task of economic and cultural construction and Communist education. The Central Committee has noted in particular the low level of

both ideology and artistry in pre-school and school-age literature, and its unsatisfactory technical design (illustrations, printing).[4]

It is curious to note in passing that illustration (i.e., graphic art) was something the Central Committee of the ruling party relegated to the province of technical design. But in principle one should not be surprised (as for so long the honest intelligentsia seemed surprised) that those very authorities for whom the artists and writers had given their poetic all were now so rudely and peremptorily attacking them. There is of course a bitter irony in the fact that the Constructivists, who had shouted "left, left, left"[5] with all their creative might, who had created a revolutionary avant-garde language worthy of the great social revolution, ended up constituting a "formalist threat" to the people. Therefore, in the art world, when as a guarantee of social consolidation the Party resolved to permanently cut off those members now found to have betrayed the general cause, this meant the "formalists."

As early as the second half of the 1920s the "child experts" had begun clamoring for realism with no frills. Their own quite childlike lack of sophistication was in part supported by experimental observation done in children's homes and kindergartens. Such research had concluded that the children of the proletariat had no time for any intellectual namby-pamby, production-oriented or not. So when, for example, after a reading of *Alyosha's Galoshes*, the teacher asked, "Did you like the story?" the children shouted their answer: "No, we didn't, read us something else. Read something about Lenin."[6] New times, new songs.

About internationalism. In children's books of the twenties, avant-garde infantilism, already noted in the Introduction, manifested itself twice over: first, in the identification of blacks and other indigenous "children of nature" with children in general; and second, in the identification of those groups with the working class. The consciousness of all three was equally (though variously) mythic. This, on the one hand, set the colonized natives, children, and workers apart from the rationalist mentality dominant in

Western societies in the nineteenth century, and, on the other, united the three among themselves. Hence was born the conviction, based on unreflexive faith, that "Children of all tribes and nations / Are for the workers and the peasants!" (*The Pioneer Charter*).

Purposefully created social mythology allotted to workers and peasants the role of a newly born, pure revolutionary force ("For theirs is the kingdom of heaven"). Accordingly, children as such (but especially childlike children, so to speak—the many-colored ones) were typologically related to the builders of the new world, themselves "born of the storm." Given that, ideologues of the Children's International (that is, a junior Comintern) felt well within their rights in declaring: "With us stand Africa and Asia, / Look out, Bourgeoisie!" (*The Pioneer Charter*).

This combining of utopian avant-garde mentality with non-Western and archaic mythological traditions is revealing.[7] By the time ten years or so had passed, Soviet mythology was more or less firmly ensconced in mass consciousness, and its primordial simplicity might be softened and tricked out in Western bourgeois tinsel without much danger to the core myth itself. At the beginning of the 1930s the organic rejection of left-wing revolutionism by bureaucrats who had come to power as a result of the great Stalinist changeover had taken on the character of a guide to action. The above-mentioned Central Committee resolution went on to say:

> The children's book must be lively in true Bolshevik fashion—
> a call to arms, a call to victory. The children's book must demonstrate, in vivid and image-laden forms, the socialist re-making of the nation and the people, and educate children in the spirit of proletarian internationalism.[8]

These commandments sound strange if we take them literally and simultaneously keep in mind the avant-garde, Constructivist basic text that they embodied to a very great degree. Our puzzlement disappears, however, when we understand that the Party resolution was talking about what

173

were essentially questions of form. It was an argument over style, and in such cases yesterday's faithful comrades-in-art are always the first to be censured.

The situation in children's literature was identical to the one that had developed in all the major arts at the beginning of the 1930s. After the resolutions on the unification and centralization of literature and art, a specifically new phase of avant-garde style emerged. The stiff-necked old guard of young artists changed also, but not so quickly as to keep up with the poetics of the general line, the sentimental-heroic Socialist Realist *lubok.*

There followed on December 9, 1933, the Central Committee resolution "On the Publishing of Children's Literature," which stated that "the flaws in children's books noted in a number of Central Committee decisions have not yet been eliminated."[9] And so a directive was issued "consolidating children's publishing into a single children's publishing house," which would "make decisive improvements in design, rooting out shoddy hackwork and formalist frills."

We should note that although the hackwork and frills were indeed being eradicated (thus Vera Ermolaeva, arrested in 1934, died in a camp near Karaganda in 1938; and thus, one after another, her Oberiu comrades and many others quitted art and life alike), noxious patches of anachronistic artistic thinking did occasionally crop up. In 1936, such a recurrence prompted an editorial in *Pravda* titled "On Artist-daubers" (March 1)— that is, Vladimir Lebedev and artists of his circle. Lebedev managed to reconstruct himself, and survived. The "building" of his drawings (an expression he used in the twenties) turned out to be flexible enough to stand some radical rebuilding. His later work—plump, smarmy little girls and striped kitty-cats—bore no resemblance to his poster sailors or his flat, chopped-up giraffes.[10]

Characteristically, as much as three years before the appearance of the article, Lebedev had painted a major series entitled *Girls with Bouquets* (*Devushki s buketom*). These girls are strikingly different from his "ballerinas" of the twenties. The new series was a representation (and presentation) of the ample, thick, and bulky body—the mature-socialist body. These

champions (more society's than sports') personified the hieratic statuesque-
ness of women athletes "ready for labor and defense," the new imperial
pomp and classicism.

At this point we may consider that the revolutionary Sturm und Drang
in Soviet children's publishing is over. A renewal, or rather a dialectical
return to the best (that is, archetypal) in 1920s book design, began in the
early 1960s. Back then, when everyone truly and timidly believed that
things had been fine until big bad Comrade Stalin came along, turning to
Russia's own revolutionary avant-garde for inspiration seemed a return to
the source, from which point one could go on and on and on.[11] Moreover,
the "severe style" of Soviet art during the Thaw coincided with a modified
recurrence of Constructivism in Western art at the beginning of the 1960s,
which also had a certain influence on the art of the Khrushchev era. But
that's another topic.

And so, the great artistic-aesthetic experiment of the 1920s, which found
perhaps its fullest, most clearly articulated expression in the art of illus-
trating and designing children's books, did not bring these artists what they
had fought for. Or perhaps it did—only the reality of what they fought for
turned out to be more awful, more merciless, dirtier and uglier than the
Constructivist design for the future. It would be historically wrong to think
that all this was destroyed by a bunch of stupid and malicious ignoramuses
suddenly come to power. Such an end was only natural, and perhaps under
different conditions it might have come gradually, and less bloodily. It was
natural, for the glorification (ambivalent and fearful as it might be) of the
machine, of the diagram, the plan, of headlong forward motion, could not
help but bring about a devaluation of simple, old human values.

Scarlet flame—
Dawn's in the sky . . .
The time has come
To march to our camps!

sang the Komsomol poet Alexander Zharov in the mid-1920s. His song was

indeed titled "To the Camps." The time came soon enough, and it was not the Pioneers' bonfires but the campfires of the Soviet inquisition that lit up the "indigo nights," the "clear dawns," and the "shining paths," consuming the children of the workers and the people, children who had grown up on revolutionary-production picture books and never did understand just what was happening. But that fire (the one over all the earth) was an awfully big one. And it needed a forest to stoke it, and wood chips too.

The "leftist" artists of the 1920s, who had undertaken to design an era, ended up like Kafka's inventor. They became, in their turn, just fodder for their own execution machine. What they did was inarguably more interesting, more progressive, and more in tune with the times than anything else in children's literature. It's a pity it turned out the way it did; more's the pity it happened at all. Then again, to think that way is to be small of spirit and ignorant of history. It's hardly likely that way what *was* was always reasonable (Hegel). But it *was*. And now, looking at these faded pictures, one can reconstruct both the formal gains and the ethical-philosophical losses of this late, great, and ultimately failed social and artistic experiment.

BIOGRAPHICAL NOTES

ARTISTS

Natan Al'tman

1889–1970

One of the leading masters of the Russian avant-garde. Born in Vinnitsa (Ukraine). In 1902–7 studied at Odessa Art School. In 1910–11 lived in Paris and attended classes at the Free Russian Art Academy. In Paris met Marc Chagall, David Shterenberg, Alexander Archipenko, and many other Russian avant-garde artists. From 1912 lived in St. Petersburg. In January 1918 was appointed a member of the Arts Board of the People's Commissariat of Enlightenment (Ministry of Culture and Education), and that year became director of the Department of Fine Arts at the Commissariat. Concurrently was appointed director of the Museum of Artistic Culture. In 1928–35 lived in Paris. During the 1920s made many illustrations for children's books: N. Vengrov, *Beasties* (1921); N. Aseev, *"Redneckie"* (*Krasnosheika*, 1926); M. Brook (Bruk), *Our*

Thirteen (1928); V. Mayakovsky, *For Children* (1936); M. Zoshchenko, *Clever Animals* (1939); and others.

Dmitry Bulanov

About 1890-mid-1930s

Worked in Petersburg-Leningrad as a poster artist and book illustrator. Apart from a small number of children's books (usually signed D. B-ov), some posters and graphic advertisements survived after his untimely death in Stalin's purge.

Sergei Chekhonin

1878–1936

Born in Novgorod province. Before 1928 lived in Petersburg-Leningrad. Studied under Il'ya Repin at the Tenisheva School (1897–1900), and worked in porcelain and ceramics. In January 1918 was appointed a member of the Arts Board of the People's Commissariat of Enlightenment. In 1918–23 headed the Art Department of the State Porcelain Factory. In the 1920s designed and illustrated dozens of children's books for Svetozar, Raduga, Gosizdat, and Zemlya i Fabrika publishing houses. From 1928 lived in Paris. Died in Lörrach (on German-Swiss border). Principal children's books: *Fire-Bird* (*Zhar-ptitsa*, 1911, his first); *Fir Tree* (1918, with V. Lebedev, M. Dobuzhinsky, Yu. Annenkov, et al.); S. Marshak, *A Book for Children* (1922), *Theater for Children* (1924), and *A Book about Books* (1925); M. Pozharova, *Sun Bunnies* (1924); S. Poltavsky, *Kids of Many Colors* (1927); K. Chukovsky, *A Cockroach* (1923), *Fifty Piglets* (1924), and *Little House*, *Bunny*, and *Fire-red and Crimson-red* (all 1927).

Galina and Olga Chichagov

Galina (1894–1967), Olga (1889–1958)

The Chichagov sisters were born in Moscow. The elder, Galina, studied art in the Stroganov School of Industrial Art (1913–17); both also studied in 1920–24 at VKhUTEMAS (Higher Art and Industrial Studios, the former School of Painting, Sculpture and Architecture). In 1922 they won a contest for the revolutionary decoration of Red Square (the project remained unfulfilled). From 1923 they worked in the field of design and illustration of children's books. The two of them were among the founders of the production type of Constructivist books. In the late 1920s and early 1930s they participated in international book exhibitions (Leipzig, Cologne, Paris).

Olga Deineko

1897–1970

Born in Ukraine. Studied in VKhUTEMAS with Vladimir Favorsky (1919–23). Worked as a graphic artist and designer. In late 1920s and early 1930s illustrated children's books in the production genre. Died in Moscow. Principal books: N. Troshin, *How Beets Became Sugar* (1927), *How Cotton Became Fabric* (1929), and *From Rubber to Galoshes* (1930).

Georgy Echeistov

1897–1946

Born in Moscow. Studied at the Stroganov School of Industrial Art (1912–19) and VKhUTEMAS-VKhUTEIN (1924–29). Worked as a book illustrator and theatrical designer. First children's book published in 1923. Lived and died in Moscow. Principal children's books: V. Il'ina, *Chocolate* (1923) and *Winged Adoptee* (1923); *The Story about Geometric Figures* (1925, not published); R. Akul'shin, *About Girl Marishka, Her New Coat, an Awful Pig and Red Star* (1927); O. Gur'yan, *Akhmet and the Vegetable Garden* (1927); N. Vengrov, *Chiriki-Puzyriki* (1928); A. Barto, *Little Brothers* (1929); V. Bianki, *Whose Feet Are These?* (1930); and others.

Boris Ender

1893–1960

Born in Petersburg. In 1905–7 studied in the private art studio of Ivan Bilibin. After the October Revolution studied in Free Art Studios in the classes of Petrov-Vodkin and Malevich. In 1919–21 was a member of Mikhail Matyushin's Studio of Spatial Realism. Created abstract compositons. In the 1920s worked as a research fellow in the Institute of Artistic Culture. From the 1920s worked in children's books.

Vera Ermolaeva

1893–1938

A principal figure in the art of Soviet children's books. Born in Petrovsk, Saratov province. In 1910–14 studied in Petersburg in the School of Drawing, Painting and Sculpture run by M. Bernshtein. In 1918 organized the workshop Today, which produced children's books. In 1919 was appointed director of the Institute of Practical Arts in Vitebsk. Was one of the founders of the avant-garde group UNOVIS. From

1922 worked in Petersburg in the Institute of Artistic Culture. From 1927 worked at Detgiz (children's publishing house) and for children's magazines *Chizh* and *Yozh*. Made several dozen children's books. Actively worked with poets from the Oberiu group: Daniil Kharms, Alexander Vvedensky, Nikolai Oleinikov. In 1934 was arrested and perished four years later in a Gulag camp near Karaganda in Kazakhstan.

Evgenia Evenbach
1889–1984
Born in Kremenchug (Ukraine). From 1910 lived in Petersburg and studied in the School for Advancement of the Arts and later in the Academy of Arts with Kuz'ma Petrov-Vodkin. In 1920s and 1930s actively traveled in the Russian North and Far East and made many works on paper during her expeditions. Illustrated about thirty children's books. In many of them she acted as co-author. Principal books: E. Dan'ko, *The Porcelain Cup* (1925); E. Shvarts, *Market* (1925); B. Zhitkov, *Cotton* (1926) and *Table* (1926); A. Vvedensky, *At the River* (1928) and *Honey* (1930); D. Kharms, *How Kol'ka Pankin Flew to Brazil and Pet'ka Ershov Didn't Believe Him* (1928); E. Evenbach, *Little Camels and Bears* (1930).

Vladimir Konashevich
1888–1963
One of the most active artists of children's books. Born in Novocherkassk, southern Russia. Studied in Moscow's School of Painting, Sculpture and Architecture (1908–14). From 1915 lived in Petersburg. First children's book published in 1918. Worked for many children's publishing houses and magazines. In 1921–30 and 1944–48 was a professor at the Academy of Arts in Leningrad, and head of the Book Illustration Studio. Published a book of memoirs.

Nikolai Lapshin
1888–1942
Born in Petersburg. Studied at the Baron A. Stieglitz Art School and at other private schools. In 1919 worked as director of the Division of Artistic Labor at the Department of Fine Arts of the People's Commissariat of Enlightenment. Besides his work in book illustration, was involved in painting and porcelain design and taught art. During 1928–31 was artistic editor of the children's magazine *Yozh*. In the 1930s was

an artistic editor for Detgiz. Made more than fifty books for children. Died from hunger in besieged Leningrad.

Vladimir Lebedev
1891–1967

Perhaps the most influential children's book illustrator in prewar years. Born in Petersburg. Studied art in private studios and the Academy of Arts. In 1918–21 taught in Petersburg Free Art Studios. From 1921 was a member of the Institute of Artistic Culture. Began to illustrate children's books in 1911. In 1924–33 was art director of the Children's Section of Gosizdat. Organized around himself a Leningrad school of children's illustrators. Was harshly criticized in the mid-1930s and drastically changed his avant-garde style after that time.

El Lissitzky
1890–1941

Studied art in Yury Pen's Studio in Vitebsk and at the architectural faculty of the Higher Technical School in Darmstadt, Germany (1909–14). In 1919, at the invitation of Vera Ermolaeva and Marc Chagall, he joined the faculty of the Vitebsk Institute of Practical Arts. Was the dean of the architectural faculty, head of the studios of graphics and typography (1919–21), and a founder of the UNOVIS group. In 1921 he lived in Moscow, and from December 1921 to 1925 in Germany. In Berlin he published his programmatic *Two Squares* (1922). In 1925–30 he worked as a professor for VKhUTEMAS-VKhUTEIN (former School of Painting, Sculpture and Architecture) in Moscow. Most of his children's books were made in 1917–23.

Kuz'ma Petrov-Vodkin
1878–1937

Born in Khvalynsk, Saratov province. Studied at the Baron A. Stieglitz Art School (1895–97) in Petersburg and the Moscow School of Painting, Sculpture and Architecture (1897–1904), and also in Munich (1901) and Paris (1906). Worked in painting, murals, theater decoration, and book illustration. Taught art at Zvantseva Art School (1910–17) and VKhUTEMAS-VKhUTEIN (1918–33). His first children's book, *Aioia: Adventures of Andy and Kathy*, was published in 1914. Principal children's books: *Goat-Shmoat* (*Koza-Dereza*, 1923); *Snow Maiden* (1924); S.

Fedorchenko, *Proverbs* (1924); S. Marshak, *Riddles* (1925); E. Bakhanovskaya, *Christopher Columbus* (1926).

Alisa Poret
1902–1984

Born in Petersburg. Studied in the School for Advancement of the Arts and at the Academy of Arts with Kuz'ma Petrov-Vodkin and Pavel Filonov (and remained a devoted pupil of Filonov's for many years). Worked in children's books from 1924. In the 1920s and early 1930s was close to Oberiu poets and made several books with them. After 1945 lived in Moscow and continued working in children's books. Principal books of the 1920s: N. Nikitich, *School Wagon* (1932); A. Vvedensky, *Railroad* (1929); N. Zabolotsky, *How the Revolution Was Won* (1930); V. Petrov, *Thirteen Octobers* (1930); S. Marshak, *Merry Theater* (19??); and others.

David Shterenberg
1881–1948

Born in Zhitomir (Ukraine). Began studying art in Odessa (1905). Lived in Paris in 1906–17 and studied at the École des Beaux-Arts and Académie Vitti. After the Revolution returned to Russia and immediately joined in building the new revolutionary art policy. Headed the Department of Fine Arts at the People's Commissariat of Enlightenment (1918–20) and the art department of the Central Professional Education Division of the Commissariat (1921). Taught in the painting faculty of VKhUTEMAS (1920–30). Began work in children's books in the late 1920s, when his radical avant-garde style of painting became the object of severe official criticism. Died in Moscow. Principal children's books: O. Gur'yan, *Galu and Mgatu, Negro Boys* (1928); *A Land of Fools (Japanese Folk Tale)* (1929): A. Mariengof, *Bobka-the-Sportsman* (1930); E. Emden, *A Song about Mommy* (1930); V. Mayakovsky, *For Children* (1931); N. Sakonskaya, *Dolls and Books* (1932).

Vladimir Tatlin
1885–1953

One of the founding fathers of Constructivism. Painter, theatrical designer, scenographer, constructor. Born and died in Moscow. From 1902 to 1910 studied intermittently at Moscow's School of Painting, Sculpture and Architecture and at the Penza

182

Art School, and in 1910–11 at M. Bernshtein's studio in Petersburg. In 1918 was chairman of the Moscow division of the Department of Fine Arts of the People's Commissariat of Enlightenment. Taught in the Free Art Studios. In 1923–25 headed the Department of Material Culture in the Institute of Artistic Culture in Petrograd. Began work as a book designer and illustrator in 1911, producing Futurist books. During the 1920s he and Malevich were the chief leaders of the Russian avant-garde. After 1932 he was singled out in official criticism as the embodiment of "formalism."

Solomon Telingater
1903–1969
Born in Tiflis (now Tbilisi, Georgia). Studied in Azerbaidzhan Art Studios, Baku (1919–20). From 1925 lived in Moscow, working as a book designer for numerous publishing houses. Prominent as a master of typographic art and creator of his own typefaces. Produced mainly books for adult and adolescent audiences.

Mikhail Tsekhanovsky
1889–1965
Born in Proskurov (now Khmelnitsky, Ukraine). Studied in private art schools in Paris (1908), at the Academy of Arts (Petersburg), and at the School of Painting, Sculpture and Architecture in Moscow (1911–18). From 1924 lived in Leningrad, where from 1926 he worked as an illustrator for Raduga publishing house and for the Children's Section of Gosizdat. Was the most radical Constructivist artist in children's books. After 1928 worked mainly in animation (after 1942 in Moscow). Principal books: S. Marshak, *The Seven Wonders* (1927), *Adventure of a Table and Chair* (1928), and *Mail* (1927); B. Zhitkov, *About This Book* (1927), *Telegram* (1927), and *Stories about Technology* (1928); M. Il'in, *The Factory in the Pot* (1928).

Nikolai Agnivtsev

1888–1932

Poet and playwright. Born and died in Moscow. Studied at the philological faculty of Petersburg University. Was a noted member of Petersburg's artistic bohemian circles. After the Revolution, lived two years in emigration. Upon returning to Russia, wrote more than twenty children's books.

Kornei Chukovsky

1882–1969

Born in Odessa. Lived in Petersburg, Moscow, and Peredelkino, the writers' village (colony) near Moscow. One of the most important figures in Soviet children's literature and in the mainstream literary process as well. Began writing for children before the Bolshevik Revolution and his works soon became classics. Never wrote production books or other politically engaged material. Was an active participant in the literary life and a prolific and influential critic. Besides children's literature he wrote about children's folklore and language (including the famous *From Two to Five*). His prose works include memoirs in addition to monographs and essays on nineteenth-century Russian literature. He translated British and American authors (Oscar Wilde, Rudyard Kipling, Mark Twain, Walt Whitman, O. Henry, Robert Louis Stevenson, and others) and wrote on the theory of literary translation. For about seven decades he maintained a diary, an invaluable document of Russian literary life, as yet unpublished. His son Nikolai also wrote children's books. His daughter Lydia Chukovskaya worked as an editor for Samuil Marshak in the Children's Section of Gosizdat, and was one of only two members of that department not imprisoned in 1937.

Nikolai Chukovsky

1904–1965

Poet, writer, and translator. Son of Kornei Chukovsky. Born in Odessa and lived in Petersburg and Moscow. Studied at the Institute of Arts in Leningrad. Principal children's books of the 1920s: *Runaway* (1925); *An Animal's Cooperative* (1925); *Our Kitchen* (1927); *Merry Workers* (1929).

Elena Dan'ko

1898–1942

Graphic artist and writer. From 1918 worked at the Lomonosov Porcelain Factory as a painter. Her most famous children's book, *The Chinese Secret* (1929), is about porcelain making. Also wrote about puppet theater and books. Died of dystrophy as a consequence of the siege of Leningrad.

Tamara Gabbe

1903–1960

A folklorist, children's author, playwright, and translator. Studied in the Literature Department of State Courses affiliated with the Institute of Art History in Leningrad. Worked as an editor under Samuil Marshak, and as a member of the Children's Section was arrested and sent to the Gulag in 1937. Wrote several popular plays, some of them staged for many years (*A Town of Masters, A Crystal Shoe, Avdotia the Ryazan Girl*, and others).

Mikhail Il'in (Il'ya Marshak)

1895–1953

Studied at Leningrad Technological Institute, and worked as an engineer. A younger brother of Samuil Marshak, at whose suggestion he began to write for children in 1924. In *Vorobei* magazine ran a column called "Chemical Page," and one in *Novyi Robinzon* called "Laboratory of Novyi Robinzon." Was one of the founders of a new genre of production books for children—about technical achievements and all kinds of machinery. Some of his books have been translated into foreign languages. His *The Story about the Great Plan* (1930) Romain Rolland called the best book about "the great significance of the heroic labors of the Soviet Union." Principal books: *100,000 Whys* (1929); *Black on White* (1928); *The Sun on the Table* (1926); *Men and Mountains* (1928); *Traveling into the Atom* (1930–31); *The Changing of the Planet* (1929); *How Man Became a Giant* (1927).

Vera Inber

1890–1972

Prolific Soviet poet. Born in Odessa and from 1914 lived in Moscow. Studied at Women's Courses in Odessa and in Western Europe. Principal children's books: *Tiny*

Multipedes (1925); *A Tailor and a Teapot* (1925); *House Painters* (1926); *Carpenter* (1926); *Sun Bunny* (1928); *An Armchair, a Table and a Stool* (1930).

Il'ya Ionov (Il'ya Bernstein)

1887–1942

Born in Odessa. Early in life became involved in revolutionary activity, was arrested many times, and spent more than ten years in prison and exile in Siberia. Returned to Petersburg after the February Revolution in 1917. Began working in a printing shop in 1899 when he was twelve, and began writing poetry in 1905. In the 1920s wrote several children's books. Major figure in the Soviet publishing industry in the 1920s and early 1930s, heading numerous publishing houses. Known for Bolshevik fervor and sheer rudeness. His activity as an author was modest, and as a leader in publishing he was largely destructive. In 1937 he was arrested during the Great Terror and perished in the Gulag.

Daniil Kharms

1905–1942

Born in Petersburg as Daniil Yuvachev to the family of Ivan Yuvachev, a revolutionary who was sentenced by tsarist authorities to hang and was later pardoned. Studied at the Electro-Technical Institute. Began to write absurdist poems and short stories very early. Was invited to write for children by Samuil Marshak. First published in magazines *Yozh* and *Chizh* in 1928. Used pseudonyms Ivan Toporyshkin, Karl Ivanovich Schusterling, Writer Kolpakov, Professor Trubochkin, D. Shardam, and, most frequently, Daniil Kharms. A friend of Vvedensky's. Like him, never published any of his adult writings. Famous for his eccentric personality and the playful nature of his texts. In December 1931 was sentenced to exile from Leningrad. Returned a year later. Eleven children's books were published before the mid-1930s, when he was suppressed and later (1941) arrested. Died in the Gulag.

Boris Kovynev

1903–1970

Born in Ukraine. From early childhood lived in Georgia, and from 1924 in Moscow. Studied at the literature faculty of VKhUTEMAS (1924–26). Wrote poetry and prose. His children's books of the 1920s emphasized class and ethnic struggle. Principal

children's books: *A Story about a Captain and Lan the Chinese Boy* (1926); *A Negro Boy* (1927); *Tale of a Negro Boy* (1928); *Revenge of a Hindu* (1927); *Eyes of a Hindu* (1928).

Osip Mandelstam
1891–1938

One of the greatest Russian poets of the twentieth century. Born in Warsaw and lived in Petersburg and Moscow. Died in the Gulag near Vladivostok. Children's books: *Two Streetcars* (1925); *A Kitchen* (1927); *Balls* (1928).

Samuil Marshak
1887–1964

Prominent Soviet poet, translator, critic, and editor. One of the founders and most prolific authors of children's literature. Born in Voronezh, and studied in Petersburg and at London University. Before the Bolshevik Revolution, felt Zionist sentiments, which are reflected in his poems. During World War I helped orphans of the war. From 1922 lived in Petrograd. In 1924–25 was editor-in-chief of the magazine *Vorobei* (later called *Novyi Robinzon*). In 1924–37 was a head of several children's publishing houses (Children's Section of Lengosizdat, Detizdat, Detgiz). Played a crucial role in organizing authors and artists around him and helping them survive by securing commissions for them. After children's literature and publishing houses in Leningrad were destroyed by Stalinist criticism (1937), he moved to Moscow (1938). Wrote dozens of children's books that became classics. A master translator of British poets.

Vladimir Mayakovsky
1893–1930

Prominent Russian avant-garde poet and artist. Born in Georgia and lived in Petersburg and Moscow. Studied art at Moscow's Stroganov School of Industrial Art (1908–9), and at Moscow's School of Painting, Sculpture and Architecture (1911–14). Worked as a graphic artist and executed many revolutionary posters. Actively worked in children's books. Committed suicide.

L. Savelyev (Leonid Lipavsky)

1904–1941

Born in Petersburg and studied at the Faculty of Social Sciences of Petrograd University and at the Institute of Oriental Languages. Worked as a teacher in high schools. Began to write for children in the mid-1920s; first book, *The Pioneer Charter* (1926). He initiated the revolutionary theme in children's literature. Died in action in late 1941 near Leningrad. Principal books: *Mute Witnesses* (1927); *The Hunt for the Tsar* (1929); *The Watch and Map of October* (1930); *For Soviet Power* (1930); *Lenin Goes to Smolny* (1929).

Evgeny Shvarts

1896–1958

Born in Kazan. Studied at the law faculty of Moscow University. From the mid-1920s lived in Leningrad and worked as an editor of the Children's Section of Gosizdat and for the magazines *Yozh* and *Chizh*. Published several dozen poetry and prose books for children. Wrote scenarios for movies and plays, some of them still being staged. Principal books: *The Story of an Old Balalaika* (1925); *The War between Petrushka and Stepka-Rastrepka* (1925); *A Camp* (1925); *Market* (1925); *Balloons* (1926); *Who Is Faster?* (1928); *To Swim, to Ride* (1930).

Elena Tarakhovskaya

1895–1968

Poet and translator. Sister of the well-known poet Sophia Parnok. Lived in Leningrad. From the mid-1920s to mid-1930s published many books for children.

Aleksandr (Alexander) Vvedensky

1904–1941

Born in Petersburg. Studied in the law faculty and later in the Oriental faculty of Petrograd University. Worked in the Institute of Artistic Culture (INKhUK), and researched the nature of poetic creativity. Founded (with Daniil Kharms) the Oberiu group of poets, the last avant-garde association in the 1920s. Now considered one of the greatest Russian absurdist poets and playwrights, his plays are frequently staged in off-off-Broadway theaters. The playful nature of his genius found its best expression in children's books. Vvedensky was one of the most significant authors in chil-

dren's literature of the 1920s and early 1930s (first books published in 1928). Before he was imprisoned and executed by the Bolsheviks in late 1941, he published about forty children's books but none of his adult pieces.

Boris Zhitkov

1882–1938

Born in Novgorod. Lived in Odessa, where he studied in school with Kornei Chukovsky, who later advised him to write for children. Studied in Shipbuilding Department of Petersburg Polytechnic Institute. Worked as a sailor, captain of a sailboat, laborer in a steel plant, carpenter, and teacher of mathematics and technical drawing. Traveled across the globe and was a man of encyclopedic knowledge. From mid-1920s lived in Leningrad. First published for children in 1924 in the magazine *Vorobei*. Wrote about 200 pieces on sea adventures, travel, technical inventions, and other subjects, and his writings have been published in 30 million copies. Persecuted in the late 1930s.

Lev Zilov

1883–1937

Born near Moscow in the village of Verbilki, famous for the Gardner Porcelain Factory (the factory belonged to his grandmother and his father was a director). Studied economics at the law faculty of Moscow University (1906–13). Began publishing poetry in 1904. First children's book appeared in 1914 (*The ABCs about Yura and Valya*). After the Revolution wrote mostly children's books (about fifty). Was principal of an orphanage. From 1924 was an official reviewer of children's books in *Pravda*.

NOTES

INTRODUCTION

1. The metamorphosis of the avant-garde, as Suprematism and Constructivism evolved into Socialist Realism, is analyzed in Boris Groys, *Gesamtkunstwerk Stalin* (1988), which I first encountered in its American translation, *The Total Art of Stalinism* (Princeton: Princeton University Press, 1992).

2. Written at the beginning of 1990.

3. *Detskaya literatura: Kriticheskii ocherk* (Moscow: GIZ, 1931), 6.

4. Groys found an apt formulation for this: "When the entire economic, social, and everyday life of the nation was totally subordinated to a single planning authority commissioned to regulate, harmonize, and create a single whole out of even the most minute details, this authority—the Communist party leadership—was transformed into a kind of artist whose material was the entire world and whose goal was to 'overcome the resistance' of this material and make it pliant, malleable, capable of assuming any desired form." Groys, *Total Art of Stalinism*, 3.

191

5. See 1 Cor. 3:2.

6. P. Dulsky and Ya. Meksin, *Illustratsiya v detskoi knige* (Kazan, 1925), 127.

7. Ibid., 78–79.

8. From V. M. Lobanov, *Khudozhestvennye gruppirovki za poslednie 25 let* (Moscow: AKhRR, 1930), 78.

9. "We'll tear the old world down by force, / Down to its foundations, then / We'll build a new one of our own. / Who once was naught shall now be all" (*Internationale*, from the Russian version).

10. Oberiu (Ob"edinenie Real'nogo Iskusstva) was a literary group founded in the late 1920s in Leningrad by Alexander Vvedensky, Daniil Kharms, and their friends. They were famous for their ludic way of life and grotesque, macabre, surrealistic writings.

CHAPTER 1

1. On Ermolaeva and her Segodnya (Today) workshop, see Evgeny Kovtun's "Khudozhnik detskoi knigi Vera Ermolaeva," in *Detskaya literatura* 2 (1971): 33–37; E. Steiner's "V. M. Ermolaeva" in the book *Sto pamyatnykh dat—1988* (Moscow: Sovetskii khudozhnik, 1987), 132–35. Tellingly enough, half of the artel's members (the more active half, since Al'tman and Annenkov, for example, did little work there) were young women. This fact, if projected onto the whole context of avant-garde artistic culture of the time, turns out to be isomorphic to that context. The large number of women in the avant-garde (Goncharova, Ekster, Rozanova, Stepanova, Lyubov' and Lydia Popova, and others) both concretizes and biologizes the metaphor "Birth of a new world."

2. I should note that the crane driven from its home by Zasuponya has associative reference to Zhuravl' (Crane), a short-lived prerevolutionary avant-garde publishing house where the immediate formal predecessors of Today books were printed.

3. Petrograd: S. Y. Shtraikh, 1923.

4. See Mayakovsky's poem "An Unusual Adventure Which Took Place with Vladimir Mayakovsky at the Dacha" and Kruchenykh, Malevich, and Matyushin's opera *The Victory over the Sun.*

5. Kornei Chukovsky, however, took on the sun itself (see his *The Stolen Sun*), choosing a somewhat toothier heliophage—the crocodile. Then again Chukovsky's

crocodile ends up regurgitating the sun, which action we might read as a reaction to Lenin's not entirely successful "electrification of the entire country." In general, this motif of a sun-gobbling monster was a fairly well developed one in 1920s children's literature and illustration; one example is Yuli Ganf's frontispiece for Nikolai Agniv-tsev's *The Chinese Chatterbox* (*Kitaiskaya boltushka*; Ryazan: Druz'ya detei, 1925), featuring a black, stylized dragon silhouette with a bright yellow sun for a tongue.

6. El Lissitzky, "Novaya kul'tura," *Shkola i revolyutsiya* 24–25 (Vitebsk, 1919): 11.

7. See *Miligroim* 3 (1922) and *Rimon* 3 (1922).

8. Lissitzky, "Novaya kul'tura," 11.

9. See his poem "The Order to the Army of the Arts."

10. Here I am alluding to performance of the opera *The Victory over the Sun*, mentioned above.

11. In general, the circle "got it" from Lissitzky at least twice more around this time: first split by the sharp point of a triangle in his famous poster "Beat the Whites with the Red Wedge" (1919) and then after the Civil War, when the Whites were re-placed by the "blacks," which in this case meant black-clad priests and rabbis. See the cover illustration of the Kiev Yiddish journal *Afikoires* (*Heretic*), issue 3 (1923), where a round little earth, on which stand a little synagogue and one lone rabbi with an umbrella, is split in two by a heretic wedge.

12. *Kirpichiki* (*Little Bricks*), a highly popular romance of the time, has a curious link to all this: the victory of the proletarian revolution turns the song's lyrics into reality: "Bolt by bolt and brick by brick / They've torn the brickworks down." This irony, a legacy of the old world, is countered by an avant-garde activist lyric from a book by Nikolai Agnivtsev, one of the most popular children's authors of the time: "They're not very big / But they're clever / Those bricks, little bricks / My little bricks" (from *Kirpichiki moi*; Moscow-Leningrad: Raduga, 1927).

13. The last words here paraphrase Mayakovsky, who called himself "an agitator, haranguer, head."

14. Mikhail M. Tsekhanovsky (1889–1965) is one of the most interesting artists and film animators of the 1920s. He not only expressed, but shaped, the fundamen-tal artistic ideas of his times—with greater intensity and stylistic purity than most of his contemporaries. Beginning in 1926 he worked as an illustrator for Raduga publishing house and for the Children's Section of GIZ in Leningrad; after 1928 he worked in animation. In 1923, he had also organized Propeller, a collective that designed movie posters. For more on Tsekhanovsky, see V. Kuznetsova and E. Kuz-

netsov's *Tsekhanovsky* (Leningrad: Khudozhnik RSFSR, 1973) and E. Steiner's "Tse-khanovsky" in *Sto pamyatnykh dat—1989* (Moscow: Sovetskii khudozhnik, 1988).

15. A typically titled book on Ivan Michurin and his methods is A. Bakharev's *V masterskoi rastenii* (*In the Workshop of Plants*) (Moscow: "Krest'yanskaya gazeta," 1930).

16. Highly indicative of the painfully hypercompensatory nature of Constructivist utopianism is the fact that Alexander Belyaev was a bedridden invalid; it was there, in bed, that he wrote his vivid descriptions of airborne and amphibious people.

17. N. Lapshin, "Obzor novykh techenii v iskusstve," *Zhizn' iskusstva* 27 (July 11, 1922): 1.

18. A. Chicherin's Constructivist considerations support this: "The word is a dis-ease, an ulcer, a cancer that has ruined poets in the past and continues to ruin them in the present, and which inexorably pushes Poetry itself into ruin and decay." In *Kan-fun* (Moscow, 1926), 8.

19. *Novye detskie knigi* 3 (1926): 120–22.

20. *Novye detskie knigi* 1 (1923): 9.

21. Cf. the name of a journal to which Lissitzky often contributed: *SSSR na stroike* (*The USSR in Construction*).

22. A. Pokrovskaya, "Evolyutsiya pouchitel'noi i obrazovatel'noi detskoi knigi," *Novye detskie knigi* 5 (1928): 63.

23. *Novye detskie knigi* 1 (1923): 9.

24. *Mumu*, a nineteenth-century classic by Ivan Turgenev, is a story that depicts the hard life of a deaf serf.

25. Yu. S. Obninskaya, "Deti v derevenskoi biblioteke," *Kniga detyam* 1 (1929) : 44.

26. Ibid.

27. In Russian, *yolka* means fir tree, Christmas tree, or New Year's tree.

28. E. Ya. Danko, "Zadachi khudozhestvennogo oformleniya detskoi knigi," in *Detskaya literatura: Kriticheskii ocherk*, ed. A. V. Lunacharsky (Moscow-Leningrad: GIKhL, 1931), 216.

29. This is an antideserter poster.

30. Lyubov' Yarovaya was the heroine of a play written by Konstantin Trenev, a prominent Soviet author. She reported on her own (beloved) husband, a counter-revolutionary White officer, and got him arrested by Reds. The character became an official symbol of a "real" Soviet woman. Pavlik Morozov was a peasant boy who be-came a Pioneer and informed authorities that his father had hidden some grain that

he had been ordered to give for free. The father was immediately arrested. Village people killed the young traitor. In official ideology, he was a young Soviet hero; in unofficial opinion, his name became an eponym for a betrayer of his own father.

31. It was almost indecently symbolic (bringing up suspicions of bourgeois efforts at sabotage) that issue after issue of the magazine *Novyi Robinzon* featured the prison "Robinsoniad" of an aged "Will-of-the-People" revolutionary, long incarcerated in the Peter and Paul Fortress, now freed. This related in detail his almost incredible efforts (after all, as Nekrasov said in *Railroad*, "human will and labor do wondrous wonders") to cultivate his own garden in the cell or prison yard, neither of which was at all suited to the purpose. The prophecies of Chekhov's shabby Petya Trofimov ("We will plant the new orchard") and Mayakovsky's Kuznetskstroi workers ("Under an old cart the workers lie / There'll be a garden city here in four years' time") took on the concrete quality of a how-to method for cultivating prison gardens, in a children's magazine for the "new Russians." No pun intended: the author's name is in fact Novorussky ("new Russian").

32. V. N. Petrov, *V. V. Lebedev* (Leningrad: Khudozhnik RSFSR, 1974), 95.

33. Pavel Neradovsky, in *Vladimir Vasilevich Lebedev* (Leningrad: GRM, 1928), 8–11.

34. Ibid., 11.

35. Elena A. Flerina, "Kartinka v detskoi knige" [The picture in the children's book], *Kniga detyam* 1 (1928): 4.

36. Nikolai Punin, *Vladimir Vasilevich Lebedev* (Leningrad, 1928), 22.

37. One more thing about coal. One of the drawings also depicts "A Chimney Sweep." This character was a rather popular one in postrevolutionary years; see, for example, Nikolai Agnivtsev's *V zaschitu trubochista* (*In Defense of a Chimney Sweep*; Moscow, 1926).

38. This is an allusion to a famous Soviet song: "[We have] instead of heart a fiery motor."

39. A. Altukhova and P. Dlugach, "Illustratsii Konashevicha i otnoshenie k nim detei," *Kniga detyam* 1 (1928): 30.

40. We should specify here that including Petrov-Vodkin and Konashevich in our discussions of avant-garde Constructivist mentality does not assume their full inclusion in the Constructivist canon itself (from which purists would also exclude Malevich and Filonov). As Stephen Bann aptly put it in his introduction to the collection *The Tradition of Constructivism*, "An operative definition of constructivism,

which reflects not only how the term arose but also how it was extended and perhaps distorted, is bound to be unsatisfactory to those who require a purely historical or genetic definition in terms of the original movement. Yet the broader lines of historical development within the arts of the century will never be understood if the divisions between identifiable movements are made to seem absolute." *The Tradition of Constructivism*, ed. Stephen Bann (New York: Viking, 1974; Da Capo, 1990), xxvi.

Moreover, it would seem both methodologically correct and heuristically fruitful to examine the various facets of the avant-garde project from a postmodern distance, which places the entire text of the Modern era in a sort of panopticon—a kind of miniature prison, with a guard at the center able to see everyone at once.

41. I should note, apropos of parallels with the Japanese way of organizing the artistic text, the percipient Mandelstam's frequent comments on European culture's Buddhist period, which began in the nineteenth century, and also his apprehensions about the numbingly destructive quality of this aesthetic. The textual strategy of Constructivism brilliantly confirms those apprehensions.

42. For more detail see Mikhail Yampolsky's "Problema vzaimodeistviya iskusstv i neosushchestvlyonnyi mul'tfil'm Fernana Lezhe 'Charli-kubist,'" in *Problemy sinteza v khudozhestvennoi kulture* (Moscow: Nauka, 1985), 76–99. Along the way, we should also note the Surrealists' fondness for toys; see André Breton's discussion of the role of toys in the artist's work in his *Surréalisme et la peinture* (1928). As for Charlie Chaplin, his popularity was also exploited in Soviet production books. One very dry, blueprint-like book about transportation uses his name to liven up the text a bit. See N. Smirnov and O. and G. Chichagov's *The Travels of Charlie Chaplin* (*Puteshestvie Charli Chaplina*), published in Moscow in 1925.

43. It was only people quite out of step with the "left march" who understood this—people like Mandelstam. Nadezhda Mandelstam recalls that "M. and I once noticed a militiaman on Red Square directing the traffic with his little baton. The way he flung out his arm, swiveling around now in one direction and then another, made it look as though he were dancing the solo part in some kind of mechanized ballet. 'He's not right in the head,' M. said, as we stood watching him for a few moments, horrified by the inspired precision of his movements: here was a cipher who, allowed to leave the ranks for the performance of this solitary duty, had decided to demonstrate the brilliance of his movements, their unbearable perfection." Nadezhda Mandelstam, *Hope Abandoned*, trans. Max Hayward (New York: Atheneum, 1974), 166. A visual paraphrase of this description, an artist's depiction of a rather hor-

rifying militiaman at his post, is Nisson Shifrin's *Na ulitse* (Moscow: Tretyakov Gallery, 1926).

44. Evgeny Poletaev and Nikolai Punin, *Protiv tsivilizatsii* (Petrograd, 1923), 22.

CHAPTER 2

1. *Oktuda posuda*, text by N. Smirnov, illustrations by G. and O. Chichagov (Moscow-Leningrad: GIZ, 1926). *O tom, kak priekhal shokolad v Mossel'prom*, poems by E. Tarakhovskaya, illustrations by Yu. Ganf (Ryazan: Druz'ya detei, 1925).

2. *Vanya-metallist*, text by P. Orlovets, illustrations by V. Denisov (Moscow: G. F. Mirimanov, 1924). *Vanya-kuznets*, text by I. Mukoseev, illustrations by V. Konashevich (Moscow-Leningrad: GIZ, 1927). *Vasya-kozhevnik*, text by E. Smirnova (Moscow: G. F. Mirimanov, 1925). *Stolyar*, poems by V. Inber, illustrations by A. Suvorov (Leningrad: GIZ, 1926).

3. *Domna*, text by N. Asanov, illustrations by G. Echeistov (Moscow: OGIZ, 1930). *Kak postroili gorod*, text by E. Papernaya, illustrations by A. Poret and L. Kapustin (Leningrad: OGIZ-Molodaya Gvardiya, 1932).

4. E. V. Yanovskaya, "Nuzhna li skazka proletarskomu rebyonku?" In *Iz opyta raboty po detskoi knige* (Moscow, 1926), 95.

5. L. Zilov, *Mai i Oktyabrina* (Moscow: Mospoligraf, 1924). *Mai* is Russian for "May." *Oktyabrina* is a neologism based on the word "October." Both are typical post-Revolutionary names.

6. N. Sharfenberg, *Vladlen-sportsmen* (Kharkov: Proletarii, n.d. [1929?]). "Vladlen" formed from *Vlad*imir *Len*in.

7. The words "forging the keys to happiness" are from a popular Soviet song.

8. P. Volzhenin, *Neobychainye priklyucheniya tovarishcha Chumichki* (*The Remarkable Adventures of Comrade Chumichka*) (Leningrad: Priboi, 1924), 3.

9. V. Ketlinskaya, P. Chagin, T. Trifonova, K. Vysokovsky, and M. Dubyanskaya, "Detskaya literatura v rekonstruktivnyi period," in *Detskaya literatura* (Moscow, 1931), 9.

10. *Na zavode*, no author, illustrations by V. M. Kaabak (Moscow: G. F. Mirimanov, 1927).

11. *Malyar Sidorka*, text by M. Andreev, illustrations by M. Pashkevich (Leningrad: Raduga, 1926).

12. I should note here that Pavel Filonov, the most rhetorical-radical character in "leftist" art in the 1920s, began his career as a housepainter.

13. I. Mukoseev, *Vanya-kuznets* (Moscow-Leningrad: GIZ, 1927), 10.

14. I. Mukoseev, *Kak Sen'ka Yozhik sdelal nozhik* (Moscow-Leningrad: GIZ, 1928).

15. From Blok's *The Twelve* (*Dvenadtsat'*).

16. V. N. Petrov, *V. V. Lebedev* (Leningrad: Khudozhnik RSFSR, 1974), 24.

17. V. Karinsky, *Azbuka pionera*, illustrated by ROM (Moscow: Moskovskii rabochii, 1925), 4, 5, 24.

18. N. Agnivtsev, *Vintik-Shpuntik* (Leningrad: Raduga, 1925).

19. M. Sandomirsky, *Pirozhok* (Leningrad: Raduga, 1926).

20. G. Solovyov, *Davaite stroit'* (Leningrad: Raduga, 1928).

21. *The Foundation Pit* is the title of a novel by Andrei Platonov.

22. P. Orlovets, *Parovozy na dyby* (Moscow-Leningrad: Kniga, 1925), 2. The expression *na dyby* or *dybom*, which means "rearing" (like a horse) or "standing on end" (like a hair), has the additional meaning of something in turmoil—normal life turned upside down. Meyerhold's production of Sergei Tretyakov's *Zemlya dybom*, for example, has come out variously in English as *The Earth Rampant, The Earth in Turmoil*, and *The World Upside-Down*.

23. From the children's book *Uncle Styopa*.

24. M. Solovyova, *Korabliki*, illustrated by F. Polishchuk (Moscow: OGIZ, 1927).

25. N. Samoilova, *Pro devochku Idu i pro Mishku Midyu* (Leningrad-Moscow: Tipolitografiya Akademii Khudozhestv, 1925).

26. G. Shaposhnikov, *Vanya v Kitae* (Rostov-on-Don, 1927). E. Redin, *Krasnoarmeets Vanyushka* (Moscow-Leningrad: GIZ, 1927).

27. N. Smirnov and G. and O. Chichagov, *Egor-montyor* (Moscow-Leningrad: GIZ, 1928).

28. *-ka* is a diminutive, pejorative suffix in Russian.

29. A. Boretsky, *Dogonim amerikanskuyu kuritsu* (Moscow-Leningrad, 1930), 23, 5.

30. M. Efetov, *Mozg zavoda* (Moscow: Molodaya Gvardiya, 1930).

31. E. Shvarts, *Rynok* (Leningrad: Raduga, 1925).

32. Several of the children's books of the late 1920s are devoted to the market theme—the hurly-burly atmosphere that had, during the NEP years (1921–28), broken out of Constructivist control. On the one hand, they emphasize the incoherence of commercial and rural life; at the same time they give the plenitude of the era

its due. ("These days you can hardly get through / All the goods, all the crowds," Evgeny Shvarts, *Rynok*.) Another example is N. Shestakov's simple and silly rhymes from B. Pokrovsky's interesting book *Bazaar* (*Bazar*; Moscow, 1928), which unfolds accordion style to reveal something like a row of market booths. ("Here / are some shafts and a collar / They're for the mare [We haven't forgotten her either].") The logical and stylistic conclusion of the theme is Tsekhanovsky's *Bazaar*, the surviving portion of an animated film based on Pushkin's *Tale of the Priest and His Servant Balda* (with Pushkin's text adapted by Vvedensky). The flat, hinged marionettes come to life in the film, making a tremendous impression. They both attract and repel.

33. See, for example, Yu. Gralitsa's *Detskii Internatsional* (Moscow-Leningrad: GIZ, 1926).

34. I. Ionov, *Topotun i knizhka* (Leningrad: Pechatnyi dvor, 1926).

35. This was hardly Tsekhanovsky's only attempt at the Young Pioneer theme. In 1926 he designed *The Pioneer Charter* (*Pionerskii ustav*), a book by L. Savelyev, in which he featured a multitude of repeating figures with bodies consisting of discrete segments, and pale pink ovals instead of faces. Such drawings, a perfect addition to the rules of conduct for Young Pioneers, create a rather horrifying visual context for abstract moral commandments.

36. We should mention here the role of lameness in myth.

37. Zilov, *Mai i Oktyabrina*, 40, 33.

38. L. Savelyev and L. Potapov, *Kak zhivut narody Severnogo kraya* (Moscow-Leningrad: GIZ, 1928), 3; P. Tupikov, *Komsomol'tsy v debryakh Afriki* (Moscow: Molodaya Gvardiya, 1923), 79. It is worth noting that the person leading the Komsomols (and hence the reader) through the wilds is someone named Tupikov (*tupik* = dead end, cul-de-sac).

39. Tarakhovskaya, *O tom, kak priekhal shokolad v Mossel'prom* (see note 1 above).

40. Yu. Obninskaya, "Deti v derevenskoi biblioteke," *Kniga detyam* 1 (1929): 44.

41. D. [Jack] Altauzen and B. Kovynev, *Povest' o negrityonke* (Moscow-Leningrad: GIZ, 1928), 13–14.

42. Although I suppose that serious scholars of art history will want to run me out of town on a rail, I cannot refrain from mentioning color symbolism here—the opposition of black and white (and the predilection is quite obvious). On the side of black we find, along with black people, the "black rage, holy rage" of the revolutionary riffraff in Alexander Blok's *The Twelve* (*Dvenadtsat'*). There is also Malevich's

Black Square; and *Art of the Negro*, a book by Union of Youth member Vladimir Matvei, which was published under Mayakovsky's aegis in Petrograd in 1919. On the white side, we have the white walls of the mansion and the white race as well.

43. Altauzen and Kovynev, *Povest' o negrityonke*, 30.

44. Z. Valentin, *Negrityonok Tua* (Moscow-Leningrad: Molodaya Gvardiya, 1925), 22.

45. Shaposhnikov, *Vanya v Kitae* (see note 26 above).

CHAPTER 3

1. *Iz opyta issledovatel'skoi raboty po detskoi knige: Sbornik statei* (Moscow, 1926), 21.

2. Written at the beginning of 1990.

3. K. Chukovsky, in *Russkii sovremennik* 4 (1924): 252.

4. Along with nondescript titles like *Poezda* (*Trains*) or *Zheleznaya doroga* (*Railroad*) there are ones like *Fu-ty—nu-ty parovoz* (something like "Nya-nya to you, engine") by Dyad Petro (probably M. I. Lasis), with illustrations by A. F. Andronov, or Grigoriev's *Shaitan-arba*.

5. A. Pokrovskaya, "Evolyutsiya pouchitel'noi i obrazovatel'noi detskoi knigi," *Novye detskie knigi* 5 (Moscow, 1928): 63.

6. *Vahana* (Sanskrit, "bearer"): in Hindu mythology, the divine bearer, an animal, which carries the senior god.

7. Vladimir Paperny is a Russian historian whose book *Culture "2,"* about the avant-garde, was published in the 1980s in the United States.

8. In those days it wasn't just the earth that was turned upside down or rearing up; see *Parnas dybom* (*Parnassus Rampant*), a collection of parodies, or the previously mentioned *Parovozy na dyby* (*Engines Rampant*). Workers as well as locomotives were rearing up, no longer willing to be reined in: "The gallows are on the right! / So that means it's reprisal night / Against working people / Who've reared up" (A. Zharov, *Priklyucheniya Fedi Rudakova*; Moscow, 1926).

9. This is a quite interesting text that invites a more detailed look, but would lead us too far astray. We might note, though, that *Absentminded* is in its own way a model of life in a world unadapted for life. It is significant that the absentminded passenger got into an uncoupled car—trains didn't run to the next life.

10. See, for example, E. Magnetshtein's *Vokzal*, with illustrations by B. Kryukov (Kiev, 1930).

11. E. Tarakhovskaya, *Zheleznaya doroga* (Moscow: G. F. Mirimanov, 1928).

12. L. Ostroumov, *Poezd* (Moscow: GIZ, 1926), 3.

13. S. Zak, *Nina i Vanya edut v Ryazan'* (Moscow: Moskovskii rabochii, 1928).

14. "Fellow-travelers" in this context means "nonproletarian supporters of the revolution," a rather derogatory definition of those intelligentsia who were treated with suspicion. Here I am making a pun: fellow-travelers on an engine and on the political line.

15. Two of Tsekhanovsky's projects were at the very cutting edge (or perhaps even over the edge in relation to verbal or book-graphic texts—which is why they ended up in a note). The first was *Poezd*, a modest little flip book from an entire series of so-called movie-books—editions without words and with identical drawings that both grew and shrank in size as the pages were flipped and the object portrayed seemed to move.

The second project was the famous *Pacific 231*, finished in the early 1930s. This was a film (or, as Tsekhanovsky himself said, "dynamized painting with sound") set to the Arthur Honegger piece dedicated to that locomotive. In essence, it was a cinema-illustration of symphonic music, visually constructed out of a clever montage of three object sets: the engine and its parts, the conductor and orchestra, and close-ups of the musicians as they played (lips, cheeks, hands, strings, horns, etc). The Paris journal *Art et décoration* published a highly flattering piece about the work in 1932.

16. *Novye detskie knigi* 3 (1926): 57.

17. Nadezhda Pavlovich (1895–1980) began her career as a Symbolist poet, and had been a close friend of Blok's in his last years. By 1925 she had already worked both in Proletkul't and at Optina Pustyn' (the famous monastery not far from Moscow, the most important center of Russian Orthodox spirituality)—a decidedly odd combination.

18. On Golodai Island, a suburb of St. Petersburg, there was an old cemetery.

19. *Steep Route* (*Krutoi marshrut*) is the title of Evgenia Ginzburg's book on Stalin's labor camps (published as *Within the Whirlwind*; New York, 1981).

20. Tarakhovskaya, *Zheleznaya doroga*, 3. We might also note *Metropoliten*, another book by Tarakhovskaya, this time about an underground train. The verses were written before the metro was built, and A. Brei's illustrations are a curious record of

unfinished plans—in part, the building of an elevated section over Sverdlov Square. The verses are no less interesting:

> From the station to Taganka
> From Taganka to Lubyanka
> It's dark outside the windows.
> But there on Sverdlov Square
> The sun comes out again
> The sun leaps in the window.

All the stages of the "great journey" are described here—stations, transits, prisons. But if from Taganka (this district was famous for the prison) to Lubyanka (the square, with the KGB headquarters; both names were widely used for "prison" and "KGB") it's dark outside, the sun comes out again on Theater Square (the old name for Sverdlov) where another mythology reigns—sunny Apollo coursing across the pediment of the Bolshoi Theater, using quite a different means of transportation.

21. Ostroumov, *Poezd*, 5.

22. Circular-centric compositions with locomotives are to be found in several books, including Nisson Shifrin's *Here Comes the Train* (*Poezd idyot*; Moscow: Krasnyi proletarii, 1929). There, a locomotive stands at the center of the composition; a number of tracks radiate from it to the depot engine sheds. The centerfold illustration for N. Vengrov's *October Songs* (*Oktyabr'skie pesenski*; Moscow-Leningrad: GIZ, 1927) is a spherical composition featuring two engines traveling along different sides of a ring of track. In these two pictures we can see the entire paradigm of locomotives' spatial existence on the Soviet conventional map of those years—in the center and also on the periphery, closing the circuit made by the viewer's eye, or the Moscow circle line.

23. K. Chukovsky, "Trinadstat' zapovedei dlya detskikh poetov," *Kniga detyam* 1 (1929): 18.

24. N. Shestakov, *Poezd*, illustrations by B. Pokrovsky (Moscow: "Krest'yanskaya gazeta," 1928).

25. B. Zhitkov, *Parovozy*, illustrations by B. Vladimirov (Moscow-Leningrad: Raduga, 1925), 149.

26. N. A. Nekrasov, *Zheleznaya doroga*, in *Sochineniia*, collected work in 3 vols. (Moscow: Goslitizdat, 1958), 2:9.

27. Editorial in *LEF* 1 (1923).

28. To complete the picture, here is a portion of the mythological-etymological context of the root *khar*, investigated by Ariel Golan in *Mif i Simvol* (Moscow: Russlit, 1993). On page 221 he writes, "In some legends Charon is a demon who steals peoples' souls, or else he himself is the ruler of the underworld. . . . It is believed that among the Slavs, *khort* was the name of the wolf who pursued the sun-deer"—which has a rather unexpected resonance with the sun-eating wolf we encountered earlier.

29. See, for example, *The Machine Is Whistling* (*Mashina svistit*), Innokenty Annensky's adaptation of verses by Ada Negri, in which there is a terrible machine, a locomotive, that heralds the approaching cataclysms. The text was published for the first time in I. Annensky, *Izbrannye proizvedeniya* (Leningrad: Khudzhestvennaya literatura, 1988), 244.

30. Alexander Blok's poem *On the Railway* (*Na zheleznoi doroge*) begins with the image of an unmoved ditch along the tracks, where a young and beautiful suicide "lay and watched as though alive."

In the 1920s, the association of the train with a flame-eyed serpent who emerges from underground was characteristic not only of children's books, but of texts written for all manner of purposes. For example, *The Floating Island* (*Plovuchii ostrov*), a justifiably forgotten book by Ovady Savich (Moscow: Nikitinskie subbotniki, 1927), begins with just such a chthonic image, one that has no connection with the remainder of the narrative, but does elucidate the author's mental-psychological context: "A narrow well extends sidelong into the earth. Grates and grass cover the entrance. To the right is a square with a tall station building, blunt-nosed trains without engines fly in, bursting out of the well—full-of-fun, toylike in the daytime, but at night more like mysterious, ringed snakes with electric eyes but no head." Here, just as in children's books, we find an ambivalent mix of daytime toys-and-fun and nighttime fears.

31. A. Toporkov, "Tekhnologicheskaya i khudozhestvennдya forma," in *Iskusstvo v proizvodstve* (Moscow, 1921).

32. Quoted in *Krokodil* 28 (1967).

33. V. Sokolov, "Novoarbatskaya ballada," *Novyi mir* 1 (1967): 83.

34. Note that here he mocks one of the most popular early Soviet songs.

35. Reproduced in *Understandable Art: Catalogue of the Exhibition*, introduction

203

by Evgeny Steiner (Ramat-Gan: Museum of Contemporary Israeli Art, 1992), 46. On the postmodern *sots-art* movement that emerged in Moscow in the early 1970s (combining the names "socialist realism" and "pop art"), see Groys, *The Total Art of Stalinism*, 10–12.

36. The discerning reader who has seen an allusion here not only to Marshak but to Mayakovsky's "with galoshes and without" is of course right—the theme of this gleaming, black, odorous marvel was celebrated often enough in children's literature (see Maria Shkapskaya's *Alyoshiny galoshi*, Lev Zilov's *U Lyoshi kaloshi*, and others). Galoshes were a shining example of how the production and international (black) themes could be integrated.

37. The Chichagov sisters, Galina and Olga, were committed Constructivists; they studied with Rodchenko at VKhUTEMAS, were part of the Constructivist First Working Group (along with Aleksei Gan, Grigory Miller, Nikolai Smirnov, and others), and participated in exhibitions subsequently considered to have been significant, such as the First Discussional Exhibit of Associations of Activist Revolutionary Art (Moscow, 1924).

38. Ostroumov, *Poezd* (not paginated).

39. Someone on the other side—Ivan Bunin—had a telling reaction to the revolutionary motorcyclist ("an animal in goggles and leggings"), and equally telling is his perceptive description of the frenzied truck traffic: "The truck—what a terrifying symbol it has become for us, how much of this truck there is in our most painful and awful memories! From its very first day the revolution was linked to this roaring, noisome animal packed first with hysterical women and foulmouthed deserters, and then later with the cream of the convict crop. All the crudeness of contemporary culture and its 'social pathos' is embodied in the truck." From *Accursed Days* (*Okayannye dni*; London, Ontario: Zarya, 1977), 60.

40. T. Bogdanovich, "Agitatsiya v detskoi literature," in *Detskaya literatura: Kriticheskii ocherk* (Moscow, 1931), 43.

41. S. Vaza, *Vozdushnye korabli* (Leningrad: Krasnaya Zvezda, n.d.).

42. Also "avio" in the original.

43. E. Tarakhovskaya, *Vozdushnyi parad* (*Air Parade*) (Moscow-Leningrad: Detgiz, 1931), 43. Autolithographs by P. Kirpichev.

44. See also L. Ostroumov, *Pochta* (*Mail*) (Moscow-Leningrad: GIZ, 1925). Illustrations by N. Ushakova.

45. See T. Gabbe and E. Zadunaiskaya, *Povar na ves' gorod* (Moscow-Leningrad: OGIZ-Molodaya Gvardiya, 1932); L. Kassil', *Vkusnaya fabrika* (Moscow, 1931); D. Semelovsky, *Kak mashiny obed gotovyat* (Moscow, 1931); B. Orsky, *Chudesnaya kukhnya* (Moscow: TsK VKP(b) and *Pravda*, 1931).

46. Orsky, *Chudesnaya kukhnya*, 11.

47. The book came out with "Biblioteka Murzilki" (The Murzilka Library), a cheap, shoddily produced series named for a cartoon character. Hence the title of one of Tsekhanovsky's critical articles—"This Isn't Murzilka—It's Serious Art!" ("Ne Murzilka, a bol'shoe iskusstvo!").

48. A very similar composition—this time not of a kitchen factory, but of a rubber processing plant—can be found in Zilov's *U Lyoshi kaloshi*. (The artist is not named.)

49. A paraphrase from Mandelstam's line: "Raznochintsy stepped their cracked leather boots."

CONCLUSION

1. Just as this setting makes its little man look tiny and out of place, so does El Lissitzky's project for the Lenin Tribune make another short man (Lenin himself) seem lost in Constructivist space. The orator looks like a little old man on a fire escape, shouting because he is afraid to climb down. In general, in children's books of the 1920s, appearances by Lenin were rare, and generally misplaced. For example, in Elena Dan'ko's *The Porcelain Cup* (*Farforovaya chashechka*; Leningrad: GIZ, 1925), a "production" book about porcelain manufacture, Evgenia Evenbach's illustration on page 5 shows a porcelain painter. The composition is entirely flat, with monotint color that conveys neither form nor depth. The multiple Lenins on multiple cups (as Salvador Dali later was to reproduce him on multiple piano keys) were utterly inadequate to this sign system. (Then again, the image was no less inadequate than the "Agitfarfor" itself—all those obscenely expensive porcelain cups and saucers covered with slogans to help the hungry in the early 1920s.) Dan'ko's text for the illustration now sounds not so much pridefully absurd as yearningly regretful:

What they paint in China
Are bright butterflies in flowers

And dragons that fly
In golden clouds.

And the Saxons love their birdies
And their tulips' sumptuous colors.
But in Leningrad it's Lenin
That we paint on our cups.

2. I should underscore that this is not a condemnation but a diagnosis.

3. We should note in passing the legal-correctional connotations of the word that was chosen as the name for the Bolsheviks' chief newspaper. *Pravda* (truth) is semantically linked to the notion of *pravyozh*, the medieval Russian punishment. Transgressors were caned.

4. *O partiinoi i sovetskoi pechati, radio i televidenii: Sbornik dokumentov* (Moscow, 1972), 41.

5. Mayakovsky in "The Left March."

6. *Iz opyta issledovatel'skoi raboty po detskoi knige: Sbornik statei* (Moscow, 1926), 50.

7. There were a few sober heads that warned against such a union. "Children, don't go off to Africa to play," admonished old man Chukovsky in his *Doctor Aibolit*, but in vain.

8. *O partiinoi i sovetskoi pechati . . .* , 412.

9. Ibid.

10. Other leading artists underwent a similar evolution, but unlike Lebedev they stopped working in children's literature. Lapshin, for example, began painting Leningrad landscapes in the mid-1930s, and in book illustration completely reversed his style; his extensive series of illustrations for *The Travels of Marco Polo* (*Puteshestviya Marko Polo*) were ink drawings in a free painterly manner. Tatlin replaced his iron-clad, angular *faktura* with miniatures of flowers and country scenes, painted thinly and transparently, "nonmaterially."

11. I cannot refrain from noting that even then, the newest and most progressive Soviet criticism continued to use (just in case) the ineradicable clichés of Stalinist servility. At the height of the Thaw, as Solzhenitsyn's Ivan Denisovich marched triumphantly through bookstores and people were being rehabilitated en masse, Ella Gankina, the country's leading specialist on children's illustration, wrote, "It can

hardly be considered an accident that two books by Lebedev, who was then a major authority in children's illustration, bore the brunt of the 1936 *Pravda* editorial attack 'On the artist-daubers.' . . . This article was the first to pose the question pointedly and directly . . . about the artist's responsibility to the new mass reader, who was supposed to accept and come to love books. The form of such books, alien to the readers, weakened and even helped to destroy their educational effect. The justice of this reproach was felt by all artists, Lebedev among them." In *Russkie khudozhniki detskoi knigi* (Moscow: Sovetskii khudozhnik, 1963), 104.

INDEX

Italic numbers refer to illustrations and (when preceded by *n*) notes

Bakhtin, Vladimir, ix
Balmont, Konstantin, 155
Baudrillard, Francois, ix
Beketova, Maria, 53
Belinsky, Vissarion, 138
Bely, Andrei, 38
Belyaev, Alexander, 40, 194
Berlin, 23, 33
Bianki, Vitaly, 53
Blok, Alexander, 82, 92, 198, 199, 203
Bolsheviks, 2, 10, 52, 140, 155, 206
Boretsky, A., 93
Brezhnev, Leonid, ix
Brodsky, Joseph, 5
Bulanov, Dmitry, 148, *149*, 158, *159*, 178
Bunin, Ivan, 204
Burmeister, A., 90, *92*

Chagall, Marc, 22
Chaplin, Charlie, 67, 196
Charon, 140, 203
Chekhonin, Sergei, 9, 100, 178
Chekhov, Anton, 51, 195
Chekrygin, Vassily, 30
Chichagov sisters, 118, 135, *137*, *138*, 145, *146*, 150, 154, 178, 204
children's literature: names of characters in, 76, 93, 197*nn6,7*; struggle against traditional tales, 72
 subjects in: adventures in exotic countries, 78, 99; automobiles, 146, 147, 148, 204; blood, 82, 85; chimney sweeps, 51, 52, 195; Chinese, 102, 104, 107–9; chocolate, 113, 114, 115; electricians, 154, 155; galoshes, 204, 205;

horses, 147, 148; kitchens, pots, and stoves, 161, 163, 164; knives, 81, 82; locomotives and train engines, 49, 90, 115, 121, 123, 124, 134, 135, 136, 139, 140, 142, 146; markets, 94, 198–99; metalworkers, 79, 81; mechanical teachers, 97, 98; "Negro theme," Africa, 52, 99, 102, 103, 104, 105, 107, 109, 172, 173, 206; new wonders, 72, 73; sports, 90, 175
Children's Section of the State Publishing House, 53, 193
Chirico, Giorgo de, 57
Chorny, Sasha, 57
Chukovsky, Kornei, 61, 98, 115, 134, 184, 192, 206
Chukovsky, Nikolai, 167, 184
Constructivism: and collision between biology and mechanics, 68, 121, 143, 147, 150, 171; and depiction of faces, 94, 97, 145, 170, 171; *dii minores* of, 145; style and mentality of, 11, 14, 23, 25, 30, 31, 34, 38, 40, 43, 50, 54, 67, 74, 77, 90, 139, 142, 157, 160, 164, 175; and "thingness," 54, 150, 151, 152, 154, 167
Cubism, 43, 67

Dali, Salvador, 205
Dan'ko, Elena, 185, 205
Deineka, Alexander, 154, 157
Deineko, Olga, 150, *151*, 179
Delez, ix
Derrida, Jacques, ix
Disneyland, Soviet. *See* Exhibit of